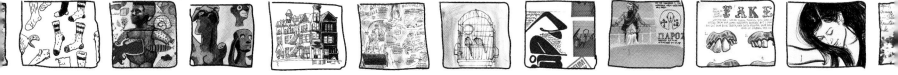

AN ILLUSTRATED LIFE

drawing inspiration from the private sketchbooks of artists, illustrators and designers

DANNY GREGORY

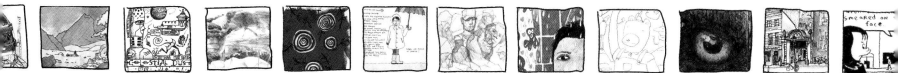

HOW
BOOKS

Cincinnati, Ohio
www.howdesign.com

AN ILLUSTRATED LIFE. Copyright © 2008 by Danny Gregory. Printed in the United States of America. All rights reserved. No other part of this book may be reproduced in any form or by any electronic or mechanical means including information storage and retrieval systems without permission in writing from the publisher, except by a reviewer, who may quote brief passages in a review. Published by HOW Books, an imprint of F+W Publications, Inc., 4700 East Galbraith Road, Cincinnati, Ohio 45236. (800) 289-0963. First edition.

For more resources for designers, visit www.howdesign.com.

12 11 10 5 4

Distributed in Canada by Fraser Direct
100 Armstrong Avenue
Georgetown, Ontario, Canada L7G 5S4
Tel: (905) 877-4411

Distributed in the U.K. and Europe by David & Charles
Brunel House, Newton Abbot, Devon, TQ12 4PU, England
Tel: (+44) 1626-323200, Fax: (+44) 1626-323319
E-mail: postmaster@davidandcharles.co.uk

Distributed in Australia by Capricorn Link
P.O. Box 704, Windsor, NSW 2756 Australia
Tel: (02) 4577-3555

Library of Congress Cataloging-in-Publication Data

Gregory, Danny, 1960-
 An illustrated life : drawing inspiration from the private sketchbooks of artists, illustrators and designers / by Danny Gregory.
 p. cm.
 Includes bibliographical references and index.
 ISBN 978-1-60061-086-8 (pbk. with flaps : alk. paper)
 1. Drawing. 2. Notebooks. 3. Artists--Diaries. I. Title.
 NC53.G74 2008
 741--dc22 2008031499

Edited by Amy Schell
Designed by Grace Ring
Production coordinated by Greg Nock

ABOUT THE AUTHOR

Danny Gregory began keeping an illustrated journal when he was in his mid-thirties, as a way to develop the habit of drawing and to deepen how he saw the world. Since then he has filled dozens of volumes and learned a lot about art and about life.

Danny was born in London, grew up in Pakistan, Australia and Israel, is a graduate of Princeton University, and lives in Greenwich Village with his wife and son. He is also the author of several books, including *Everyday Matters*, *The Creative License*, *Hello World,* and *Change Your Underwear Twice a Week.* His illustrations are published in the *New York Times*, in *HOW* magazine, and in books and publications around the world.

Photograph by Andrea Scher.

Every day, thousands of creative people visit his website, DannyGregory.com, for discussions about art and creativity, and a regular dose of his watercolor journals.

ACKNOWLEDGMENTS

First and foremost, I have to thank all of the many contributors to this book. They were all eager to participate, patient with my endless questions and demands, and forthcoming beyond my hopes. I hope this book is what they expected.

My friends at HOW Books made the process of wrangling all this material into a real pleasure and a beautiful book; thanks so much to my editors, Megan Patrick and Amy Schell, and my designer, Grace Ring. They are gems and geniuses.

Thanks also to my agents, Charlotte Sheedy and P.J. Mark, for all their help over the years and the books.

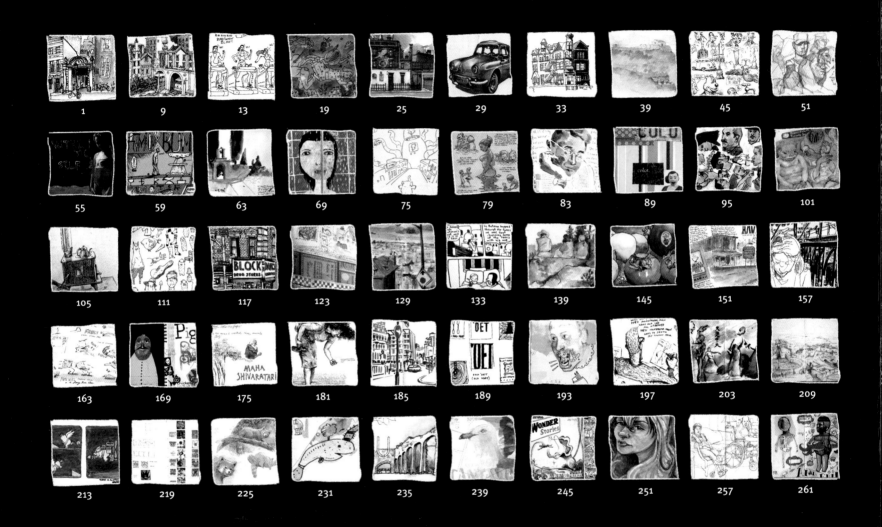

1 9 13 19 25 29 33 39 45 51

55 59 63 69 75 79 83 89 95 101

105 111 117 123 129 133 139 145 151 157

163 169 175 181 185 189 193 197 203 209

213 219 225 231 235 239 245 251 257 261

TABLE OF CONTENTS

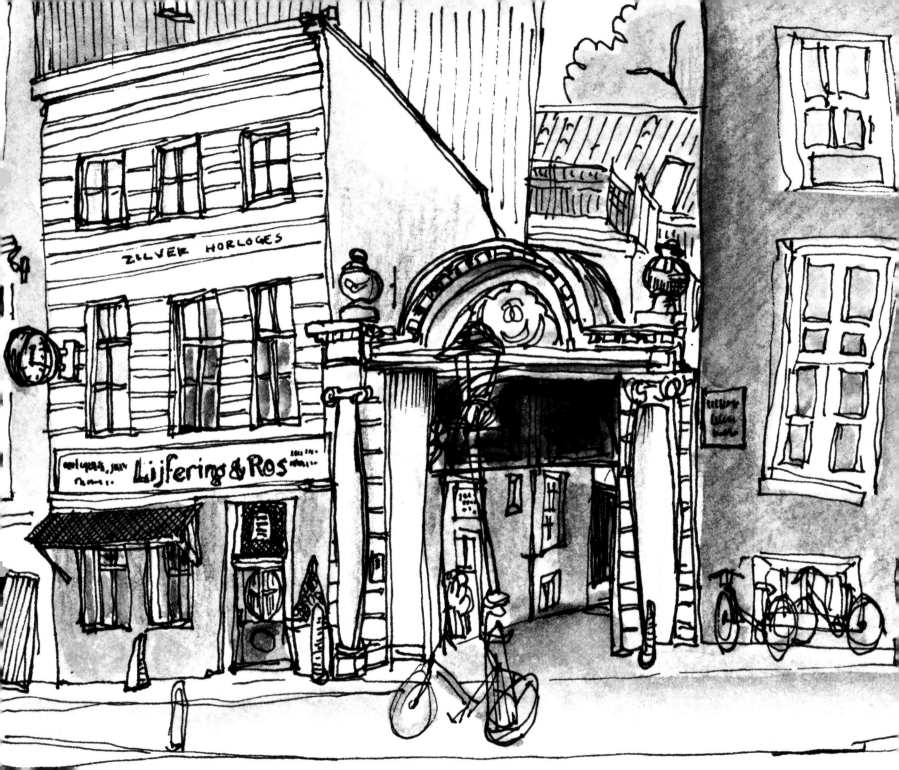

ILLUSTRATED LIVES: AN INTRODUCTION

I have been looking for this book since I was a boy drawing at the kitchen table. I've looked for it in dusty secondhand bookshops, in the art sections of libraries, in online bookstores and in auction houses. Because I never found it, I had to put it together myself—a book full of sketchbooks and illustrated journals from all sorts of people who love nothing better than to hunch over a little book and fill its pages with lines and colors.

That seems fitting somehow, making a book about books people have made—books that were generally not intended to be shared at all, and certainly not to be seen by strangers in large numbers. The pages of this book are filled with doorways to private worlds, drawn and written to record impressions, to work without judgment, to take risks and to chart new directions.

It's that intimacy and unguarded freedom that makes these books my favorite art form. It's the closest one can get to being inside an artist's head, to feeling the raw creativity flow: a book bulging with drawings and scrawled captions, some pages experimental, some pages carefully observed. The pages are buckled from layers of watercolor. The margins are filled with shopping lists and phone numbers. The cover is battered from traveling about, stuffed in a bag or a pocket and yanked out in the rain or thrown down in the grass.

This is not an art form that can be displayed easily in a gallery or museum, and throngs of viewers can't flock around it hanging in a golden frame. No, this is an art form that must be experienced as it was created, one on one, just as you are doing now, your head bent over the pages, absorbing each sketch and note, then turning to the next. With each turn, a fresh surprise, a new juxtaposition. The pages unfold like a story, a journey, a life. Each of the books is a slender slice of a life, a slice that could be weeks long or months or years, depending on the habits of the artists and the thickness of the volume. As you turn the pages, you feel the time pass. You see moments being recorded in sequence. You see ideas unfold and deepen. You see risks, mistakes, regrets, thoughts, lessons, dreams, all set down in ink for posterity, for an audience of one.

In each book, the form is the same—pages set between two covers—but the approach is as varied as the lives the pages record. Some journal keepers are methodical,

bound by self-imposed rules that instill regularity and consistency in the drawings. Others are wildly improvisational, radically changing style, medium and subject— the pages almost unrecognizably from a single hand.

Some of these books are unromantically utilitarian, rough sketches for professional tasks, but they too demonstrate the gestation of ideas being hatched and fed. We see the first inklings or several stages as a notion blossoms. There are pages that feel like scrapbooks, filled with a collage of scribbles on napkins, yellow legal pads and Post-It notes—repositories rather than true journals.

There are books that were filled like crossword puzzles, doodles and sketches to pass the time while waiting for a load of laundry or the express train. But as you page through dozens of random sketchy portraits of commuters or empty streets, you feel the accumulation of time, the flaky layers of pastry that make up the years of a person's life, enriched by living in the moment instead of doing sudoku, contemplating the world as it passes—even if it is serving up just a glimpse of a Kmart parking lot or a slumbering night-shift worker.

Then there are books that are achingly intimate, full of worries and ambitions, and you wince at what the artist must feel to share them with the world. You can feel the anxieties spilling out or the disappointments being massaged with layers of ink. These artists chart their obsessions with death, or failure, or sex, or food, or the simple visceral pleasure of hypnotic cross-hatching.

Their sketchbooks are their therapists, their sidekicks, their crying towel.

There are some people in this book who are secure in their roles as artists, who sell their work to put food on the table. There are others who do not equate their art with work, who do it solely for their own pleasure, who

would never rip a page from their book even to put it on the block at Sotheby's. Some of the contributors to this book are famous for their art, and consider their sketchbooks to be important chronicles of their work, if not their work itself, while others dismiss them as very raw materials for projects that are infinitely more polished and considered.

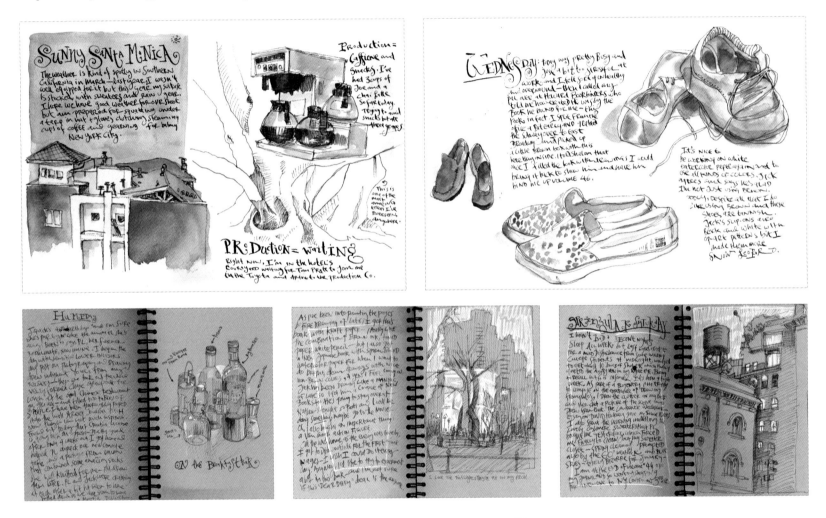

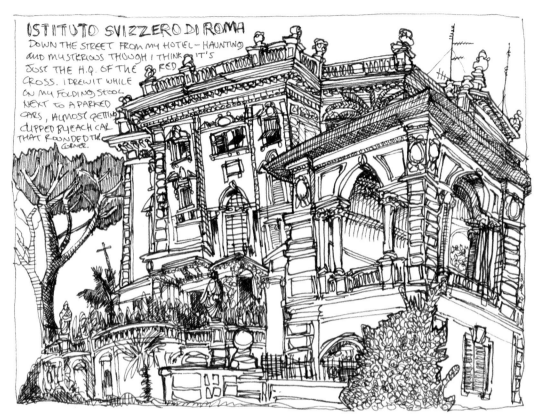

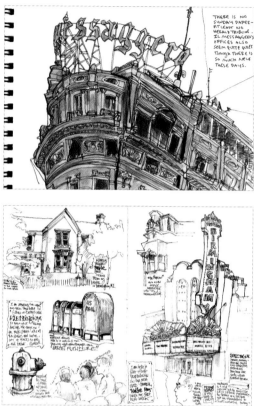

There are people in this book whose lives have been transformed by the simple act of drawing their breakfast in a book, who have seen their world for the first time by sketching it on the page. Many of them did not grow up with any understanding of their artistic potential, were flummoxed by the system of art education, and late in life taught themselves, slowly, to make their hands draw what their eyes could see. These pages contain the works of prodigies, self-flagellators, millionaires, paupers, professionals and novices. But they are all following the same path, working toward the back cover one page at a time.

As you turn the pages, you feel the time pass. You see moments being recorded in sequence. You see ideas unfold and deepen.

I began drawing, and drawing in a book, at one and the same time, when I was in my mid-thirties and convinced I could neither draw nor make books. Ten years and some sixty volumes later, I know I can do both. My art rarely steps out from between the pages of my sketchbooks. I don't paint or draw for exhibition or commission. I just draw the things around me that count. It may be my toothbrush, my dogs asleep in the sunshine or the corner Korean deli. Mundane stuff that I used to pass blithely by every day until I stopped to notice what my life was made up of, the blessings I need to count to give myself meaning.

I have drawn in many types of books. I began, as most do, with those black, covered sketchbooks with the lousy paper. Then I moved onto spiral-bound, watercolor pads.

Eventually, frustrated by my options at the stationer and art supply store, I took classes in bookbinding and made tall narrow books filled with smooth, heavy bond, which I covered with ink and brush markers. I filled dozens of Moleskines, most small enough to fit in my hip pocket and pop out several times a day to record a five-minute sketch of a street corner, an old man on the bus, a piece of furniture, a glass of wine.

I am by nature and training a writer foremost, so I have always surrounded my drawings with captions and titles. I try to add a little wit when I write, to write beyond the obvious descriptor and make a connection or describe the larger scene. My sketchbooks are personal but not private. I assume that several times, in the course of filling each volume, I will be asked to share my book with some curious passers-by. If they chuckle while they flip the pages, I know we are sharing a worldview.

Generally I write with a scratchy dip pen, scrawling, so no one but me can read my words. I love the look of an ancient manuscript, like Da Vinci's Codex, or a Beethoven manuscript on vellum. For me, the spidery marks make the page complete, and I feel a drawing or painting, no matter how long I have worked on it, is incomplete without a flowery, embellished piece of text. I am a student of Ronald Searle's ink blotches and Saul Steinberg's illegible calligraphy.

Periodically, I give myself assignments. I will draw each bite I take from an apple, or every car on my street, or all the contents of my fridge, or each position my dog assumes when he pees in the park. I have filled entire books with daily self-portraits, or drawings of each person on death row, or all the African-American CEOs in the Fortune 500. I like the music that emerges from drawing variations on a theme.

I also impose limits on the materials I use. For a month, I'll just draw in pencil or just with a 000 Rapidograph pen, or grey Sumi ink. I burst in a new direction after I lift the restriction and find myself in a brand new phase, brimming with ideas.

My journalkeeping ebbs and flows. Sometimes, I go a month or two without drawing, and then I slide back into a regular rhythm, stopping to sketch several times a day. I feel empty during the barren phases and wholly myself when the pen is my daily companion. I love to look back through these books I have filled, for they are little time machines. A glance at a page can send me back a decade, and I am fully returned to a moment long gone, re-feeling and seeing and smelling and hearing the experience I had when I was so intently concentrating on my drawing. The hard drive in my head downloads the whole moment again and again whenever I look back at the page. A twenty-minute patch of time spent nine years ago on a cold SoHo sidewalk can be a lot more vivid than what I ate for breakfast yesterday morning.

Illustrated journaling has transformed my life and given me the clearest form of identity I've ever had.

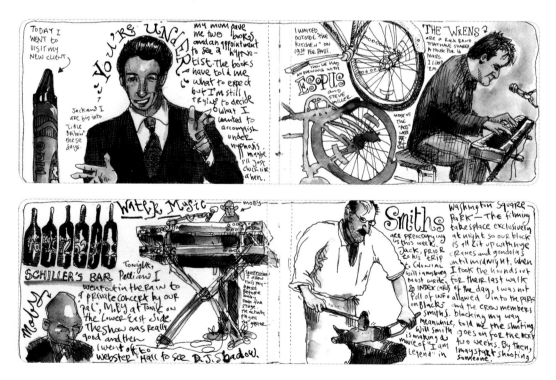

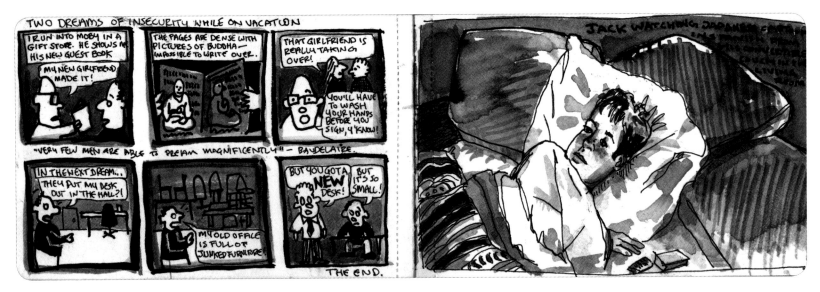

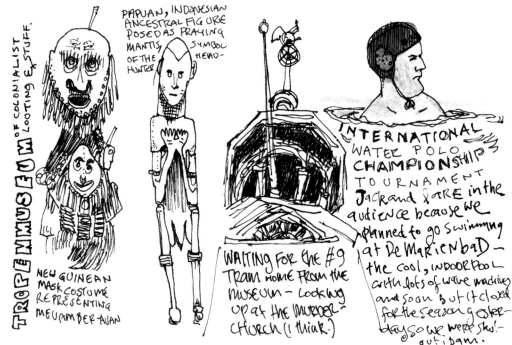

Illustrated journaling has transformed my life and given me the clearest form of identity I've ever had. I am now a person who draws; they can carve that on my headstone. Next to being a husband and a dad, it is the thing I am most. My passion for drawing has taken me on many adventures, opened many doors and made me many friends. We draw together in all sorts of places, wild or familiar, then pass our books around like family albums. I draw before work, in the middle of the night, at dinner parties or sitting shoulder to shoulder with my son as he draws as well.

I began keeping an illustrated journal because I was inspired by people who did the same. Extraordinary artists like Robert Crumb, Ronald Searle, Chris Ware, Hannah Hinchman, Frederick Franck and Dan Price published their journals and shared their daily lives in their work. As I looked through their books, it felt so right to me, and I began to chart my own days. At first my drawings, my calligraphy, my design and my observations were cramped and crude. But I found

the process so interesting that it soon became habit. Within a month or two, I hit my stride. I started to augment my pen drawings with colored markers, then pencil, then watercolors. And I began to feel like I was making art.

A sketchbook is a great, nonthreatening place to begin to draw. It also turned out to be an ideal place to develop ideas, experiment and break away from the restrictions imposed by our increasingly digital workspace. Computers are key to so many parts of the creative process, but they don't fit into a coat pocket or really let ideas stream out of the brain, down the arm and onto the page. I found that a pen on the page inspired many new connections and creative breakthroughs.

I hope this book will inspire you, too. I have purposefully assembled a group of people with all sorts of experiences, professions, philosophies, backgrounds and degrees of ability. Some may intimidate you. Some may scare you. But I hope they will all encourage you to buy a little blank book and start recording the contents of your medicine cabinet, fellow passengers on your commute, the clutter on your desk.

Whether you are an artist, a designer, a writer, a musician or a CPA, I hope you'll discover the richness, the adventure and the endless horizons of your own illustrated life.

MATTIAS ADOLFSSON

Mattias grew up in a small suburb of Stockholm, Sweden, then moved to Gothenburg to study architecture and earn an MFA in graphic design at HDK School of Design and Crafts. He has had various careers as a freelance illustrator, children's book author, animator and video game designer. He now lives in one of Sweden's oldest towns, the thousand-year-old Sigtuna. To see more of his work, visit www.mattiasa.blogspot.com.

I guess I need an audience to use a sketchbook. I started keeping sketchbooks when I studied architecture, and they were mostly filled with doodles. I used to let my classmates look at them from time to time, and I loved their responses. I lost interest after graduation when I started working, and I didn't start drawing in a sketchbook again until I discovered blogging.

For me, the web is like a substitute for people flipping through my book. Of course, it's not exactly like the real thing but a way to make flipping international. I'd like to be able to make a better online presentation of my sketchbooks someday, but now it's all a bit haphazard. Maybe when this book is published, I will have it ready.

I try to update my blog daily so I have to produce at least one spread each day. My sketchbooks are my playground. I don't use them as a journal or to tell stories from real life. I tend to draw from my imagination rather than reality.

I find that drawing in my sketchbook is easier for me than using other media. I can feel freer and not be concerned that every drawing has to be perfect. I like the unpretentiousness of it. I can spin off with a rather silly idea and make a small comic out of it. I've always used a lot of humor and comedy while interacting with my classmates, friends or fellow workers, a purely verbal type of humor and not always easily translated. But using sketchbooks, I've been able to transfer my sense of comedy to another medium.

Sometimes I use my sketchbook to do sketches for illustrations, and occasionally, the drawings are good enough to be the final art work. But, for the most part, the ideas in my sketchbook stay in the sketchbook and my blog. I am thinking of keeping special sketchbooks for commissioned work. I'm not always happy with having those kind of pages in my regular books; they tend to break the flow.

I do not leave blank pages, as they also break the flow when I go back and am paging through them. After a spread with complicated drawings and colors, I tend to follow with simpler pages, maybe just a small animal or something.

It's very easy to see the progress you make when the drawings are in a book. I can also see a big difference in my new sketchbooks; I've started using more and more color in them, and they tend to be more and more complicated over time. The drawings I make outside of my books tend to be more elaborate than the stuff I draw in the sketchbooks.

After I started to draw in my sketchbooks again, I stopped having "dead time." If I have to wait for something, I

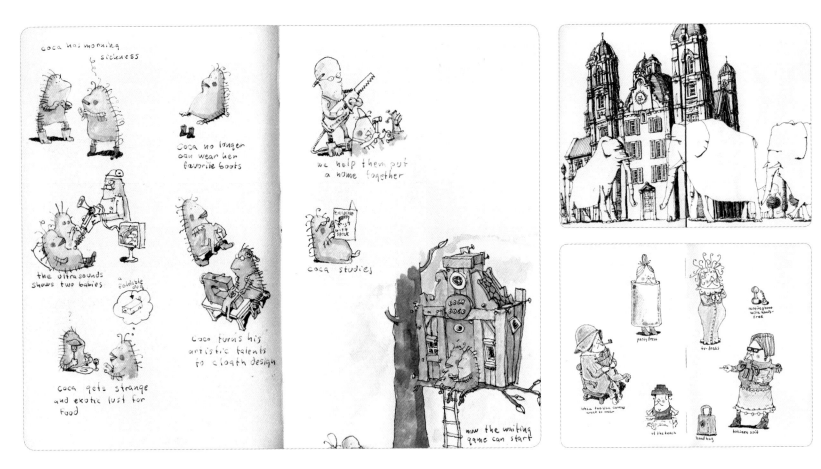

don't see it as time wasted, but rather sketch time won. I draw while commuting. I travel mostly by train—it gives the line an extra tremble to it. I used to be rather self-conscious when drawing in public (and can still be, especially when starting a new page) but nowadays I'm much more secure. I seldom watch television these days without drawing. I often use time while on conferences or lectures to draw and sometimes feel I look rather uninterested in the lecturer; I hear while I draw, but I'm not sure what signals I send out. When I'm in my studio, I sometimes have to force myself to use ordinary paper; the sketchbook is so easy to use.

I draw with fountain pens: a Montblanc meisterstück 149 and a Namiki Falcon. I use ink from Noodler's and watercolors. When I restarted my sketching I chose Moleskine sketchbooks. I think they are great but could consider choosing something else. My wife is a bookbinder, and she has promised to make sketchbooks for me.

My sketchbooks tend to move about the house, but I like to keep them together, always close at hand. It feels good to look back through them, though sometimes I marvel at what I was thinking when I filled them.

Matties Adolfsson

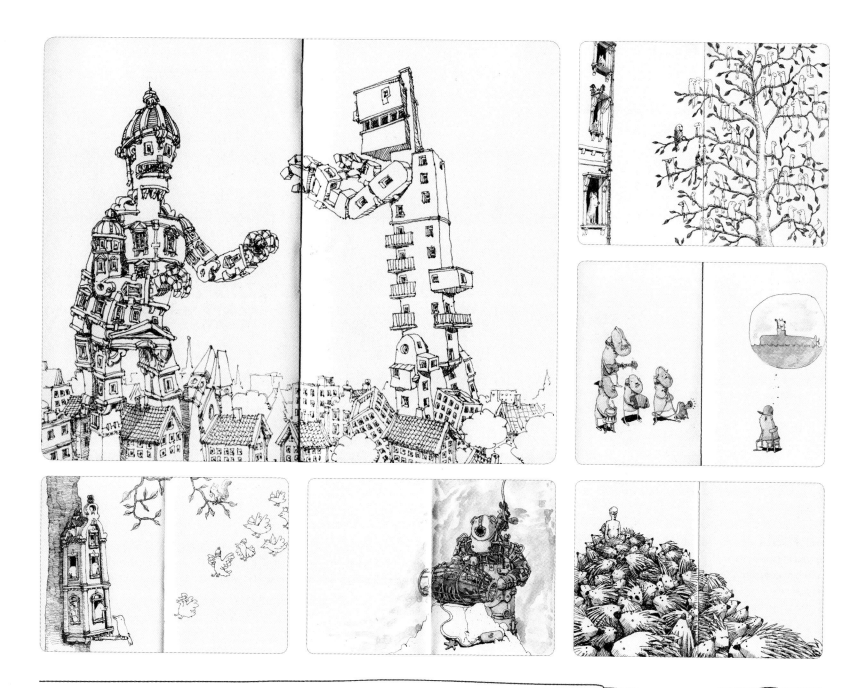

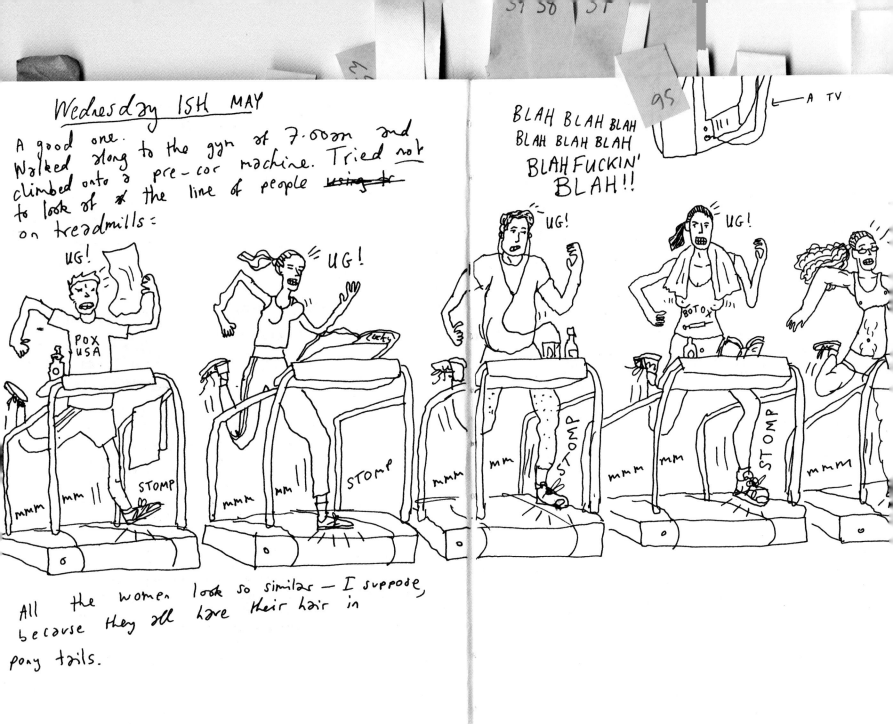

PETER ARKLE

Peter grew up in Scotland, completed a degree in illustration at Saint Martins School of Art and Design and an MA at the Royal College of Art, both in London, and now lives in New York where he is a freelance illustrator of books, magazines and ads. He shares an office with his wife, writes and draws a column in *Print* magazine, and occasionally publishes "Peter Arkle News," a zine of his illustrated journals. For more of his work, visit www.peterarkle.com.

My sketchbooks have two purposes: First, they are where I collect ideas for my work. I make notes and rough sketches of things that I find interesting or am amused to see or think of. Some of these ideas are destined to stay in the sketchbooks forever, others get taken out, often reworked and edited, and end up in "Peter Arkle News" (if they're the more personal work I like to publish there) or in whatever commissioned piece I'm working on. Doesn't happen as often as I would like, but sometimes I get sent to events or places as a kind of reporter (this is what I do in my *Print* magazine column). I make notes and take loads of photos and, less and less, do the odd drawing while observing. Back at home, I try and turn that jumble of stuff into something that's easy for someone else to make sense of.

The other purpose of my books is to entertain me. Often, doodling in them just gives me something to do, but other times it can make me pay more attention to what's around me. I set out to draw one thing just because it'll pass the time but end up seeing another thing and then something else happens that makes the first thing even more interesting and so on and so on until a little narrative (a slice of real life) has been captured. It's rare that one of these little narratives doesn't turn out (especially with a bit of editing) to have some kind of poetic quality.

Doodling in my books can also be therapeutic. I've genuinely had nasty or upsetting experiences that I've been able to get through much more easily by documenting them. When I was in the hospital for hernia surgery it was very helpful to be busily documenting everything. I was too busy trying to get down the way the guy in the next bed looks to actually stop and think about the tale of horror he was telling me!

Obviously, too much standing on the edge of life looking in as an observer can be dangerous or silly—dangerous because you are missing out on actually taking part. I remember being on a train in the Swiss Alps with a girlfriend when she screamed at me because I was making a drawing about how the toilet worked rather than looking out at the incredible mountain scenery. The toilet just had a flush flap that opened onto the tracks below. You could actually see the rails/ ties slipping by underneath. Oh, I must mention how silly things can get if you try to document everything you are doing—you end up writing "I am making a drawing of me drawing."

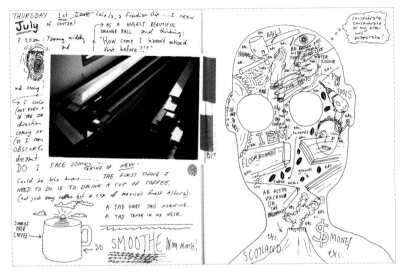

For me drawing in a book is mainly practical. Books are easier to draw/write in when standing up or lounging in a comfy chair. It's good to be able to hide things—especially if you've just done a bad drawing of the person opposite you on the F train.

I must, however, admit that there is something satisfying about arranging a collection of these books (objects that have character after being carried around and used) on a shelf. I actually enjoy putting all books (published ones by other people) I've enjoyed on a shelf. They remind me of where I was when I read them (and often contain things from that place or adventure that I used as bookmarks). Sketchbooks just take this a bit further. I do love looking at the few of my dad's that I have and would like to think that someone in the future will look at mine and be surprised by my weird ramblings (although still better to surprise people now, while I'm alive).

My only sketchbook rule is that my writing should be as legible as possible. I constantly urge myself to draw

If you make a drawing, you remember much more than if you take a photo.

more, or to do better drawings. Drawings in my notebooks work in the same way drawings in magazines do. They make me stop and pay attention to something. Adding drawing to a story of something odd happening means there's less risk of that story being forgotten. I sometimes try to tell myself that every page must contain one drawing (no matter how small), but this law always falls by the wayside when I find myself trying to get down the funny or weird thing that someone just said.

I like the very first blank page in a new book. It makes me think I will try to do better drawings, write more neatly, begin anew … but then a few pages later I'm back to my old ways: just trying to get the facts down and not really caring what it looks like. I used to care

more how books looked when I was an art student because my tutors would sit down and look at my books and grade me accordingly. In real life, this doesn't happen.

Sometimes I make myself draw something when I am somewhere I really want to remember. If you make a drawing you remember much more than if you take a photo. When you draw, you have to learn weird boring facts: "Oh that building has rows of five windows that do that and then one that does that and then five more that do that." That building, or whatever, will be burned in your memory forever. Sometimes I draw a thing (a piece of fruit, a cup of coffee, a piece of trash on a beach) and the drawing of that thing reminds me of much more than that humble thing itself.

I draw like a hairdresser cuts hair (on demand for other people) all the time—nearly every day at the moment—and therefore spend less time drawing for the sake of it than I used to. After a long day of drawing at my desk, I just want to lie on the floor—and

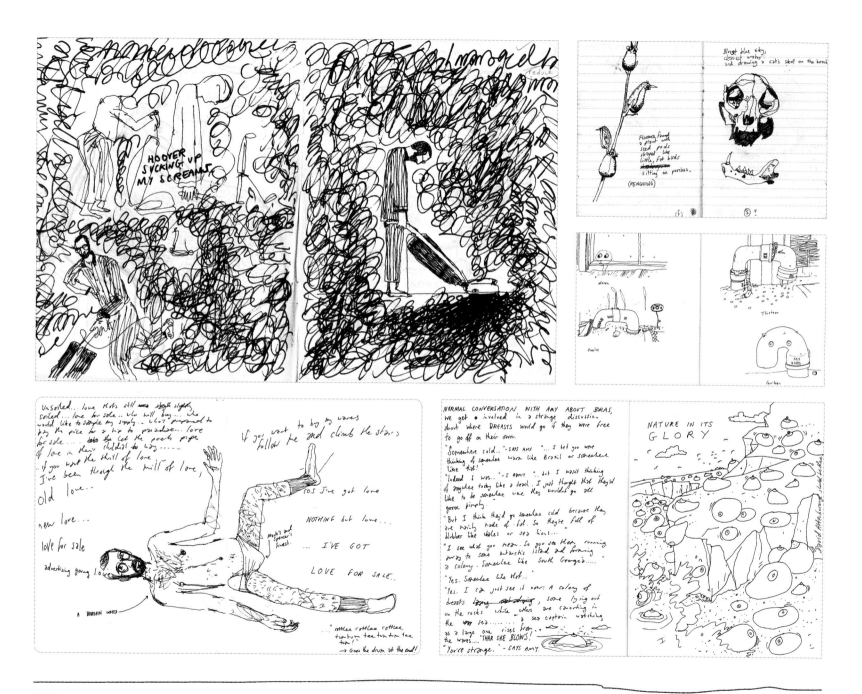

certainly not draw. After drawing, I need to do passive things: reading, watching, listening, eating. Doing the dishes, vacuuming or watering plants can feel great after a day of drawing. Full-color, real-life people are most enjoyable after a day of drawing little black and white people.

I feel okay about other people looking through my sketchbook … as long as I've checked to make sure that it isn't one that contains something too personal or embarrassing. Sometimes I want to push the envelope and try to document something different. These

somethings aren't all things that I'm proud of or want to share (and, as I said, no art school tutors can pounce on my books and insist to look these days).

The most interesting things that go in my notebook are often comments or pictures of people that I wouldn't want them to see. Not necessarily nasty, but not something I'd want to discuss with them. For example, one time I was drawing tourists outside a famous cathedral. A tourist I'd just drawn came over and asked to look—assuming I was drawing the cathedral. I pretended I was deaf or insane until they went away.

I usually have some kind of notebook with me. Usually a digital camera too. I've stopped taking lots of art materials on vacation with me because it always works that, if I take them, I never draw or paint a thing, but if I don't, I suddenly do want to draw or paint. Better to want to and have no art materials, because something can always be found. And not having proper art materials can sometimes lead to making more interesting things (drawings using coffee, drawings on driftwood or just odd sandcastles).

I like cheap, nonprecious books. I don't like them to be precious objects. I like them to get dirty and beaten up.

It's what they contain that's more important. Small is good for sneaking about. It's hard to do secret drawings of people in a huge, leather-bound book.

My main tool is a Rotring Art fountain pen with lovely solid black Rotring ink. It's rare I use anything else. Pencil doesn't reproduce well.

When I look back through the books I've filled, I usually feel annoyed that there's still so much good stuff in them that is just sitting there having nothing done with it. "Why haven't I done something with all the books made during my time in Switzerland, or when I was a telephone market researcher, or … etc?" Sometimes I catch myself laughing at something and realize that it's only funny because it is in an old notebook and that is where it has to stay because it just won't translate to another medium. And then I wonder if anyone will ever even read it again …

PETER ARKLE

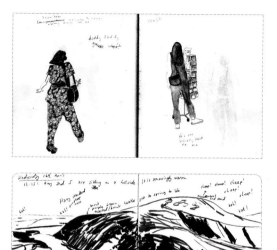

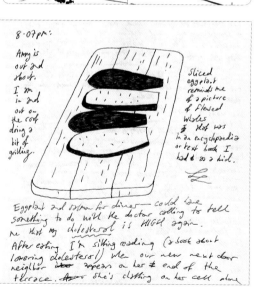

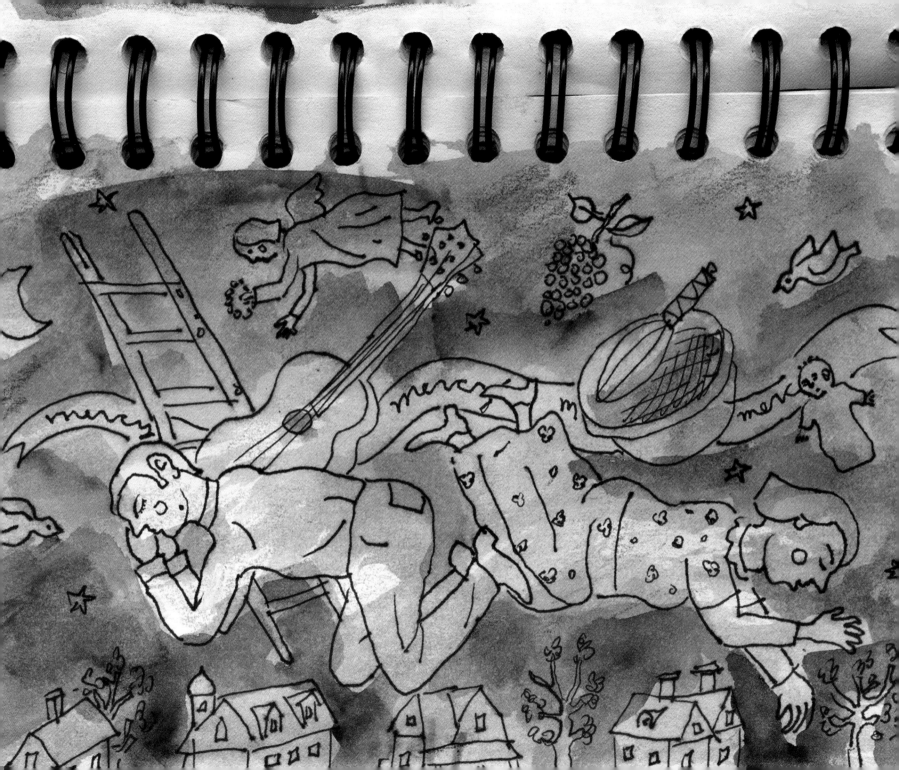

RICK BEERHORST

Rick grew up in Grand Rapids, Michigan, earned a BA from Calvin College and an MFA from the University of Illinois. After a year in New York, he is now a full-time artist in Grand Rapids where he and his wife, Brenda, home school their six children. His work can be seen at http://studiobeerhorst.com and at www.eyekons.com.

My sketchbooks serve me as a place to draw any time, anywhere. They help me stay free and, at the same time, help me get connected to the world around me in a deeper way. I think of the sketchbook more as a place to play—not for sale, not for exhibition, just a private place to be a kid again and stay curious about everything.

My journal helps me remain sensitive to my surroundings. Drawing in my sketchbook quiets me down, slows me down so I am more able to hear the quiet voice of God speaking through ordinary things and situations. It's like tracing through the thumbprints He left all over the crowded world.

Drawing is a sort of drinking in of the sensory world. It is also grounding because of the quiet concentration. The stillness is like meditation or study. I also play music, which feels more about pouring out than drinking in. And while playing music is a public performance that needs an audience, drawing is more private and contemplative.

Drawing is a mystical activity that makes places holy when and where it is practiced. It is a sort of prayer. People are naturally drawn to it much like a live musical performance. Though, since it is more private by nature, they are unsure how to respond.

My sketchbooking comes in waves. When I'm doing it, it goes with me everywhere. The ritual lasts for a while. For a while, I drew after breakfast as a way to stop eating too much and yet be at the table with my kids. When I went to church, I would draw during the musical worship time as a way to connect with God. When I lived in Brooklyn, I drew while I rode the subway train as a way to acclimate myself to a new place and as an excuse to stare at people. Drawing in a new place helps me get acclimated, to connect and adjust to a new environment. Traveling by subway seemed so strange and sometimes scary but, when I began to draw there, I felt like all those strange people began to open up to me.

My sketchbook is an extension of my home art studio. It is like an alien mother ship sending out an exploration pod to collect data and impressions and maybe even a temporary abduction or two.

My sketchbook is a place where anything goes. It doesn't have to look good or smart or professional. If there is any rule, it's that it needs to be fun and sometimes stupid and silly. I'm not drawing to develop ideas for a particular painting—there is usually no larger

MOMA 11 West 53rd St
B train to Rockeffeler Ctr.

"moderation is better than muscle, self-control better than political power."
prov. 16:

the universal intercessor
Great mother-protectress

mantel of protection
standing with arms out stretched attended by angels

December 27 2006

secret history
dear John letter
making apology
christmass decorations
speaking in tongues
dirty socks
chocolate kisses
sand in my shoe
penny rolls
taking dictation

a dirty window
wind up clock
broken glass
pulling up weeds

purpose the sketches are tied to. They just live in that simple moment.

The fact that my journal is in book form helps it seem more of a "place to go to" than loose sheets of paper. The containment of a book seems to have a theme or some kind of representation of a specific artistic territory. It also seems in kinship with a diary and to represent a particular period of time and life experience.

Blank pages sometimes feel empty and lonely. If it is an expensive book with extra fine paper, it can be scary and intimidating. But blank pages can also feel inviting, like a new house to explore, unfamiliar woods to ramble in, a big couch to stretch out on, a friend who knows how to really listen.

Drawing is a mystical activity that makes places holy when and where it is practiced.

I like nice, heavy paper that doesn't bleed through with markers and watercolor. I like homemade blank books that I get from friends or art fairs. I like a spiral binding so it lays out flat when I draw. I don't like spending too much money or it begins to feel too precious, and that can be inhibiting.

Media wise, I use anything and everything in my books. I like Micron pens. Lately, I have been using a wooden holder and a couple of different steel nibs I keep in a tiny Ziploc bag. I have a small water bottle

with a cork and a small Schmincke watercolor kit and a box of hard charcoal and charcoal pencil I like to smear over ink drawings. Crayons are cool, the way the wax resists the watercolor.

I have many sketchbooks. I try to keep them together but they end up all over the studio and carriage house, buried in with our other books, laying on shelves, under the couch. I love having them handy so I can look back through the books. It brings me back to specific times and places that became meaningful because I drew them. Moments that would have been forgotten or not realized if I hadn't taken the opportunity to draw in the midst of them.

Deep inside, I think drawing and writing help me remain whole in a world that feels so broken apart.

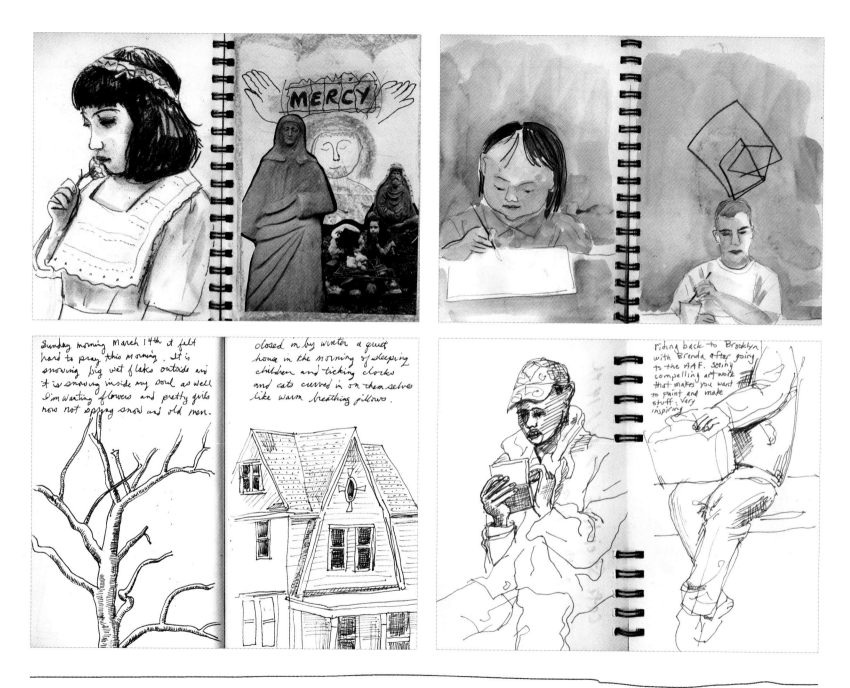

Sunday morning March 14th it felt hard to pray this morning. It is snowing big wet flakes outside and it is snowing inside my soul as well I'm wanting flowers and pretty girls now not spring snow and old men.

closed in by winter a quiet house in the morning of sleeping children and ticking clocks and cats curved in on themselves like warm breathing pillows.

riding back to Brooklyn with Brenda after going to the A.A.F. seeing compelling artwork that makes you want to paint and make stuff. Very inspiring

Perhaps the best thing to do is draw often and everywhere. See it as an opportunity to live more deeply. Think of the sketchbook as a portal into a life of more potency, more mystery and perhaps even a tool to help you go "through" hard times rather than go "around" them. Drawing brings me into the quiet presence of God.

Rick Beerhorst

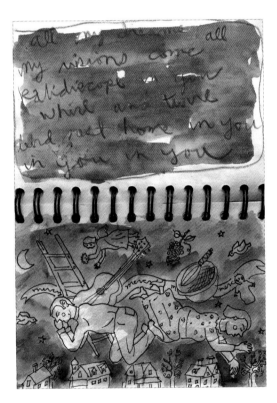

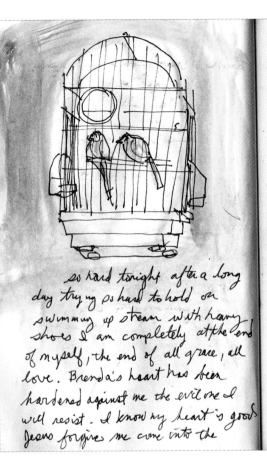

so hard tonight after a long day trying so hard to hold on swimming up stream with heavy shoes I am completely at the end of myself, the end of all grace, all love. Brenda's heart has been hardened against me the evil one I will resist. I know my heart's good Jesus forgive me come into the

christmas 2003

welcome to the soul of the Virgin

place in my heart that feels so completely alone, abandoned. God where are you, why do you hide yourself when I need you so much. Heaven help us all.

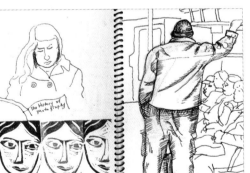

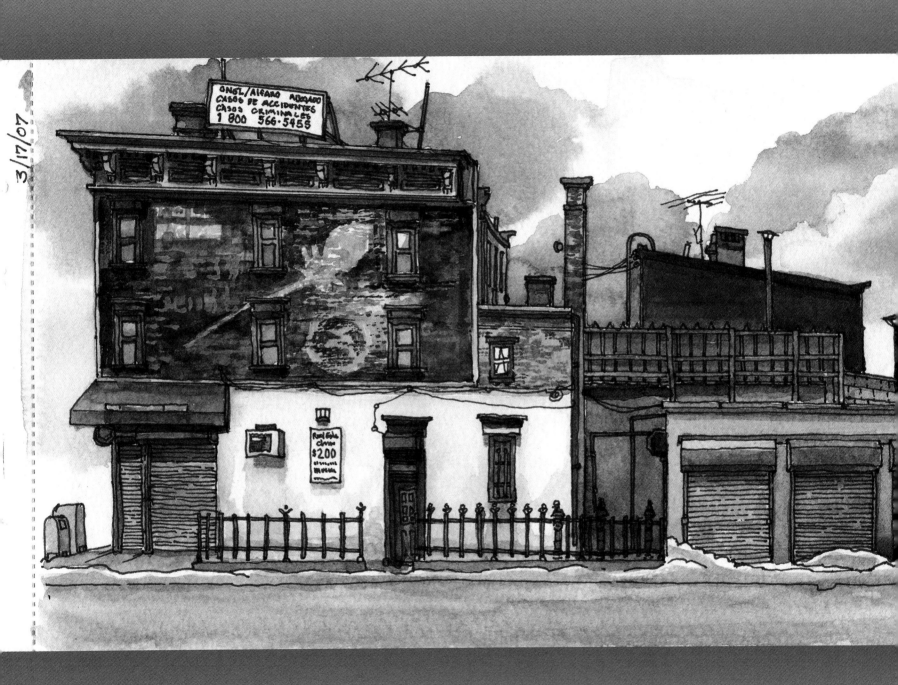

3/17/07

BUTCH BELAIR

Butch grew up near Boston and now lives in New York City. He went to a two-year photography school and is now a freelance photographer and 3-D illustrator. You can see his work at www.butchbelair.com.

I usually draw alone in my car. Very few people know I am doing it. I think I may be hiding, somewhat, in the car. Having people watch while I do it would be a bit of a buzz kill. Don't tread on my Zen, man.

Sometimes I will drive to a place that has caught my attention in the past. But usually, I just get in my car and try to get lost. When I see something that has a story to tell, I stop. I try to record what it is that I see and somehow fuse the feeling of being there in my memory.

I tend to view these places as stage sets, just after the play has been performed. In science, there are certain phenomena that cannot be seen or directly recorded (black holes for example). Scientists only know they exist by observing their effect on the objects that can be seen. For me, people are one of these phenomena: actors that have left the stage. I may be attracted to the evidence in the details of buildings or an arrangement of structures that would suggest the people or generations of people that have passed through and made their mark.

Finding a place to park is also very important in selecting a site.

And the light. Light is also very important to me. Representing the quality of the light in a scene is something I struggle with. It is probably a big part of what attracts me to a place, so learning how to achieve this would be very satisfying. Learning to do it quickly would be a huge conquest for me. Even when I feel I am onto something, more often than not it takes me so long to do one of these sketches that the light has changed drastically by the time I've finished.

I have kept sketchbooks in the past, but my reasons for doing so were different. There was a time, early on, when I felt drawing might be directly related to how I made a living. And there was more doubt and stress involved in the process. It felt as if it were a requirement as opposed to a desire.

In 2005, my mother passed away, and after some conversations with a friend who also keeps sketchbooks, I began drawing again. I thought I would give it a try as a way to relax—a bit of self-therapy. It helped me through that period, and I continue to find it helpful.

Lately, I find myself drawing, just to be drawing, in and of itself. I have no expectations of it other than as a way to unwind and possibly to learn.

There is little regimentation in my life. I sometimes view drawing as a present I can give myself if I can spare a moment, like a mini vacation. Other times, there is little else that I am able to do. I feel compelled. I wake up, I go out and draw all day. I sleep. I do it again. For days.

I do not write in my books. I have tried, but I usually find my own commentary insipid and contrary to my reason for drawing. For me, one of the great joys of drawing is that most of the critical self-commentary that usually bounces around my head disappears when doing it. I strive to be, simply, seeing and drawing. To subsequently recall and record the thoughts that do slip through, would, to quote Raging Bull, "defeat its own purpose." I do greatly admire those that can write well, but it is simply not my thing.

Drawing in a book is part of the process. I feel a sense of permanence, substance and chronology that a loose collection of drawings might not give. This is both inspiring and terrifying.

I have grown fond of the Moleskine watercolor books. The quality of the paper is important to me, but I am still discovering how to judge paper in the store. I have discarded a few books after a page or two because of the paper. I prefer the covers to be black, or at least unobtrusive, and I generally keep them undecorated. I am comfortable with the "S" size Faber-Castell Pitt Artist Pens. I have a small selection of Schmincke Watercolors, and a Da Vinci sable travel brush.

I also use a very thin woman's makeup compact. I removed the makeup bit and the mirror and then glued in a number of Peerless Watercolor papers (sheets of paper infused with pigment). This, in combination with a Kuretake Brush Pen (a cheap synthetic brush with a water reservoir in the handle) and a small Moleskine watercolor book, make a set you can carry in a breast pocket.

I view the relationship between drawing and my professional photography as peripheral, but ultimately crucial. Many samurai would spend a great deal of time composing verse or creating sumi-e paintings. Sword fighting and painting may not seem connected, but they must have found the exercise essential to their craft. And the consequences, if performed poorly in their profession, were considerably more dire than most. For me, drawing as a non-samurai, it keeps my eyes sharp, my mind broad and my attention focused.

1571 RL 25

3.12.07

FRANCE BELLEVILLE

France grew up in France but now lives right outside of Newark, New Jersey. She is a high school French teacher and hasn't taken an art class since she was in seventh grade. You can view her work at her blog, www.wagonized.typepad.com.

My sketchbooks are the desk I can carry in my purse.

I have several with different functions. The drawings you see here are from a Moleskine I started to keep in touch with someone I couldn't see for several weeks. It was a way to journal what I was experiencing daily. It was my very first Moleskine.

I reserve my Moleskines for drawings I do in under an hour, usually during a break at work. I draw a lot of faces and cars, and I don't always write in them.

I also share a thin Moleskine journal with someone in Canada. We've been filling it with drawings and sending it back and forth between New Jersey and Québec.

I also have what I call my "crappy" sketchbook. I keep it purely for doodles. Whenever I sit somewhere, on the train, in a waiting room or a restaurant, I doodle what's there, just to see if I can render it on paper.

My "crappy" sketchbook was a gift from a friend—he didn't even choose it himself—and I am not fond of the overall format of the book: It is too thick, the crease is mean, the pages are see-through and über-white. But it's this very lack of preference that makes me use it for what it is: a practice ground, where doodles overlap, text interferes and sometimes color comes into play.

I find the Moleskines a bit solemn—only a couple of screw-ups (truly failed drawings—the kind I write "I thought I could" or "shit happens" next to) have lightened the mood a bit. The other drawings (in retrospect) seem to have suffered a "gotta do it right" pressure syndrome, because of the thickness of the page and the overall price of each Moleskine book,

That's why my "crappy" sketchbook is so essential. Garrison Keillor would probably refer to these two types as front porch (the Moleskine) and back porch (the less formal and aimed at nothing but sheer observation) draw-

ings. And despite their flaws (the former for its formality and the latter for its transparent pages and overall sloppy appearance), I like them both when I flip back through their pages, because I guess they reflect who I am.

Be it a portrait or the drawing of a single object, the format of my drawings is always defined by the book, and it sets a tone. I love opening it and seeing the promise of the blank spread, especially in the Moleskines. I love ignoring the crease and taking full advantage of the square-ish space. One rule I have is to try to flip the Moleskine 90° with each spread, so the crease goes up and down or side to side.

I always draw with a Pilot pen (I always carry a couple in my purse or school bag), a rolling ball Precise V7 or V5. I sometimes add color with colored pencils (Prismacolor, the very soft kind) or watercolor.

I have always drawn. Strangely enough, I don't consider it a way to "express myself." It is something I do

and have done for years. I still draw "serious" portraits, maybe once every couple of months in a good year. Compared to playing the guitar, petting my cat and teaching a foreign language, it is definitely the activity I enjoy the most in my life.

But, up until the summer of 2006, I didn't draw in any sort of consistent, committed way. I would doodle anywhere, from my head—little cartoony characters, body parts, etc. Then one day, on a stroll down Twenty-Third Street, my friend Raheli Millman mentioned *Everyday Matters* and explained the concept of recording your life in drawings in a book, and I became inspired to carry a little sketchbook in my purse.

France Belleville

"YOU SAID "DONE IS GOOD" BUT DONE WELL IS SO MUCH FUCKING BETTER".

(STEPHEN MALKMUS)

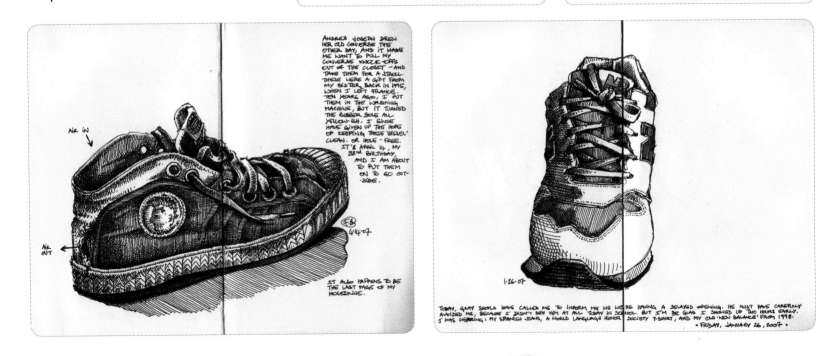

ANDREA JOSEPH DREW HER OLD CONVERSE THE OTHER DAY, AND IT MADE ME WANT TO PULL MY CONVERSE KNOCK-OFFS OUT OF THE CLOSET — AND TAKE THEM FOR A STROLL. THESE WERE A GIFT FROM MY SISTER BACK IN 1995, WHEN I LEFT FRANCE. TEN YEARS AGO, I PUT THEM IN THE WASHING MACHINE, BUT IT TURNED THE RUBBER SOLE ALL YELLOW-ISH. I SINCE HAVE GIVEN UP THE HOPE OF KEEPING THESE 'DIESEL' CLEAN. OR HOLE - FREE. IT'S APRIL 14, MY 38th BIRTHDAY, AND I AM ABOUT TO PUT THEM ON TO GO OUT-SIDE.

AIR IN

AIR OUT

IT ALSO HAPPENS TO BE THE LAST PAGE OF MY MOLESKINE.

TODAY, GRAY SHOULD HAVE CALLED ME TO INFORM ME WE WERE HAVING A DELAYED OPENING. HE MUST HAVE CAREFULLY AVOIDED ME, BECAUSE I DIDN'T SEE HIM AT ALL TODAY IN SCHOOL. BUT I'M SO GLAD I SHOWED UP TWO HOURS EARLY. I WAS WEARING: MY SPANISH JEANS, A WORLD LANGUAGE HONOR SOCIETY T-SHIRT, AND MY OLD 'NEW BALANCE' FROM 1998.

• FRIDAY, JANUARY 26, 2007 •

TRUST B
SEDAL
9/13/

BILL BROWN

Bill Brown grew up in Texas. He went to film school and then became a nomadic zine publisher and filmmaker. He considers Texas to still be his home because his P.O. Box is there, but says, "I'm between towns right now." His life is recorded in his zine *Dream Whip*, a taste of which is available at www.heybillbrown.com.

My sketchbook is the opposite of my job. It's like a pocket-sized vacation.

I make films—personal documentaries—and when people ask what I do, I usually say I'm a filmmaker. I never say I'm a sketchbook artist. I'd feel funny about that, like admitting I'm a masturbator; it's not something I'm ashamed of, I guess, but I'd prefer not to talk about it. I'm publicly a filmmaker, and I make films I think of as public art, but privately I keep a sketchbook. It's rare that I let someone look through my sketchbooks, and when I do, I usually blush. Being in this book feels like coming out of the closet.

No one knows I keep these books; it's a dirty secret. When I draw, I wander off alone. When people are around, I always put the book away. Anyway, drawing in my book with my friends around seems annoying, like talking on a cell phone or surfing the Internet.

Maybe I think sketchbooking is antisocial; that's both its appeal and its curse.

My sketchbooks are filled with the raw materials of the zine I make. So I don't think of my sketchbook pages as finished products. They're unrefined. Uncut. And uncensored. They're the first draft of things: movies I'll never make, novels I'll never write, cartoons I'm too lazy to draw, the first draft of some never-to-be-written history of the stuff I have experienced. Their immediacy is what I like best about them. My sketchbooks are filled with words and pictures I haven't started second-guessing yet. Things I wanted to say before I thought better of it.

My sketchbooks aren't constant companions. More like faithful friends. I work on them when I am alone—on long bus trips, late-night subway platforms—trips, most of all. I am most dedicated to them when I'm all alone. And far from home. Sometimes my sketchbooks feel like an obligation. Sometimes there's a moment I feel obliged to draw a picture of or write about. Obliged, because otherwise the moment is lost. When something gives me goose bumps, I grab my sketchbook. It's not a good method. Sometimes, I'll go weeks without getting goose bumps, and my sketchbook gathers dust.

Before I go on a walk, I'll sometimes decide to make it a sketchbook walk. It changes the nature of the walk. It means I have permission to spend an hour drawing an old neon sign or storefront or something, and it doesn't matter if I don't cover much ground. Having the sketchbook along means I am allowed to get lost in the details of the world. When I go somewhere without the book, I cover more territory but see a lot less.

A book gives my drawings and writings a kind of dignity I don't think they'd have otherwise. I mean, a

**SELF GUIDED
TOUR SCRIPT
OF SOUTH DAKOTA
STATE CAPITOL BUILDING**

My sketchbooks are filled with words and pictures I haven't started second-guessing yet.

sketchbook also has more credibility than some little scraps of paper. A book also imposes a chronological discipline I like. It's a bittersweet pleasure to leaf through a sketchbook and see the days and months pass by. Sketchbooks are secretly calendars, and leafing through them is as much an act of recollection as anything else.

Once I finish a sketchbook, I stick it in a dresser drawer in my boyhood bedroom back in Texas. That drawer is full of books. It's my private Library of Congress. The ink in the oldest sketchbook is already fading. Guess I used cheap pens back then (1992). This makes me anxious and sad. In fact, looking at my old sketchbooks,

faded or not, makes me a little anxious: about time passing, about the ways I've spent my days. When I was scanning my books for this project, I looked at a pile of them—twenty, maybe—and I thought, "Jeesh, there's my 1990s. There's how I spent a decade."

I usually fill the first pages of a new sketchbook with phone numbers of friends. It's a good way to break in a new book, plus it's an incentive to keep the thing with me even when I'm feeling like I'd rather not. More than

once, checking the sketchbook for a phone number has resulted in a drawing or a couple pages of writing. And, if it doesn't result in anything, at least I can telephone a pal.

I don't think about the design. I just artlessly add stuff to the pages. My sketchbooks are junk drawers filled with odds and ends: AA batteries, twisty ties and bad poetry.

I do have some rules: (1) Blank areas on a page aren't allowed unless I'm drawing a picture and it looks pretty sitting there by itself. (2) It's never okay to write or draw

THEN EACH GUY WOULD GO BACK TO HIS ROOM AND THINK ABOUT

THEN IT WAS OFF TO BED IN THE COMFORT OF A LORLODGE MOTEL ROOM.

?? write out folds!

THERE MAY BE A LORLODGE IN LORDSBURG, BUT I'M NOT SURE. OR MAYBE THERE'S ONE IN LOS ALAMOS. THERE'S DEFINITELY ONE IN ALBUQUERQUE. IT HAS A VERY SMALL POOL THAT SITS IN A CORNER NEXT TO A ~~BIG~~ BRICK WALL. THE POOL IS SURROUNDED BY ACRES OF ASPHALT, AND THE FREEWAY ARCHES OVERHEAD

I'VE
ALWAYS ~~THOUGHT~~ WANTED IT'D BE STRANGE TO FLOAT IN THAT POOL LATE ON SOME JULY NIGHT. I'D FLOAT ON MY BACK, AND COUNT BIG RIGS HEADING TO MEXICO.

on the back of a page that has a drawing on it (the ink might bleed through). It's always all right to draw on the back of a page that's just got writing on it because it doesn't matter. (3) Writing should be done with a cheap ballpoint pen; save the fancy Staedtler .005 black pen for drawings. (4) If absolutely necessary, it's okay to leave some blank pages at the end of a sketchbook, but it's not okay to go back and use them once I've started a new sketchbook. Once a new sketchbook is started, all old sketchbooks are declared archival.

I always—well, almost always—get the same sketchbook. I forget the brand and, actually, I think a couple of companies make it, but it's 5 ½″ × 8 ½″, with a green

My sketchbooks are junk drawers filled with odds and ends: AA batteries, twisty ties and bad poetry.

card stock cover and a spiral binding along the left side. One brand perforates the pages along the spiral. I hate that one. I mean, who rips pages out of a sketchbook? It seems wrong. If I'm in a jam, I'll pick up any old sketchbook, and lately, I've been experimenting with little palm-sized pads with a spiral on the top. I like them. They're portable. The only downside is they can be confusing to leaf through because you'll lose track of where

the front cover is, and you get confused about which pages follow which page. As for ink, my favorite pen is a Staedtler black with a super thin tip. Drawing with anything else is practically not worth it. If I'm writing, any pen will do. My sketchbooks are mostly black and white because I make a zine that is black and white. I'd probably add color if it were easier to reproduce. I am always jealous of people who keep colorful sketchbooks.

I started keeping sketchbooks for real after I met my pal Carl in college. He made incredible sketchbooks, vivid pages colored with Cray-Pas and watercolor washes. Carl's sketchbooks were inspirational, but also demoralizing. My efforts always looked mediocre by comparison. Still, I kept at it. Probably because it's a pleasure to make them. An act of meditation. Keeping a sketchbook sometimes feels like a religious observance; it's private the way praying is private. I used to pray. Now I draw.

Bill Brown

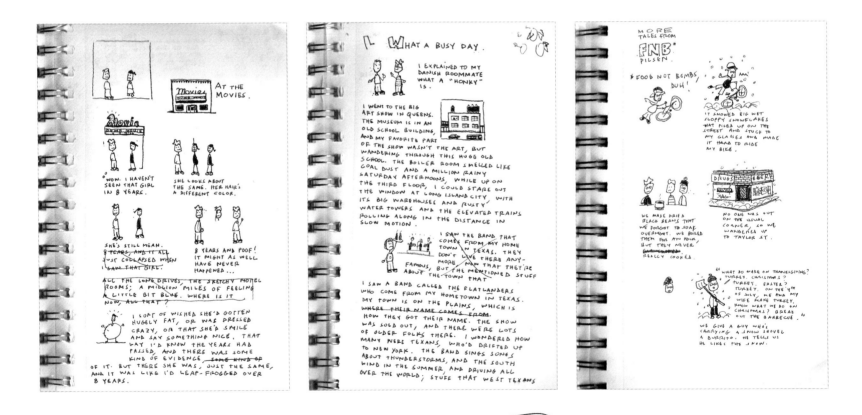

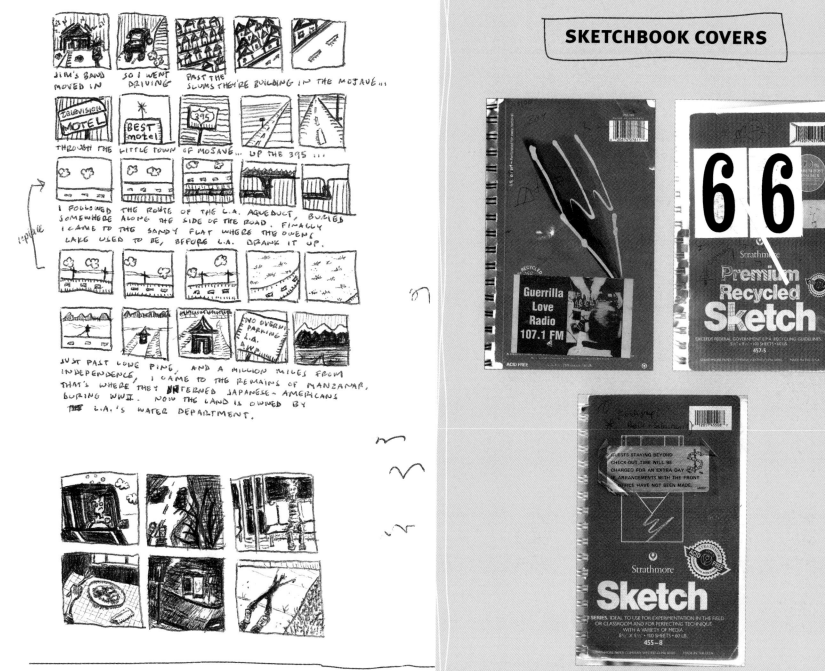

JIM'S BAND MOVED IN

SO I WENT DRIVING

PAST THE SLUMS THEY'RE BUILDING IN THE MOJAVE...

THROUGH THE LITTLE TOWN OF MOJAVE... UP THE 395...

I FOLLOWED THE ROUTE OF THE L.A. AQUEDUCT, BURIED SOMEWHERE ALONG THE SIDE OF THE ROAD. FINALLY I CAME TO THE SANDY FLAT WHERE THE OWENS LAKE USED TO BE, BEFORE L.A. DRANK IT UP.

NO OVERNT PARKING L.A. AWP

JUST PAST LONE PINE, AND A MILLION MILES FROM INDEPENDENCE, I CAME TO THE REMAINS OF MANZANAR, THAT'S WHERE THEY INTERNED JAPANESE-AMERICANS DURING WWII. NOW THE LAND IS OWNED BY THE L.A.'S WATER DEPARTMENT.

Guerrilla Love Radio 107.1 FM

66 Strathmore Premium Recycled Sketch

Strathmore Sketch

BILL BROWN

Avanporto Borbonico, Falconiera

villaggio preistorico

strada di vasoigano

molo →

cala del Camposanto

25.4

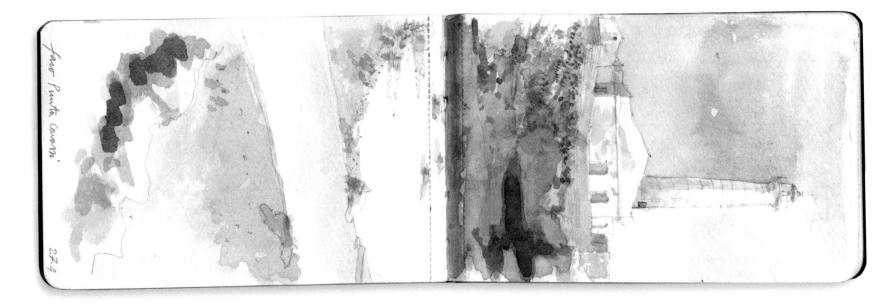

Faro Punta Caverni

27.4

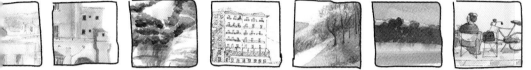

SIMONETTA CAPECCHI

Simonetta was born in Milan, Italy, and grew up in Bologna. She studied architecture in Venice and is now assistant professor at the Faculty of Architecture in Naples. She was curator of an exhibition on travel sketchbooks for the cultural fair Galassia Gutenberg in Naples (www.galassia.org). Her travel sketchbooks can be seen at www.inviaggiocoltaccuino.blogspot.com.

"Why do you do it? Do you sell it afterward?" people ask when I open my sketchbook. I do it for fun; it makes me happy. I do it because I need it. I do it to keep a memory of things that have happened and of places where I have been. I transform my daily life into drawings. They probably are my "true art form," even if I do not think of myself as an artist and I like to consider my books as simple diaries—a way of expression, a language and a tool to observe reality and to understand it better. And to tell it to others, in the future: I like to think that my sons will have my books as a heritage.

I always draw real places or events, and I usually describe something while it is happening. I rarely draw by memory. When I go out, I always take a sketchbook with me, even if I am going to the park with my children, where I know it will be very difficult to have a spare moment. Many times, I come back with white pages, but carrying the books with me is now a habit.

A book means a sequence of pages. A sequence means a story, and I like to tell stories, even if sometimes it's with no words. To have pages in a fixed order is somehow a challenge for me, and I try to resist the temptation to rip pages out. I keep the story as it comes out, as a report where there is no single masterpiece but the whole group of drawings matters.

At the university, I teach about architects' sketchbooks. It has been a great pleasure to organize the two exhibits on travel sketchbooks. I wish, like many of us "sketchbookers," I guess, that somebody would pay me for traveling around and just drawing and drawing.

A few years ago, after visiting the French Biennale du Carnet in Clermont-Ferrand, I started using different books for different subjects, and making private books (i.e. about my children) separate from more public ones. I no longer spontaneously mix different subjects in the same book and force myself to add more writing in a less personal way. Right now, I have two books about Napoli (one is for watercolors, and in the other I use only sepia ink), and another one for a small village on the Apennines, where we often go. Then, I start a new one for each journey. I filled one in Crete this year, one in Ustica (Sicily) last year (exposed in Moleskine Detour London), and one in Calabria this summer. Over the last ten years, since my sons were born (they are nine and four years old), we don't travel far away, no exotic places.

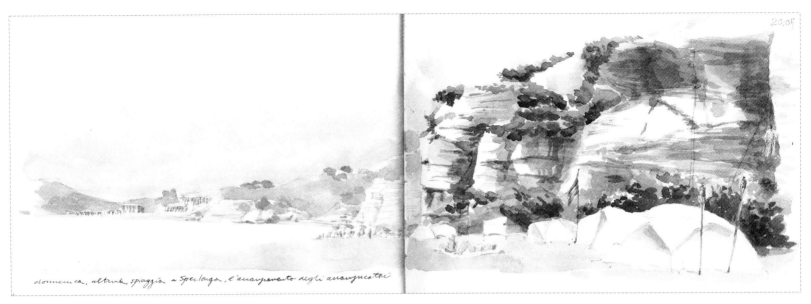

domenica, ultima spiaggia a Sperlonga, l'accampamento degli accampicatori

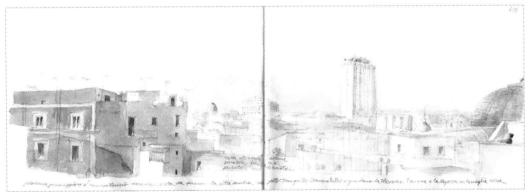

I wish I could draw more. It keeps me alive and focused and makes the experience of the place where I am more intense.

Recently I made three Japanese Moleskines as a project, using the long foldable strip for drawing a unique landscape: Venice (seen from the water), Naples (360° panorama from the terrace), and Bologna, with people sitting on a sidewalk in the main square.

I try to design each page. I consider the open double page as a unique composition. As an architect, I can't help trying to balance different objects in the page. And I can't doodle in books. I have a desperate need of order that sometimes is a real handicap, as I am afraid of ugly pages!

In a way, I have always drawn, though for many years I made mostly technical drawings. I like to draw architecture, and in my architectural design, I have always drawn lots of people and landscapes, too.

I wish I could draw more. It keeps me alive and focused and makes the experience of the place where I am more intense. I think drawing is my best form of expression, though I have much to learn, too. I like talking a lot, and telling stories, but I am very slow in writing (especially in English, sigh!!).

At the beginning, I was shy, and I felt uncomfortable. I considered my sketchbooks to be private and only close friends and my family could see them. Now I am more self-confident, and it often happens that I show them to strangers. Recently, I displayed them in public exhibitions (in Napoli, and in the Moleskine Detour

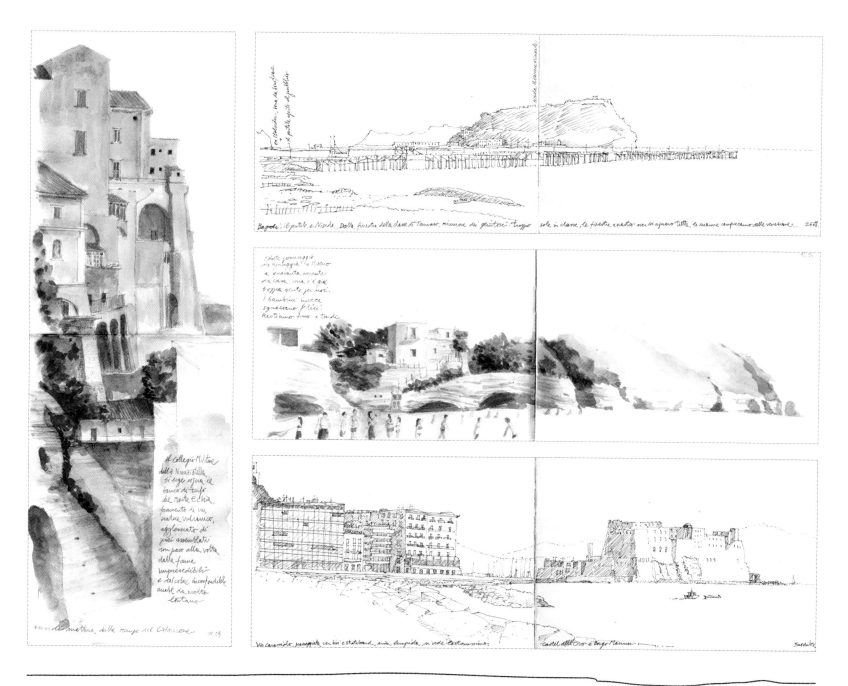

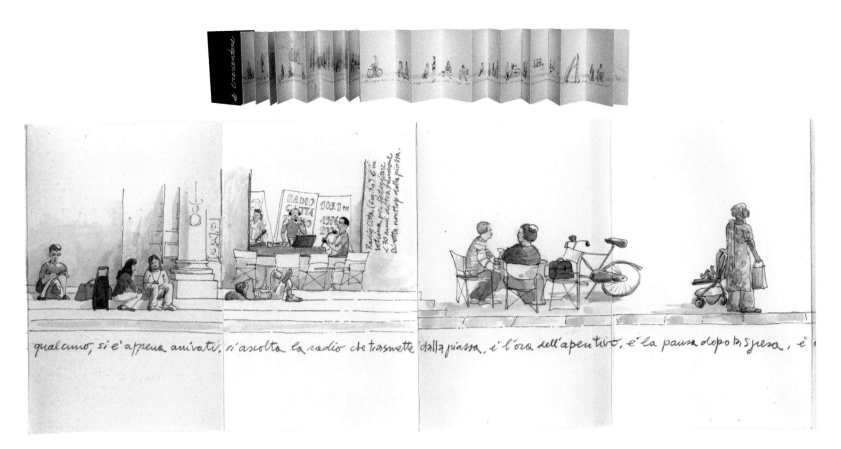

qualcuno, si e' appena arrivati, s'ascolta la radio che trasmette dalla piassa, e' l'ora dell'aperitivo, e' la pausa dopo la spesa, e'

project in London and New York), and in 2006, I was invited to France, at the Clermont-Ferrand Biennale du Carnet de Voyage, where for three days, I had to show my books to hundreds of strangers. Well, that definitely helped not being shy about it! This was also the beginning of a different way of using the sketchbook. I am less spontaneous, unavoidably, when I think other people might watch. And I started keeping different types of sketchbooks.

I started my blog in April, 2006. It was intended as a temporary introduction to my first exhibition of various authors of sketchbooks in Naples. Then, I decided to continue and to publish my sketchbooks, too. From the beginning, my blog has been a mix of public and private things, and sometimes the balance is not easy.

On the Internet, one can be visible all over the world (while at the same time protect or hide one's real identity), and this has changed my relation with my sketchbooks. The YouTube video of my Usticas book has been watched by more than six thousand people, and this is a frightening number to me. All this exposure is certainly very stimulating, even if sometimes I risk feeling overwhelmed by it.

I discover and learn a lot about sketchbooks from the Internet, and I have met very interesting authors; in a few cases they even became real friends. Blogging helps me write clearly and concisely and to look critically at my drawings. The support I receive from visitors—and also from "lurkers"—is an incentive for frequent posting.

I use five or six types of books. During my university studies, I filled many black hardcover A5 and A6 vertical books with light paper, using black ink. When I started using watercolors, I had the spiral kind of album, horizontal, max A4 size, but I was always making a unique drawing across the two open pages.

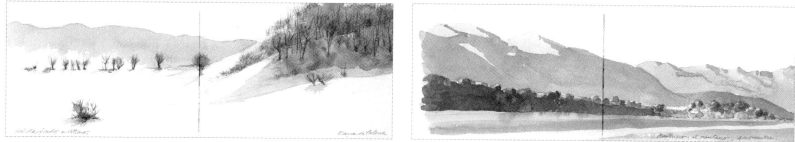

Sometimes I have cut the album in two, to have an even more horizontal space (like 12 cm × 35 cm). Recently I bought some landscape hardcover type A5 and A6 with normal light paper that I found in London. I am also using the new kind of Moleskine for watercolor, both pocket and large size, and I filled three or four Moleskines of the Japanese kind, which are very bad for watercolors, but very interesting for the size.

I use Winsor & Newton watercolors, mainly because I am too lazy to try different brands. I mostly use Kolinsky brushes: a big one (no. 16-25) and a very small one (no. 3 of Series 7, Winsor & Newton), and recently I started using a waterbrush. I'm not such an expert, and I do not have a technical approach. I use a pencil, also, and—horror!—even an eraser. One day, maybe I will be capable of watercoloring without it!

And I also like to draw in black and white, with a pen, a normal rollerball. When I draw directly in ink, I am very quick and never feel the need to correct the drawing, except when drawing people, which still requires a certain effort.

I often encourage my children, their friends and students of architecture to keep a sketchbook. It is not necessarily an artistic matter, and I suggest, like the French architect Eugène Viollet-le-Duc said, to consider drawing as a language, like writing, and as a tool to investigate and represent things, both reality and personal invention. I suggest trying different books, techniques and materials in order to find the right one, and to think about pages as a sequence and the content as a reportage, trying to use texts as well as images, drawing daily and not being afraid, like I am, of bad drawings.

Simo Capecchi

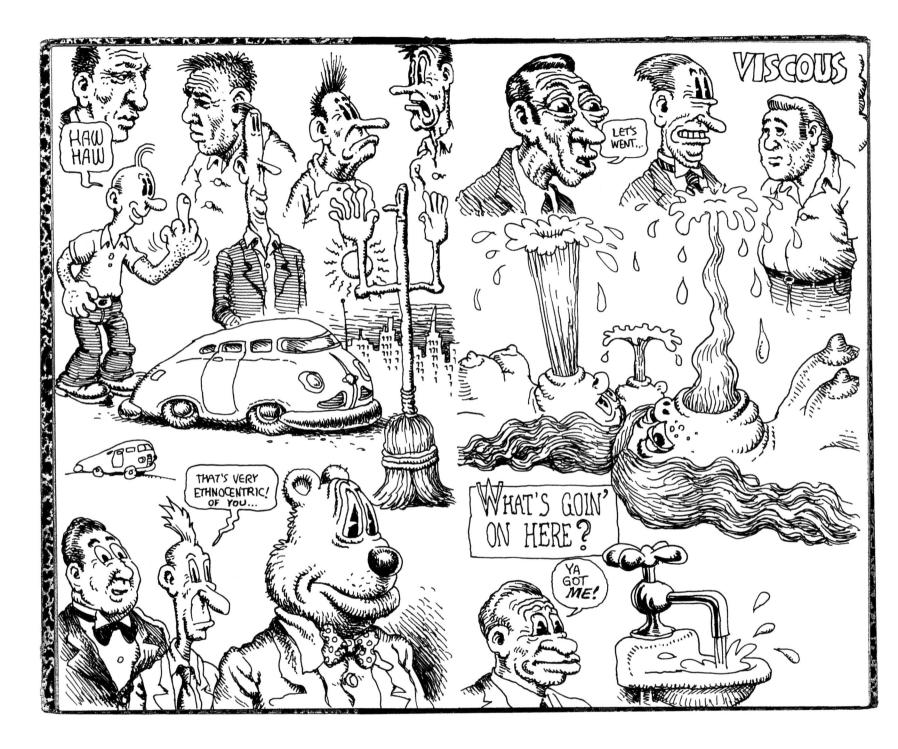

ROBERT CRUMB

Robert grew up on or near military bases around the United States. He drew compulsively through his youth, but did not attend art school. He now lives in the South of France in a house he acquired in exchange for several sketchbooks. The pioneer of underground cartooning (*Zap, Weirdo, Fritz the Cat, Mr. Natural*, etc.), he has also published many volumes of his sketchbooks. His current project is an epic comic-book version of the Book of Genesis. His work can be found in bookstores worldwide, in *The New Yorker* and at www.rcrumb.com.

When I see a nice book with blank pages, I feel a strong compulsion to fill it with drawings and text. I want to transform those blank pages into a book filled with rich visual or literary information. I wish there were twenty of me with nothing but time to fill hundreds of blank books!

I've always drawn in books. In the beginning, through my older brother Charles's powerful influence, I drew comic books … only comic books. I had to complete those comic books. Later, I had to fill up those sketchbooks. I don't let a sketchbook go until it's filled up. I like having those completed sketchbooks lined up on a shelf. I always like going back to look at them, reading them like a diary. They inspire me. But I'm also very critical. I've gone back and corrected bad drawings in old sketchbooks, especially now that so much of the old material has been printed, subject to public scrutiny. I am very

book oriented, I guess. I only draw on separate sheets of papers if I'm working on something directly for print, or if the drawing is to be immediately given away or sold.

I've always drawn. My older brother tyrannically trained me to be a cartoonist. How do I feel about it? I dunno … I just have to do it … I don't know anything else. It's not always a pleasure. Sometimes it's even painful. But the results are usually satisfying. Again, I guess I'm lucky that way. I know I can do it well, that it's something worth doing. I have a big, narcissistic artistic ego … typical, classic … I like to play music and write, too, but I'm a mediocre musician, nothing special, and writing is, for me, a utilitarian endeavor, not an artistic one. My "gift" or "talent" is in drawing and making comics. Sometimes, I take breaks from the arduous, intense concentration of drawing and

play simple tunes on my mandolin. Music for me is a "hobby," and drawing is my life's work.

I've gone through many in-and-out periods of drawing—especially in more recent times. I just don't have as strong a compulsion to draw all the time as I used to. Sometimes, you just have to give it a rest, or life itself just overwhelms you and forces you to lay it aside for a time. I was so unbalanced when I was young, drawing was such a crutch, a shield, that I was very bad at coping with reality. Finally, I was forced to stop drawing and deal with the mess, or it was going to kill me! I always went back to it because, well, what else could I do?? I had no other skills or abilities to get me through life, could barely dress myself. Drawing and writing is what I do. I'm lucky, in a way, that I know what I have to do. A lot of people don't have this certainty about their work, their "calling."

My sketchbook used to be a constant companion. Not as much anymore. I'm too famous now, too self-conscious. And, too, I used to hide behind it when I was young. I was "the timid soul" who was always drawing, even in the middle of social situations. I don't have that compulsion so much anymore, to hide behind a sketchbook—but, you know, I filled my share of sketchbooks in my life … thousands of pages of drawing.

I can withdraw into my book, but because of my renown, nowadays it's often not possible. "Oh look. R. Crumb is about to draw in his book!" It starts to feel like a performance, which makes me feel very self-conscious. You know, you want to be the observer, not the observed! When I was young and unknown, I felt invisible. I could roam freely and draw anywhere and was rarely noticed. I had no idea how free I was, how unencumbered. I still like to go places and be alone and anonymous. I enjoy that very much. When I was twenty, my aloneness was painful to me. Now it's a pleasure.

I've become acutely self-conscious whenever I draw. There is rarely a moment when I'm drawing that is casual and playful anymore because of all the renown and praise I've gotten. Ironic, but there it is. I still enjoy drawing as much as ever, but I have to fight off this paralyzing self-consciousness that I'm "R. Crumb" and every drawing has to be a masterpiece. Sometimes I succeed and sometimes I don't.

I seem to draw in the book more when I'm traveling. Probably because I'm less caught up in the work for print that I'm always doing at home and have more time to be alone and unobserved. I never go somewhere in order just to draw it. If I'm into drawing, I'll draw anything, as you discussed in your first book. "How does drawing a place help impact your experience of it?" you ask. Since I lived so much of my life on paper, I guess "drawing a place" was more or less, my experience of it.

I let people look at my sketchbooks. I don't mind, unless I've put some quirky sex-fantasy drawings in there. It's embarrassing to be in the presence of

When I was young and unknown, I felt invisible. I could roam freely and draw anywhere and was rarely noticed.

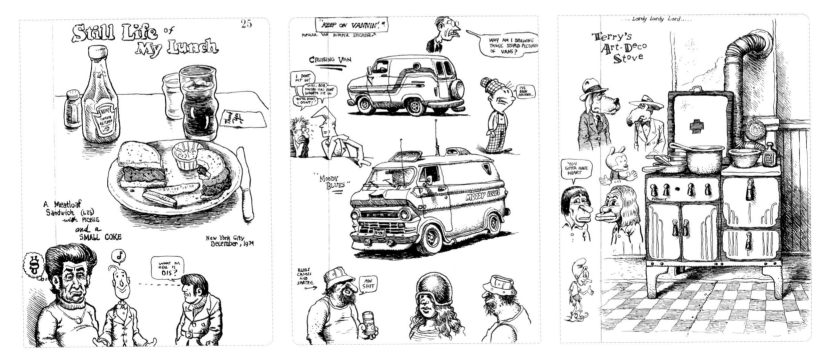

someone while they're looking at and reacting to my sex-fantasy drawings.

The idea to publish my sketchbooks was not mine. People began urging me to publish the sketchbook stuff quite early on. I even resisted the idea at first. I didn't think my sketchbook drawings were presentable enough to publish. After the German publisher Zwei Tausend Eins published the first big compendium of my sketchbook work in the late '70s, creating a very nice facsimile of an old record-keeping book I'd use as a sketchbook, I knew it was all over for me as far as casual, playful drawing went. I became much more conscious of the presentation of each page, the attractiveness of the drawings. I began to use more Wite-Out in the sketchbook. Granted, this change produced nicer, more finished looking drawings, but the crazy, mindless looseness of youth was pretty much over. So it goes in life.

The sketchbook is much more spontaneous than work done for print. When doing comics, record covers, illustration work, etc., there's much more formal planning, layout, careful penciling done before the ink is applied. I often used to do rough versions of comic book stories in my sketchbooks. Sometimes, a spontaneous sketchbook drawing would inspire a whole comic-book story, or even a character. Mr. Natural and many other characters started as casual, off-the-cuff sketchbook drawings.

My rules about my sketchbook are pretty simple: After about 1980, I started trying to remember to date the page after doing a drawing for diary purposes. I also, at some stage, decided to stop using the sketchbook as a place to write out extensive personal text and started keeping separate diaries just for writing in. Although I'll write stuff in the sketchbook, I confine long personal literary ruminations to a separate book. I now have a stack of those alongside the sketchbooks, but

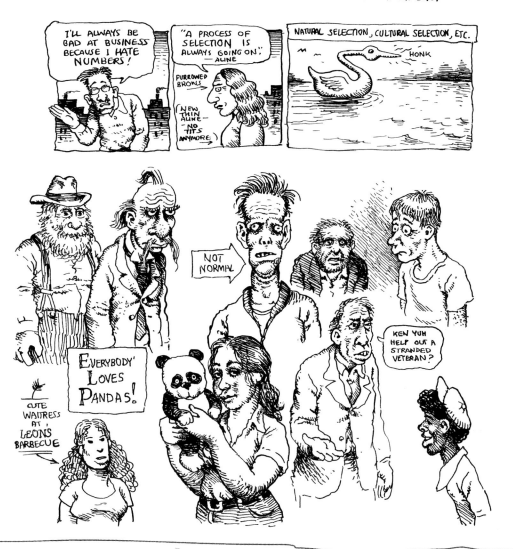

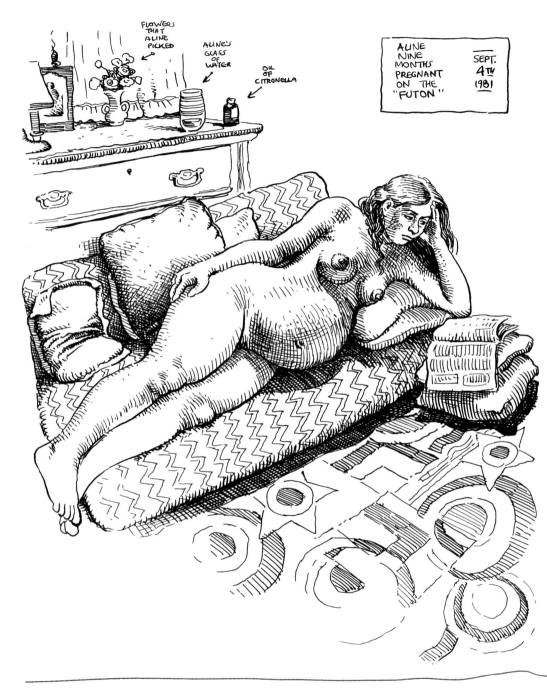

To draw from life is to learn about life.

those diaries I keep completely to myself. A person has to have some privacy! Some place to confine intimate, confidential thoughts and experiences.

In my teens, I gradually went from drawing those "homemade" comic books to keeping sketchbooks that had comic stories in them. Up until about age twenty-one or so, I would always make a cover with a title and number and glue it on the cover of the book when it was filled. I used the title "R. Crumb's Almanac" at first, and then "arcade." I used ordinary composition notebooks until about age twenty. Then, when I was working in the greeting card company, I adopted a

As I get older I get more twisted, convoluted, depraved, cynical, embittered, self-centered, jaded, debauched, ruthless, greedy, conceited, set-in-my-ways, long-winded, absent-minded, prejudiced, closed-minded, misanthropic, nervous...

TREE IN A PARK

DEC. 5TH '84

Demons Staring at Me
FROM AN OLD TOWEL HANGING BY THE BATHTUB AS I TAKE A BATH...

EVERY TIME I TAKE A BATH I LOOK UP AND THESE GUYS ARE GLARING AT ME... THE DRAWING DON'T CONVEY HOW SINISTER AND HORRIFYIN' THEY REALLY ARE.

HEARTBREAK HOTEL

THE MORNING AFTER THE NIGHT BEFORE...

MIGHT THROW UP

more professional attitude and started putting together my own sketchbooks out of good paper I "requisitioned" from the company. After that, I used ready-made, hard-cover books I bought at art supply stores, but still often end up using the school notebooks.

Finding good books to draw in is always a problem. Since I draw with pen and ink—Rapidograph, usually—those standard black covered books sold in art supply stores were not very satisfactory. Although they look good, the paper's too soft. School notebooks were actually better for pen and ink, but it's hard to find ones without blue lines for writing. For a while, there were some nice cheap Chinese notebooks, very well bound, strong, wouldn't fall apart, very good, though thin, paper with very light blue lines, but those were later replaced with an inferior type. I found some

beautiful hardcover blank books in France in the '90s with excellent paper for pen and ink, but the binding was no good at all. They just fell apart completely. A shame. I found some other, smaller, nice French books: good paper, good binding, but very ugly covers with bad modern graphics on them, so I glued blank paper over the covers. I'm always on the lookout for good sketchbooks. Don't like spiral-bound books. I rarely tear out pages. A good sketchbook is hard to find.

I almost always use a .035 Rapidograph to draw with, and various kinds of Wite-Out. The Rapidograph has the advantage of being portable. If I'm at home, I'll sometimes use the crow quill, which is not very portable, as you have to carry along a bottle of ink and a jar of water to clean the pen point after use. It gives a nicer line than the Rapidograph, though. I never use dispos-

able pens, felt-tip or ballpoint pens. I almost never use any kind of color in sketchbooks.

My sketchbooks are precious objects to me. I keep them all on a shelf in a cabinet in my studio. I've sold a lot of the earlier ones. It made me sad to see dealers get their hands on some of those I've sold and cut them up and sell off the pages individually. Fortunately, I have Xerox copies of most of them.

To look at old sketchbooks is, for me, like reading old diaries. It takes me back to those times, the mental state I was in. I can perceive what a fool I was when I was, say, twenty-five. I can see how LSD and marijuana affected my work and my whole outlook. I can see when I was depressed, vexed, lost, confused. I can see the influence of old friends, of their humor and worldview. I can see the prominence of different women in different periods, my first wife, various girlfriends, my second wife, Aline. There may be drawings of women I had brief affairs with, women I was trying to impress by drawing their portrait (it sometimes worked!). I can see how much I had yet to learn. I can even see things I've lost—a certain quickness of mind, a certain cocksureness. I used a lot less Wite-Out in the early days—actually none up until about 1975! But I'm technically much more skillful now, for whatever that's worth.

My advice: Draw from life as much as you can stand to. That's where you really learn things. And learn to express your real, personal feelings. And don't worry about creating masterpieces or only drawing the pretty things. Look for the commonplace, the unnoticed details of everyday reality. To draw from life is to learn about life. But, you know, you need to be compelled by some inner need to fill the blank page. It's gotta come from inside.

R. CRUMB

PETER CUSACK

Peter has lived in and around New York his whole life. He studied at the private studio of Andrew Reiss, at The Art Students League with Harvey Dinnerstein, at L'Ecole Albert Dufois with Ted Seth Jacobs, and earned an MFA in illustration at Syracuse University. He is an illustrator and book designer and teaches painting. His work can be seen at www.drawger.com/cusack and at www.illoz.com/cusack.

At about twelve, I stopped drawing all together. As a teenager, I spent most of my time hanging out and following nothing. My mind was too chaotic to draw or even think in any deep way. I went along like this through high school, college and five years into a job in publishing.

At twenty-five, I began to wake up. At twenty-eight, I found myself in the countryside of France studying the skills I realized I'd longed for all my life. When I began to learn the foundational concept of drawing, I found my truest self, and much of the emptiness in my mind was filled.

At times my sketchbook was my only creative outlet. I have been through long periods of time where my art-work had to be put on the back burner so I could work and support myself. During these times, my sketchbook was where I continued my artist's life.

I refer to my sketchbook as my train book. It's usually with me whenever I walk out the door. It comes with me to see the Yankees, or the to the hospital, or to visit family. But I'm not as active in it in these other environments. The solitude of the subway and my commute allow me to drift into my own thoughts and draw.

My commute becomes an extension of my studio. It usually takes me under an hour, and this time is perfect for coming up with concepts for illustration jobs. I find that the change in my environment, from my home studio to the train, energizes me and stimulates ideas. Often, I get on the train with very little inspiration, and by working out thumbnails in my sketchbook, I leave the train with a brilliant idea.

The fact that I use a bound book allows me to carry a whole cycle of work and ideas. At any time, I refer back to previous pages. I may make corrections or additions to a composition, but most importantly it anchors my artistic voice. It's a source that I spring from in any artistic venture, commercial or personal. Over time, my sketchbook work has influenced my easel paintings and illustration work as well.

I have a knack for being anonymous in a public setting. Even in the close proximity of the train, I feel relaxed and comfortable, which allows the people I draw to feel relaxed. I don't hide it, but I don't announce myself in anyway. I don't ask permission, and I don't freak out when I'm noticed.

My artistic voice tends to be quiet, pensive, emotive and based very much on people and their inner life. That describes, as well, the people I draw on the subway.

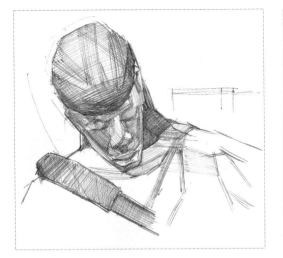

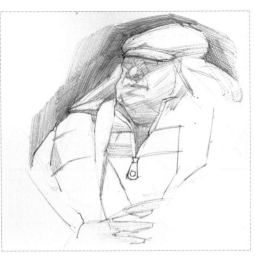

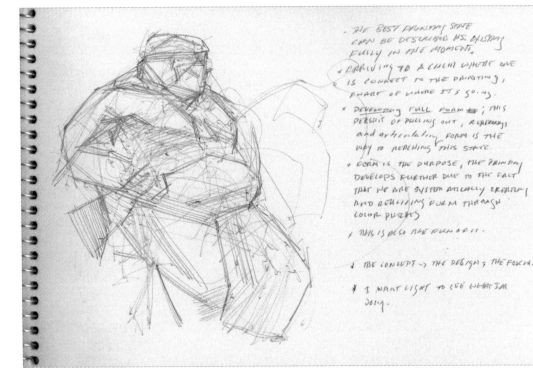

I don't skip pages, and only on excruciating occasions do I rip out pages.

My sketchbook can be very ritualistic. I use the same type of book, same two pens. I don't flip the book around. I don't skip pages, and only on excruciating occasions do I rip out pages.

I only use a black ballpoint pen, the cheaper the better. The cheapest brands seem to have the right flow of ink. It can create an almost silver-point quality. Pens that one finds in hotel rooms or are given out in restaurants to sign credit card receipts seem to always be the right fit. Because I build my drawings in layers, I like the ink to go on softly. The pen should be able to create a light touch. As the drawing develops, I like the pen to be able to handle a firmer application with a darker result.

I have used many different types of sketchbooks, different bindings, different types of paper and covers, different sizes. But now I feel much more particular. It must be bound in such a way that it will lay flat. If the paper has a warm tone, that's perfect. The paper stock must be of good quality and have a soft texture. The book must be small, but big enough to handle a full figure. The cover should be durable because it travels with me and takes a beating. And I don't like to spend too much money on them because if I did, I might have the tendency to freeze up. I pay about four bucks for Strathmore sketchbooks.

I only work with a horizontal format. I do not work on the back of any pages. Nor do I think of the composition as a spread. I do allow myself to rip out pages that are just awful. I don't like to leave any pages blank. I also feel that I must finish a sketchbook right down to the final page. I try not to get too crazy about it, but the

first and last pages of the book are significant to me. I don't like to start the book off with my best work. It puts a hex on the rest of the pages. But I do like the last page to be of my highest quality. The last page feels, to me, like a wrap-up and makes a statement about the work in the book as a whole. And, hopefully, there are a handful of knockout drawings in the meat of the book.

I'm very aware of the composition of each page. It is an extremely important element in the overall success of the sketchbook page. Often, I'll overlap a few drawings on one page. All are related in content and stem from observations made in one single environment. This layering allows me to create a more complex composition where numerous rhythms run through the drawings and excite the viewer's eye.

My sketchbooks are driven by my love of drawing and a natural curiosity for people. Living in an urban environment has been so important to me. It offers an endless onslaught of changing subject matter … always energetic. My sketchbook is a record of my life spent pondering other people.

Peter Cusack

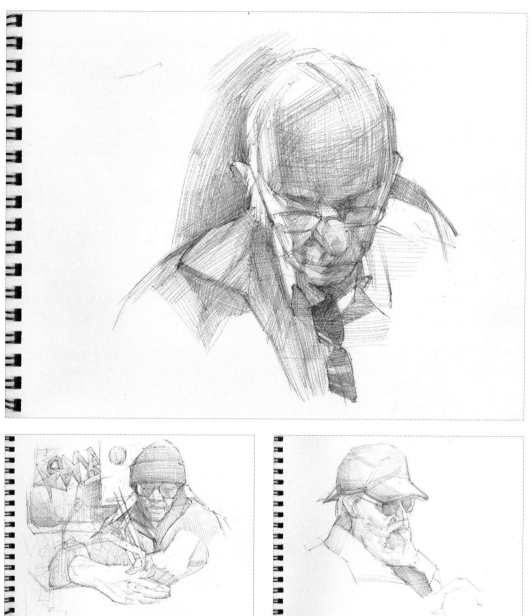

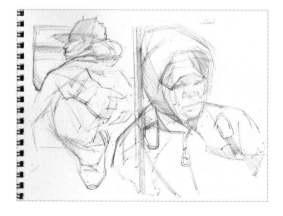

PENELOPE DULLAGHAN

Penelope grew up in northern Indiana, graduated from the University of Indianapolis with a BFA and went immediately into design and art direction for an ad agency. Five years later, she quit that to pursue illustration full time. See her work at www.penelopeillustration.com.

I started keeping a journal when I was eight years old. It started off as a "dear diary," and I even recorded what the weather was like that day and what I ate. It morphed over the years to paint blobs and a gathering of thoughts—less conventional and more free. I think that just comes with learning that you can do whatever you like with your journal.

All my books are different. I like to experiment with different sizes and types of paper. I just bought a new book with grid lines on the pages and am curious to see how that affects my journaling. Will I stay in the lines? Make even more collages? Write bigger? Who knows, but I'm excited to see.

I don't have any rules except I can't tear any pages out. If I absolutely hate a page, I paint over it in white and start over. Or just leave it white. No rules.

I think it helps to see the book as a covered, bound book because it helps it feel more like, I dunno, a solid thing. Something you can reflect back on and think: I did that. Those are my thoughts. Loose papers get lost.

My sketchbooks are more of a visual journey, not necessarily an accurate description of what happened day-to-day. They are more just what I'm thinking at the moment, or a recording of ideas for later use, or color studies. Sometimes I will just slop down paint dabs on a page and call it a day. I try not to make my journals too precious because I want to stay loose in them.

If I am in sort of a creative rut, I will make assignments for myself in different mediums and record the results in my book. For instance, I gave myself an assignment to collect found objects in nature, placing them in a sculptural form. I took pictures of the results and then pasted the pictures in my book. It helps pull me though times when ideas aren't flowing.

When I travel, I use my journal to record where I go, mostly through little collages of kept receipts and post-cards and pics and more paint blobs. It does help me to really see and try to retain what I experience when I travel. Makes me spot the beautiful things more … the empty cigarette pack I found, a torn label, a grocery list.

I mainly work at home and in my studio, but always throw my journal in my bag when I leave the house. I tend to get a lot of ideas when driving, so it's valuable to keep with me (and I've gotten really good at driving with my knees!). Also, you never know when an idea will hit you, so it's good to always keep it nearby.

These days, I am trying to pare down: one personal book for thoughts, mini paintings, quotes and life recording, and a second book for doodles and sketches for my illustration work.

I have always drawn, ever since I can remember. I don't feel I'm very good at it yet. I feel like I'm still drawing like I did when I was nine. But I'm starting to be okay with that.

I have stopped drawing for myself for periods of time. It mainly happens when I'm working too much or get too involved in other things and I don't have time or the inclination to sit down and do work for myself. It happens periodically. I get back into it when I come back to the realization that my personal work actually helps and feeds my professional work.

I keep my journals that I save in a closet, stacked up. I don't really open them for a long time after I'm finished. For regular sketchbooks for my illustration work, I just throw them away (recycle them) because I don't need them. They are just the mechanics of my job and not really my thoughts.

I don't look through my books very often. But I am sometimes embarrassed, sometimes happy that I followed through on a recorded idea, and sometimes inspired by that "former" self.

I love looking at others' sketchbooks. It always inspires me (and sometimes makes me feel like a complete loser because I don't feel my work is as good or good enough). But, mostly, I am just in awe of other people's ability to express themselves in unique and beautiful ways.

GOD DWELLS WITHIN YOU, AS YOU. ...EXACTLY THE WAY YOU ARE. GOD ISN'T INTERESTED IN WATCHING YOU ENACT SOME PERFORMANCE IN ORDER TO COMPLY WITH SOME CRACKPOT NOTION YOU HAVE ABOUT HOW A SPIRITUAL PERSON LOOKS OR BEHAVES.

TO KNOW GOD, YOU NEED ONLY TO RENOUNCE ONE THING — YOUR SENSE OF DIVISION FROM GOD. OTHERWISE, JUST STAY AS YOU WERE MADE, WITHIN YOUR NATURAL CHARACTER.

—ELIZABETH GILBERT "EAT, PRAY, L

CAN I DO this?

MAKE SOMETHING OF IT.

MARK FISHER

Mark grew up in Upstate New York outside Albany in the hamlet of Elsmere. He has an associate's degree in advertising design and production from Mohawk Valley Community College in Utica, New York, and a BA in graphic design from Buffalo State College in Buffalo, New York. He now lives in Lowell, Massachusetts, where he has a freelance illustration and design business. For more of his work, visit www.marksfisher.com.

I have a security job on weekends, from midnight to eight a.m. It's at a large, old mill building in Lowell that has been converted to office space for businesses. I have a few tasks to perform during the night, but other than that, I have a number of hours to sketch in my book. My mind is a bit foggy and tired in spite of coffee and a pre-work nap. So the drawing sometimes gets a bit loose and disjointed. Often, I find myself suddenly awaking after a second of dozing off and having lines or blobs or words I don't quite remember drawing. I have been scanning some of the drawings from the book and introducing color and effects to them in the computer.

I have kept sketchbooks since 1974. They are a constant recording of ideas for assignments and personal art. My book accompanies me most places and gets drawn in every day. If I can't take it with me, I always have a folded paper in my back pocket that I record sketches on, and when I can, I transpose the drawings to the main sketchbook. I don't sketch places or scenery. I mostly draw what's in my head. I used to carry a small sketchbook in my back pocket all the time, 4 × 6 inches. Then I switched to a 9 × 11-inch format about twenty-five years ago. I like acid-free, hardbound books with a semi-smooth finish. I mostly draw using a black Sharpie pen.

I usually do about four to six books a year. I have over eighty books, and they are great to look at and find old drawings from years ago that somehow relate to a project I am working on. Being a book helps keep it assembled in one place and easy to file on a shelf. They are very important to me because they contain so many ideas and images that I pull inspiration from years later. Looking back through them is like visiting old friends.

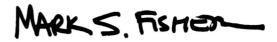

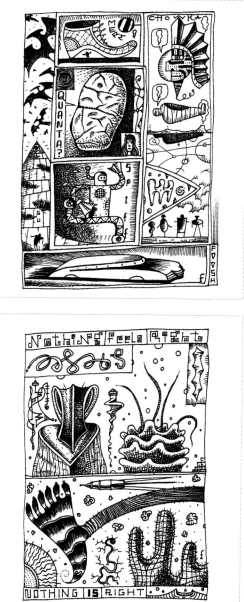

LUNES
12

Simpático Ex-marinero
en un bar de la plaza de
STAVROS. Intenta hablar
con un alemán diciendo
que conoce SANKT PAOLI, en
HAMBURG, y sus chicas.
Ahora se embarca en un ferry
por 2500 €/mes.

No somos los primeros
extranjeros que llegan
a ITACA disfrazados
de mendigos

MANESTRA

Comemos una pasta con forma
de ARROZ bastante apetitosa en
la minicocina de nuestro aparta-
mento en la St. ELIAS VILLA
de STAVROS

una
extraña
pieza
con cara
en primer plano
encontrado en
la cueva de L
en la playa de POLIS

El bonito cem
con vistas a
al EXOGHI
(ESW)'n
mucho rile
llevamos
nuestros p

ENRIQUE FLORES

Enrique grew up in a small village in Extremadura, Spain, then studied fine arts at The Universidad Complutense in Madrid and earned a MA in graphic design from Central St. Martins College of Art and Design in London. He is now a freelance illustrator in Madrid. You can see more of his work at www.40jos.com.

I suffer from a horrible memory and writing and drawing help me a lot. I keep a daily diary to record the landmarks in my life. There I write/draw appointments, visits from friends, random thoughts, notes about books, movies or exhibitions I see. My travel sketchbooks are roughly the same but a bit more "exotic," as I see a lot more, and I am more open minded when I'm in a strange surrounding.

I keep the daily book on my work table. When I go out, I take other books I use for specific projects (people on queues or tall buildings, to name two recent ones). When I'm traveling, I keep my diary with me all the time, even at nighttime. Losing it has been a constant nightmare.

The quality of line in my sketchbooks and in my professional work are quite different. I guess I think more when I'm in my studio and try to be more spontaneous when traveling. When I draw on location, I am often seated down in very uncomfortable places and the lines or writing are not as clean as I can make them at my work table where the lighting and conditions are ideal. Sometimes, I've used my travel sketches to produce commercial work but I always prefer the first sketch and think it's a lot fresher.

I carry several books around with me. Lately, I've been using an A4 (8 ¼" × 11 ¾") book for architecture and landscapes, A5 (5.83" × 8.27") for writing and drawing in difficult places (like standing up), and a smaller A6 (4" × 6") book for drawing people, because I am shy and don't like people knowing I'm drawing them. This is a good solution when weight is not a

problem (carrying three books all day long can be tiring). I stick to my A5 book when I have to move fast. Watercolors dry quickly, so I use them and India ink for all the books. I don't use markers, pastels, pencils or dry techniques as they force you to carry a lot of different colors.

Occasionally, I keep specific books for particular subjects. I have several on buildings or drawings from newspaper photos. Some others are made only with collages. It's a good exercise, just to keep the hand moving, and I consider it a part of my training as an artist.

I draw any place and everywhere, even in rather ugly spots. Train and bus stations are favorites of mine as I never travel by car and spend a lot of time waiting for transport. If I'm in a postcard-like place (like the Parthenon or the Eiffel Tower) I try not to avoid sketching. Lately, I'm trying to escape from an always threatening,

nineteenth-century picturesque quality that I detect in my drawings from time to time.

I feel more comfortable with images than words, even though I also write a lot. Years ago, I didn't even carry a camera when traveling, but I bought one about two years ago when I realized how difficult it was to reproduce the handwritten signs on the streets in watercolor.

My first sketchbook is from 1990 or so, and I did it on my first long trip, to Cuba. I wasn't very concerned about the quality of materials back then, and it was done on ruled school paper with a blue Bic rollerball. Lots of changes and improvements (and more than fifty sketchbooks) since then. I've been using Winsor & Newton sketchbooks for a while. They're easily available in two weights of paper (50 lb and 80 lb), and I use the thinner one even if it's crap for watercolors because they have a lot of pages (160 instead of 96 for the 80 lb books).

Lately, I've been traveling with the new, big Moleskine watercolor sketchbooks. They're great for watercoloring but a waste of paper for collage or writing, so I also use a Midori Traveler's Notebook for writing and sticking things in. I'm afraid I steal some charm and truthfulness at the final book by separating it into two. I mainly use two techniques: ink and watercolor, so it's difficult to always get the perfect paper. Sometimes what is good for ink is too thin for watercolor and vice versa.

I paint with Winsor & Newton cheap (Cotman) watercolors in a plastic box and average brushes (never Kolinsky). I'm very absent-minded, and I can't afford losing expensive stuff every two weeks. Besides, there's no big difference between using excellent or average watercolors on the paper I'm using. I draw with a Rotring 2.0 Calligraphy and Art Pen, Talens India ink, and steel dip pens. I rarely use a pencil, sharpener or eraser.

I like to think about my diary as a magazine, and so I try to "design" it in a not boring way. That is, I never do a spread of writing alone. I try to alternate landscapes and people, etc. I always draw first and write later, so I search for a good place for the words and try to use them as a design element. The words help a lot in the composition, and one must be very careful with the weight. On the other hand, I feel quite comfortable with the idea that everything I do is there to stay. I never rip out pages just because I don't like the result. Bad drawings are also a part of the book. It's the proof that shows you've been looking and seeing, and, as they say, it's not the destination, it's the journey. And, who knows, maybe the "bad" drawing will become "good" when seen with older, more experienced eyes in the future!

ENRIQUE FLORES

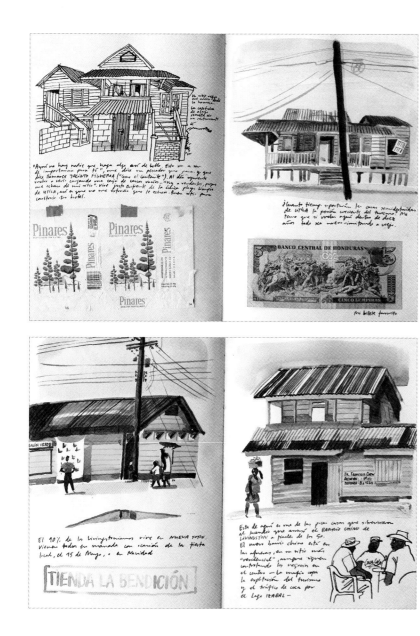

ENRIQUE FLORES

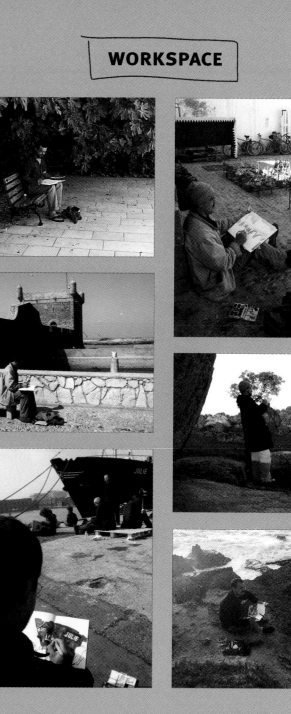

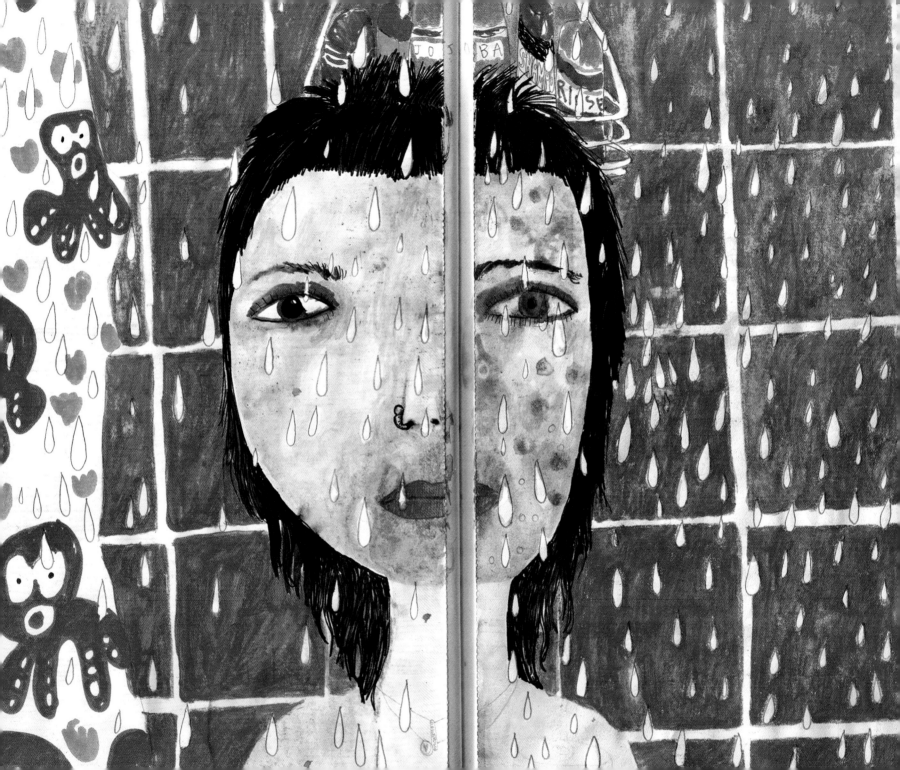

PAOLA GAVIRIA

Paola grew up in Ecuador and Colombia. She studied visual arts in Medellin, Colombia, and took some short courses in Sydney, Australia. She is currently living in Sydney, where, she says, "Mainly I live as an artist, but sometimes I have to be kitchen-hand, babysitter, waitress, model for fellow artists and practically every day job I can lay my hands on." Her work can be seen in many places online, but start at www.flickr.com/photos/powerpaola.

My sketchbooks started as intimate expressions, a form of personal journal that in time became part of my work as an artist. They can simply depict my own life through drawings, tell a story or illustrate specific subjects. They are my journal and, at the same time, they are a deliberate art form that makes my subjective-intimate-private life a public display. They are real journals that make my private life a public subject: I am a bit of an exhibitionist, I'm afraid.

I think that a book or a journal is an intimate object so I feel free when I draw on it; when I change into another material like a sheet of paper or canvas, the way I draw is completely different. It might be that, in the sketchbooks, I feel like I draw for myself and not for other people—even though I know that they will be shown publicly. Also, I guess the fact that it is an object, with covers—whose content is not immediately visible and that you have to work your way through—makes it something that creates a more complex relationship with the viewer (than paintings for instance).

I've drawn my whole life. Drawings are the way I understand the world. I'm also a painter, but that is another feeling. For me, the painting is the body and the drawing is the mind. I've stopped drawing occasionally, but not many times, and not for extended periods. I guess I've stopped when I've been extremely sad but, paradoxically, coming back to it has gotten me out of the depression.

I have one sketchbook that I carry with me all the time, and I draw and write everything in it—whatever comes to mind or catches my attention. I work on it when I have to wait in the train or the bus stop. There is absolutely no order to that sketchbook. In this specific book, I'm completely free with the subject and media.

However, at home or at my studio, I have other sketchbooks I work on in a more deliberate way: following a theme or a subject I've decided upon for example, or using only one kind of ink, exploring only one subject or using narrative on one specific subject. My only rule that applies to all cases is that I must finish them; that is, I must draw until the last page is used.

Sometimes, my journaling is more disciplined and oriented to an end result. For example, last month

my work was all about the neighborhood where I live (Kings Cross, Sydney), which is a controversial place in the city—sort of a red-light district. This work was produced for a specific exhibition in a gallery. So every day, and at different times, I would go to different coffee shops to draw the people, sex shops, streets, the objects in the street, etc. In this case, I knew exactly what I wanted because I had the show in mind. At other times, however, I just draw because I can't help myself. I would say, then, that it is both a spur of the moment thing and a disciplined practice.

I've always drawn in small sketchbooks. But my perspective shifted when I lived in Paris for two years. Everything was so new to me that I wanted to draw it all. Sketchbooking became an obsession. When I finished the second sketchbook, I realized that I wanted to use it as part of my main artistic work. Also, I lead a bit of a nomadic life, and it is a lot easier to take them with me than taking larger pieces.

Traveling changes my sketchbooking. I prefer to have a new book for the journey. Sometimes, I go to a place just for the sake of drawing it, and sometimes, I just take a picture and then I draw it in my studio, but of course the impact and the experience of the drawing is completely different when I travel.

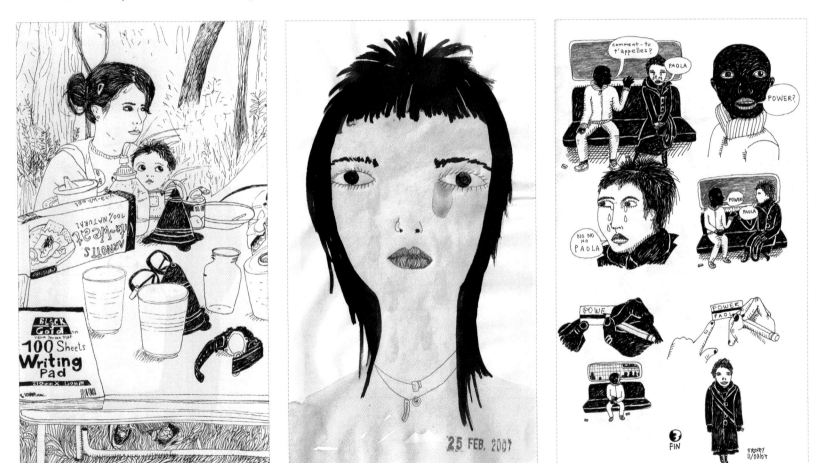

SKETCHBOOK COVERS

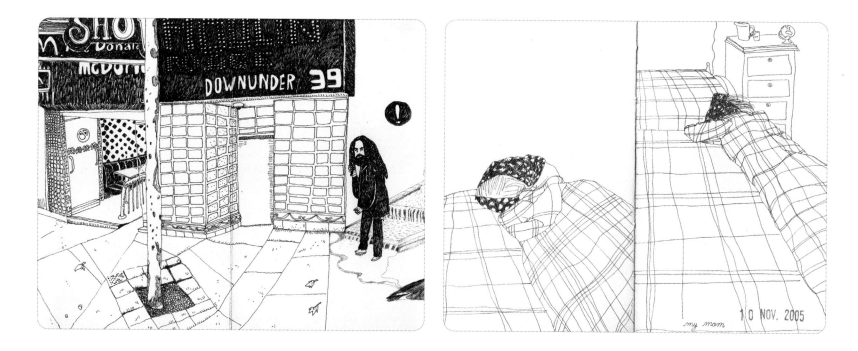

Starting a new book is very difficult for me. More so if it is made out of nice expensive paper. I find that it is easier, and less scary, to work on cheap paper; I feel less pressure. Also, choosing the subject is a difficult process for me. In short, the first drawing is always scary and intimidates me.

I like the Moleskines and Winsor & Newton sketchbooks best, but if I have the time, I love my handmade sketchbooks. I recently learned to do bookbinding, so

I now prefer to make them myself using different kinds of papers and shapes. I love drawing with ink pens, 0.05 markers, ballpoint pens, color pencils and 0.7 HB and 0.5 HB pencils.

I keep many of my books in a Converse shoebox in my home-studio in Sydney, but I have more in Colombia in other boxes. There are some in galleries, and the ones that have been sold to collectors are leading a life of their

own who knows where. I feel more attached to my books than to my paintings; when I sell them I usually feel sad. I don't have that feeling when I sell my paintings.

POWERPAOLA
PAOLA GAVIRIA

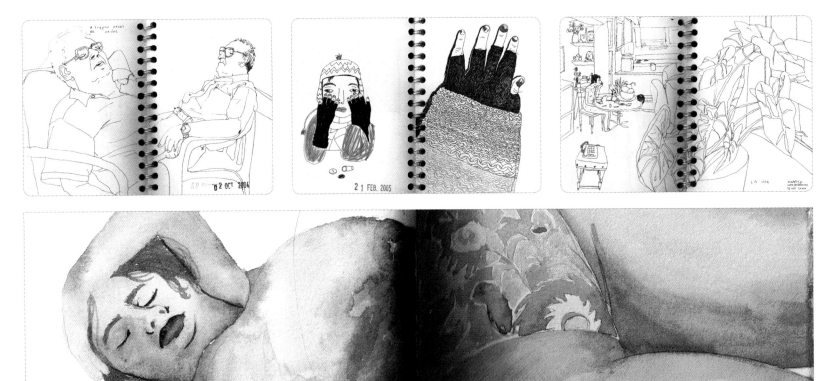

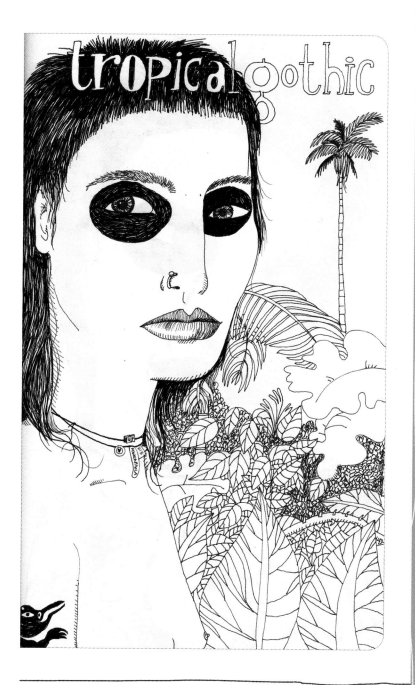

PAOLA GAVIRIA

BARRY GOTT

Barry grew up in Cleveland, Ohio, still lives in Cleveland, and hopes to die somewhere besides Cleveland. He received a BFA in painting from Bowling Green State University. He illustrates children's books, writes and draws greeting cards, and raids the refrigerator from his home studio. His work can be seen at www.barrygott.com, in children's books like *Dino-Hockey* by Lisa Wheeler and on greeting cards from Recycled Paper Greetings.

My sketchbooks are sort of my playtime. They're a chance to relax and have some fun. I don't really care if the drawings are logical or done well, which is helpful since they're neither. I enjoy being able to do these for my own pleasure and throwing out all of the rules and expectations I have for my illustration work. Come to think of it, I often sketch so I can momentarily avoid "real" work.

If I'm sketching in my sketchbook, it's usually while I'm sitting on the deck as my kids play in the backyard. In theory, I am supervising them, though this theory has not been tested. If I'm sketching on the computer, it's early in the morning over a hot gallon of coffee.

I like to sketch only if I'm alone or if my wife is engrossed in a book of her own. Perhaps if I left the house more often, I might sketch in public. As it is, sketching is my version of lounging in a hammock with a beer, watching the clouds go by.

For me, deciding to pick up the sketchbook and draw is always a spur-of-the-moment thing, never a planned activity. How often I sketch seems to have an inverse relationship to how much fun my work is. If I'm illustrating thirty-two pages of *Happy Children Playing Nicely* in which no dinosaurs trample Omaha and no squid arise from the sewers to devour poodles, then I spend a little more time in my sketchbook.

I've always drawn. It's just normal. It's like driving or walking. I keep forgetting that not everyone draws.

When I was a kid, I drew on the back of misprinted paint can labels that my dad would bring home from the factory by the box load. In college, my sketchbooks featured poetry that could destroy all life on earth. After that, it was quick gesture drawings of zoo animals. Then for a while, it was mostly cartoon dogs floating on helium balloons and riding unicycles.

I draw two ways: on paper and on my computer.

Even though with my Cintiq tablet I can draw directly on the computer screen, there's still a world of difference between drawing on paper and drawing on the computer. I enjoy both, and I enjoy the different things each brings out of me.

My sketches on paper are a bit like odd dioramas or set designs for Martian Opera. My digital sketches don't usually have that scene-like quality; they tend to

I don't really care if the drawings are logical or done well, which is helpful since they're neither.

be character studies. I'm much less aware of the page edges when I'm sketching digitally, which makes me feel less like I've got an entire page to fill.

Despite the impromptu and fun nature of my sketches, having a real, bound sketchbook is important to me. It makes me draw more intentionally than I do on loose sheets of paper. Also, if it's a book, I'm less likely to accidentally throw it away or use it as a grocery list. My only rule is to draw a little slower than I often do. When I start sketching too fast, I get looser and sloppier until I've got pages filled with illegible scribbles.

At times, I've stopped sketching for months at a stretch, usually when I'm busy with work. Eventually, I notice that I'm not having much fun, my pets hide from me and my wife renames me Grouchy McGrumpyman. That's when the sketchbook returns. Don't get me wrong—I love my work, and I do have lots of fun with it. However, taking the time to just draw and doodle whatever pops into my head is what really fills my creative gas tank.

I like the little Moleskine sketchbooks the best. I like them when they're empty. They have that "new sketchbook" smell. To break the blank-page-heebies, I'll stick a face in the middle, and work outwards from there.

I draw with Pigma Micron pens. I don't like anything that would smear in a sketchbook. When I'm sketching digitally, I use Corel Painter or Adobe Illustrator.

I consider my sketchbooks to be important, despite the fact that too often I just plop them on my desk, lose them under reams of paper and find them buried under coffee cups and CDs. When I look back at them, I feel a genuine sense of satisfaction, as something that's completely in my own voice and on my own terms.

My advice to would-be-sketchbook-keepers: Relax. Make it fun. And if it has a "this book belongs to" line, put "Oprah."

Barry Gott

...IS WHAT IT IS. REBEKAH'S
GONE FOR A ~~FE~~ COUPLE
NOW, AND THE UNIVERSE
...S TO BE SETTLING,
...LY, BACK TO STABILITY.
...T LEAST A SEMBLENCE
...HAT IT WAS BEFORE.
...'S A GOOD TIME TO GET IT
...DOWN, THOUGH FOR THE
...ST TIME, I AM UNSURE
... MY RIGHT TO DO SO, ..
...RE OF MY ABILITY TO
...HE EVENTS OF LAST WEEK
...JUSTICE AT ALL...

...t Started ABOVE

...ENS. BEAUTY-LESS, BOX-BOUND
...ENS WITH ITS FILTH AND NOISE AND
...IC ART EVERYWHERE. THE HOSTEL WAS TOO HOT, TOO CONFINED,
...WE WENT TO THE ROOF FOR THE COLD FREEDOM OF A SLIVERED
...N AND STARS BRIGHT ENOUGH TO BURN THROUGH THE SMOG-
...W. WE TALKED THEN, AND THE LAST HOURS THAT STOOD BETWEEN
...ND DAWN PASSED IN MINUTES; SLEEP COMING IN A BLINK
...LEAVING FAST AND ANGRY. WE COULDN'T HAVE KNOWN THEN,
...THIS BECAME A KIND OF PRECEDENT FOR THE REST OF THE
...EK, OUR PULSES SET TO WAKEFULNESS.

THE FERRY
RIDE WAS
SUPPOSED TO
BE FOR SLEEPING,
BUT CONVERSATION
AND "NESCABUZZ"
FOUGHT OFF THE
SANDMAN, TOOTH
AND NAIL. "PAROS,"
I SAID, "WE CAN
SLEEP ON PAROS."

BUT OF COURSE, THIS WAS
NOT POSSIBLE. PARIKIA
WELCOMED US WITH WHITE
WARM ARMS, AND REBEKAH
MARVELED AT IT, AS I HAD
DONE MY FIRST DAY. SHE WALKED
SLOW, PETTING TREES, FLOWERS
AND WALLS AS IF TESTING
ITS CORPOREALITY. I ASSURED
HER THAT IT WAS IN FACT REAL,
AND THAT SHE WAS IN FACT
ACTUALLY HERE; AND THAT TO-
MORROW THE WEATHER WOULD
TURN, SO WE SHOULD
WASTE NO TIME AND
GO, TO THE BEACH.

AND SUDDENLY... WE WERE CHILDREN.

ALMOST.

THE PLAY WAS F...
MEMORIES OF THE...
OF BEACH-DAYS PAS...
ONLY WARMED BY...
AND OUR LAUGHTE...
THE KINDNESS OF...
MINDS MEETING.

BUT WE WERE
CHILDREN WITH RAVENOUS
HOPE FOR THE WORLD
OF OUR FUTURE...

...AND MA...
COULD HAVE...
CHILDRE...

... MAYBE WE COULD HAVE
LET OUR GAMES STAY
THERE, SIMPLE...

...IF WE WER...
IF WE WERE L...

AND SO I DID MY BEST TO BE PRESENT IN THAT MOMENT, TO...
THROUGH THE EYES OF A SEVEN YEAR OLD BOY. AND IT WORKED
BETTER THAN I THOUGHT IT COULD. BUT THEN I WOULD TURN TO...
AND SHE WOULD TURN IN PERFECT PROFILE AND WALK WIT...
RIPPLES; AND LIKE A LITTLE BOY I WOULD LOOK AWAY FAS...

SEAMUS HEFFERNAN

Seamus grew up in New England and now lives in Portland, Oregon. He recently graduated with a BFA in painting from the Pacific Northwest College of Art and did a semester abroad with the Aegean Center for the Fine Arts in Greece. He is a freelance illustrator/painter/comics artist. His work has been published in various anthologies such as *The Portland Nobodies Comics Anthology, Postcards: True Stories that Never Happened* and *The Portland Funbook* and can be seen at www.seaheff.com.

I've been drawing since I figured out how to hold a crayon. My mom has piles of sketchbooks from the time I was three, mostly filled with little "Calvin-esque" characters and anatomically impossible superheroes. It is my main, most intuitive way of expressing myself. It's also essential to my well-being as a person. I go through slumps when I don't draw as much, but I think the longest I've ever gone without putting ink down in my sketchbook was a couple of weeks. I get really depressed when I don't draw for a while, and it gets even worse when I actually get to it and I see how out of practice I am.

I never go anywhere without my book and an arsenal of sketching tools.

Different pages fulfill different functions, and depending on my place in life and environment, my books change to meet the demands of what I'm doing. When traveling, my journals function as a record of my experiences, as well as a research codex into the cultures. When I'm at home, they work more as a place to keep my chops sharpened and a place to make studies for larger pieces. However, I think that my sketchbooks are the truest thing that I do, and that their scope and interest outweigh my more finished pieces. I can do whatever I want in my sketchbook, whereas, with illustration, I usually have to mold my vision to the whims of a client. In my own artistic practice, my sketchbook allows for mistakes and fruitless discovery, which I'm not so free with in my finished paintings/drawings.

I like to keep the drawings in my book chronological. I'd love it if all of my pages were filled to the edges, but often, as the next day or week comes to pass, I can't go back and add an irrelevant drawing to a past page. I don't like to collage, and I try to keep everything inked, as lead smudges too much. Also, I always make it a point to treat the text as drawings too, spending time on fancy lettering and incorporating text compositionally. I try my best to make not just each page but each spread compositionally balanced. Text is good for this.

Before I saw Chris Ware's first published sketchbook (*The Acme Novelty Datebook*), I wasn't nearly as careful with my sketchbooks. I didn't spend the time to really work the pages and balance the spread's compositions, and I rarely treated text with any importance. Also, up until college, I did very little observational drawing, and now it is almost all I do.

I usually make my sketchbooks with the understanding that people will want to look through them, so I keep anything I wouldn't want people to see out of them.

Art is for looking at, and many people seem to genuinely enjoy them. I especially like it when little kids check 'em out, because it usually inspires them to draw more.

I am far more inspired to work in my sketchbook when traveling. I have a camera as a backup, but I do most of my recording of place, people and events by hand. I do this especially to enhance my impact of "place." Traveling is very precious and fleeting, and most tourists make it less precious and more fleeting by speeding from site to site, snapping photos, going home and looking at all the places they've been. Mediating one's experience in a foreign land through a tiny camera screen is sinful, so I do my best to translate the fascinating things I see through my eyes, mind and hand. By letting the experience of a foreign land flow through you, it resonates in your memories in ways unavailable to the average tourist. When you spend three hours

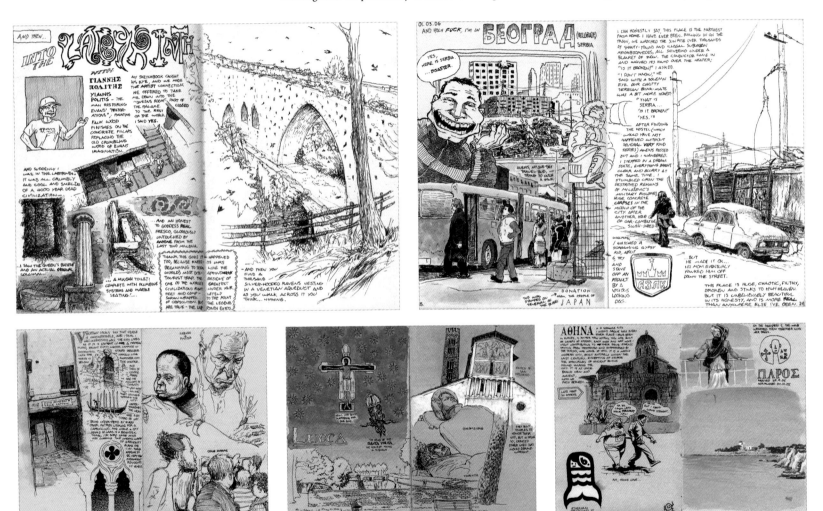

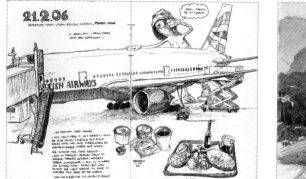

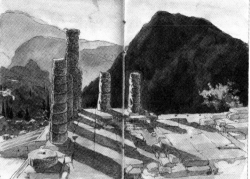

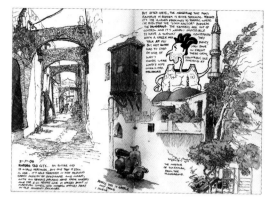

By letting the experience of a foreign land flow through you, it resonates in your memories in ways unavailable to the average tourist.

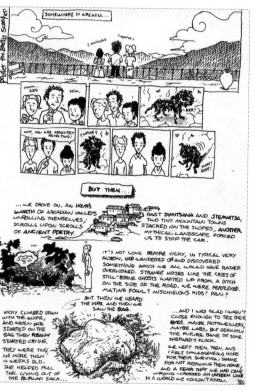

drawing the majestic expanse of the Roman Forum, you leave with a visceral recollection—the smell of the breeze, the shine of the marble, the murmur of thirty-odd languages intermingling. I have less of a desire to do this when at home, mainly because everything is "usual," and I will still be here next week.

For a while, I was into the larger (11" × 14") hardback sketchbooks with a spiral binding because I could work larger. But once I started seriously traveling, that size became unmanageable and paper quality and durability became a more serious issue. I had a book hand-made for me, novel size with printmaking paper, and it changed my life. It added a sense of quality and authenticity that made me really pour effort into the pages. Since then, I've been making my own sketchbooks and painting their covers. It's pretty cost-effective, and I get the added benefit of choosing my favorite paper, number of pages, dimensions, etc. The "book-ness" of the thing is a major reason why I've started binding my own books. There is beauty in tactility, in holding an object of art in your hands and manipulating it to make the art

unfold. Intimacy, a close human connection to the work, is something you usually don't get from contemporary fine art, whether digital video art or paintings.

My books are primarily illustrated with ink and gauche paint. There are touches of pencil, and I even tried egg tempera in one of them. I use a Rotring Art Pen (fine or extra fine) with a refillable ink cartridge, the closest thing I've found to an actual dipping pen that is portable. After years of trying different waterproof inks, I've finally settled on plain old Higgins India Ink, as it does the least amount of cloggy damage to the ultra-sensitive Rotring with the richest black possible. I also use a Kuretake waterbrush filled with the same ink as a brush pen.

My advice: Always keep your sketchbook with you and draw all the time. In the words of my mentor, John Abel: "If you're sitting, you're drawing." Draw from observation as much as possible, as that enriches your "vocabulary" and lends added realism and weight to the things you create from your mind. Consider a spread as a canvas. Think intently about composition and text placement. Oh yeah, and draw all the time.

this is the day before the 9/11 anniv
I think about that day a lot. I left that J
open in my PMCS
display.
two water-
self port.
afternoon.
the
i did
daily

march 22, 06
7:46 pm over here
at Black Butte —
Just found the
pages of van Gogh's
drawing. Reminded
me of my last
conversation with
Jason Novak
re: the man.
felt like
van Gogh. Just today drawing
the back woods/ pines here.
mixing more watercolor & graphite

APRIL
11, 06
THIS moment
Jamie sent
email, commit
to IVYGLIC
Friday. AP. 7
BIG DAY,
HAD SECOND
.OUGHTS OVER
VIKMO., BUT A
feeling more and
RE EMBOLDENED
MY DECISION OF
DECISION TO
RESCATME

MAY 2, 06 — t
is wonderful. Clear
way up to 70°. Star
farly this morn. M

September 10
2006
Saturday.

KURT HOLLOMON

Kurt grew up in Portland, Oregon, attended the Burnley School for Professional Art in Seattle, and is now an illustrator and teaches drawing and illustration at Pacific Northwest College of Art in Portland. He has illustrated many books including *On Foot, In Gear* and *The Adventure Journal*. You can see more of his work at www.kurtdhollomon.com.

Drawing in a bound book is so satisfying because you are in the world of books. Bound books carry a great deal of respect. It's not a casual happenstance—you are filling up a book over time rather than an isolated, unconnected piece. I like to have my work related to something bigger and sequentially placed in a book. Plus, books store nicely on a bookshelf, like the library.

My first sketchbook was a small, pocket-size spiral I made while guiding up in the Alaska Range. That was 1979 when I was nineteen. I started keeping sketchbooks in art school, but in a more determined way since my first major job as an art director at Borders, Perrin and Norrander, Inc. in Seattle. The main purpose of these books was to contain my ideas for jobs that I was working on at the agency. To this day, I still keep these books, and they have helped me track the evolution/development of my professional work.

My sketchbooks are always with me. I can and do spend full days working on my book in the studio. I have many books going at one time. I have six kids, and at least two are currently attending art school. Every one keeps a sketchbook.

Traveling doesn't change my relationship to my sketchbook. I am always armed with the right tools and at least two sketchbooks, including at least one spiralbound (so I can rip out pages of art to give away or sell). This summer I have been mixing it up with drawings/watercolors in my books and a spiral pad painting or drawing. I usually take different size books to draw in, like when I went to Mexico this past March. I ususally draw in ink, but more recently have used watercolors at the Oregon Coast and in the high desert of central Oregon.

I go for more of the finished look in my books rather than the quick sketch. I tend to design my pages, more or less. In my personal journal, I write in two vertical columns and write around the drawings as I make them. Just like inset book illustrations. I usually make my drawings intentional—like they were meant to be there. I have never just randomly doodled.

I have tended to start new journals with my take on a traditional book title page. There was a time when I would start a volume with a map I'd drawn based on things going on in my life at the time.

Occasionally I will give myself assignments. Recently, I picked a topic like hand tools done in different types of line. Then I've painted them, affecting the ground plane in different ways. Then I moved on to various compositions using my old climbing gear. This process is my newest obsession, and it has been very satisfying.

It's not a casual happenstance—you are filling up a book over time rather than an isolated, unconnected piece.

Many of these experiments make their way onto my web site and have led to commissioned assignments.

I have always used the 8½" × 11" Canson standard black sketchbook. I think of these as my working-class books. I pick up two or three at a time when they are on sale.

My pen of choice is the Micron Pen 01 Black. I carry along some 005 and maybe a 03 or 05. I'll always have my Winsor & Newton watercolor field kit along with a Yasutomo waterbrush. I have been doing a fair amount of paintings in gouache. I keep those in a wooden art box along with a 1 ½" flat Winsor & Newton sable/synthetic brush and a no. 6 round. My standard default is to color my ink drawings with Rembrandt soft pastels. These I will always apply when I'm back in the studio—too messy out on loca-tion. Also, when I'm in the studio, I will use colored inks and the traditional bamboo pen and miscella-neous other dip pens. Lately, I have been influenced by my students to use the medium NIB Sharpie and the ballpoint pen.

Drawing is my art. It's the bedrock of art. I teach drawing and I practice my drawing; it is my lifetime pursuit. After all the years I have been drawing, it's just something I have to do. It's that simple.

KURT D. HOLLOMON

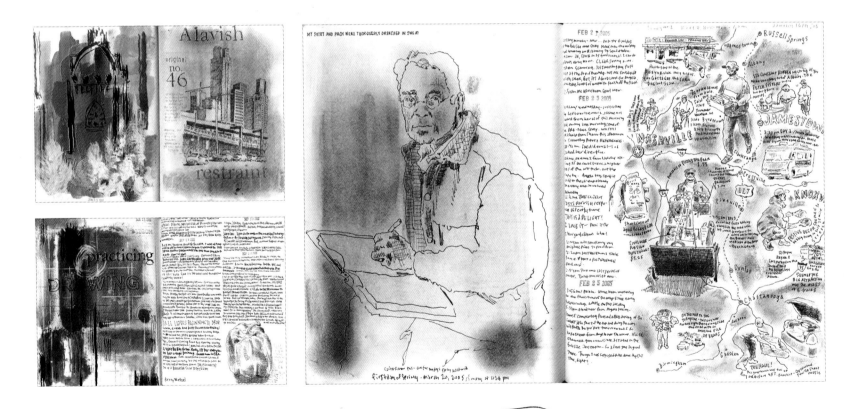

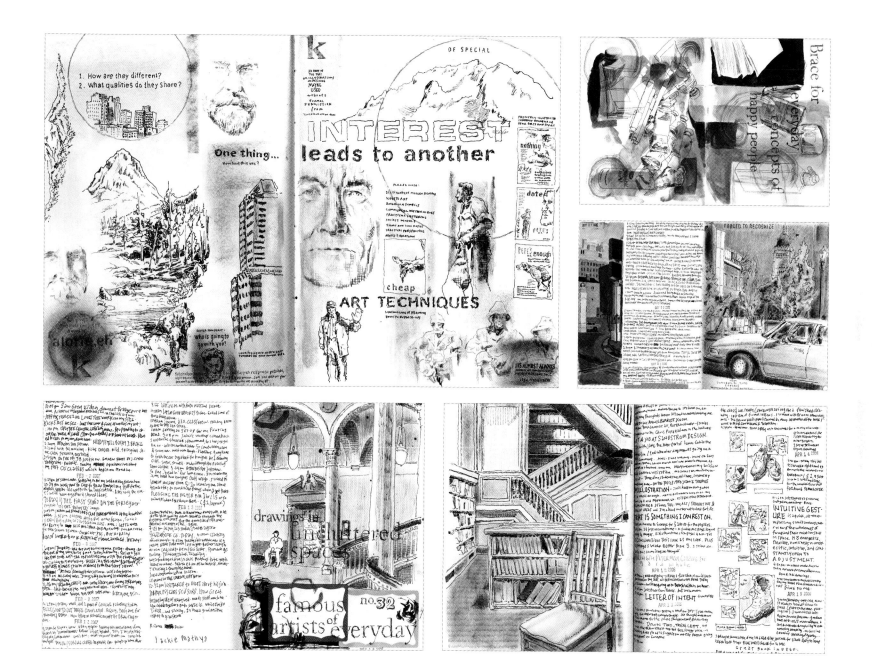

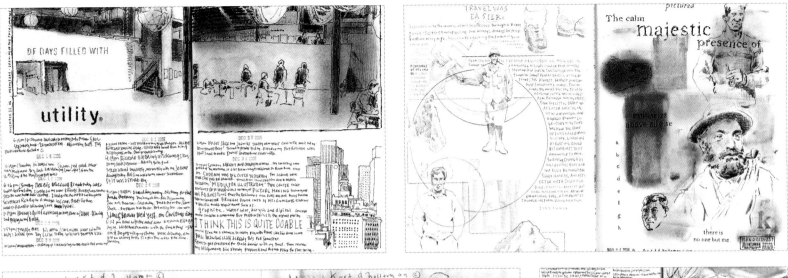

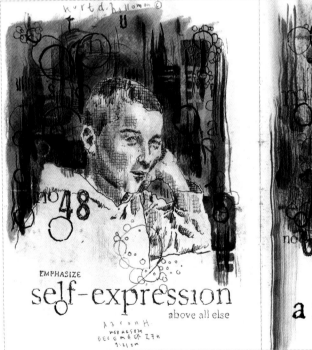

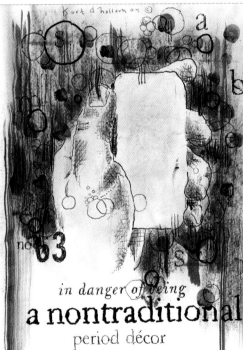

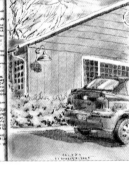

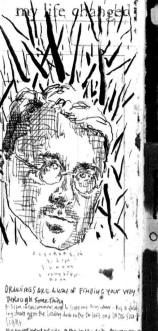
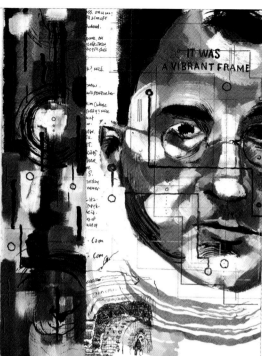

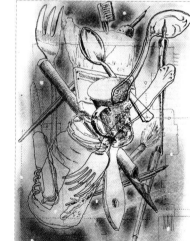

COLOR

color.

FEB 28 2006

i am learning how to **sew** (again.)

threading my
needles and
dreaming up
projects, again.

i am inspired

and anxious and
humbled by the
process of learning
something
from the very
beginning.

CHRISTINE CASTRO HUGHES

Christine was born in the Philippines and grew up in Placentia, California. In college, she studied journalism and American studies. She now lives with her husband Rama in Glendale, California, and runs Darling Design. For more of her art, visit http://maganda.org.

I keep my journals to remind myself what is good and beautiful in the world. To let go and let loose. To embrace life. I try to create a "Good Things" list each week, starting Monday and updating frequently throughout the rest of the week.

My journals are a record of my life, but by no means a complete one. Once in a while, I make a masterpiece, but, usually, I just make a mess. Sometimes, what I create finds its way into a larger piece or a project for a design client. Most often, though, what I create in my journal remains untouched and unseen by anyone but me.

I take my journal with me wherever I go out for the day, whether it's just to a coffee shop or to the beach. You never know when inspiration will strike. I don't have a ritual, but I often fill my journal when I'm out to lunch alone, when I'm lying in bed before I sleep or when I'm having an art date with my husband, Rama, in our living room.

I have kept a journal since I was a little girl. They didn't become visual, though, until the summer after high school, when I visited my older brother, Tom, in the Netherlands. He bought me my first blank book and encouraged me to sketch and paste in it. Influenced by artists like Sabrina Ward Harrison and Rama, my books have become more and more visual over the past several years. They have also become less about secrets and confessions and more about hopes and celebrations.

I have always been stuck in a love triangle between writing and drawing. Because of my education and experience, writing comes more naturally to me, so sometimes words win over pictures. But I am always brought back by a desire—conscious or not—to draw.

Blank pages definitely can be intimidating to me. I always have grand plans to start a new book with a bang, but it doesn't always happen that way. The best

first pages are the ones where I don't think too much, where I just have fun.

I used to try to impose rules on myself, like "I have to finish every page before moving to a new journal" or "I cannot cover anything up that I don't like," but I broke them all. So now, I don't have any rules.

I love drawing in a book. I just like the way it feels in my hand, looks in my bag and sits on the shelf as a volume of my life. If I am drawing on a piece of paper or canvas, I am probably working on something for somebody, like a client or a show. If I'm drawing in my journal, though, I'm doing it just for me, for kicks.

For several years in a row, I used a square Cachet spiral-bound sketchbook, but the 9" × 9" size became too big and heavy to carry with me everywhere. I switched to graph paper Moleskines, then to an Exacompta journal with gilded pages and a ribbon bookmark, which I

They have also become less about secrets and confessions and more about hopes and celebrations.

ordered online after seeing an artist I knew use it, and now to a Hand Book artist journal I got at a local art store. I love my new journal. It's a square 5 ½" × 5 ½" book with a green cloth book cover, and its paper is a wonderful, heavy weight.

For pens, I use Micron .005s when I am specifically sketching and Uni-ball Vision Elites or gel pens when I'm writing or doodling. The pen has to be waterproof so that I can add watercolor washes later on. If I'm traveling, I use Prang watercolors. If I'm at home or in the studio, I use Winsor & Newton watercolors and

good things
04 feb 04

- surprise visit from ®
- sizzling rice soup
- craft day cupcakes & projects
- ice cream truck treats (thanks, bubba)
- maraschino cherries
- ikea mazes
- new enamel blueberry blue ring (you know, for christines!)
- fire dragon cinnamon gum
- penelope, aka p-lope
- iron-jawed angels
- non-hollywood hollywood
- red + white tulips, tart candy hearts, down with love, and a filipino cinderella children's book from rama
- pasalubongs from auntie beth, uncle boy & marybeth (w/her own money)

when it rains it pours—!

good things
week of august 18

- freshly brewed almond tea
- CRAFTERNIGHT
- chocolate brown
- "brick wall, waterfall."
- a rainbow of blazers
- Willy Wonka & the chocolate (& golden tickets!) factory
- SIDDO
- Spega yogurt in apricot
- fresh lightbulbs
- GAMA·GO
- my new jacket from anthro
- how rrama can cheer me up
- calling in sick (heh)
- being on a roll with work

MAR 2X 2007

ONE-MINUTE rama
at ihop, ontario

while waiting to see sidra

*i mistakenly drove 45 out for cooking.com's sample sale 2 hours early. ugh.

2007

i'm coming out of a jetlag haze and finding myself smack dab in the heat of summer. thank god for air conditioning & ice cold water & tank tops & bad cable tv that has made this week of recovery & decompression bearable — even enjoyable.

in a minute, i'll resume my magazine browsing and diet soda drinking. tonight, rama and i will be visiting mom & dad in p-town. eat some good food, maybe watch a movie or play mah jong or both. this weekend, see some friends and enjoy the last days of honeymoon/vacation bliss.

JUN 22 2005

summer

gouache or Liquitex Basic Acrylics. I also use Crayola markers, crayons and any kind of stamp pads. I like Dixon Ticonderoga #2 pencils, but I'm not picky about pencils. Since I also collage, I use everything else under the sun: rubber stamps, paper and fabric scraps, vintage ephemera, collected fortune cookie fortunes and a whole lot more.

I have my most recent books on a shelf in my studio. The rest of them are in a box in the closet. They are quite precious to me. When I look back through them, I sometimes feel embarrassed, often nostalgic, but mostly proud.

I thing everyone should keep an illustrated journal. Just do it! The joys and beauty are usually found when you're not trying too hard, so let yourself let loose. Make a mess. Don't aim for perfect. Allow mistakes. Have fun.

Christine Castro

{07 OCT 2004} **good** THINGS

BEAUTIFUL BROWN **mug** FROM BECKY A 'CONGRATS' GIFT

FRED **62** HASHED BROWNS

EVERYTHING DONE ☺ WITH **lorraine** AND HER SWEET MELODIC VOICE!

GINGER-GRASS SPACE-AGE **tofu**

party WITH ALL KINDS OF HOLLYWOOD TYPES, LIKE JASON SCHWARTZMAN & ZOOEY DESCHANEL

also MEETING RAMA'S NICE **co-workers**

LYING ON A **roof** IN DOWNTOWN L.A. AND STARING UP AT THE SKY

pizza AND DEBATE NIGHT

darling HANDBAG WITH LOGO AND little darling, MY OWN A BABY DIVISION OF NY.CO.

xerox MACHINE FUN

THE ALL NEW **youth** MINISTRY TEAM

LETTERS FROM **rama** DISGUISED IN KIDS ART STATIONERY

ITALIAN SANDWICHES FROM BAY CITIES IN SANTA MONICA **deli**

gouache FOR 40% OFF

"ABOVE ALL ELSE, IT IS ABOUT LEAVING A MARK THAT I EXISTED:
I was here. I was hungry. I was defeated. I was happy. I was sad.
I was in love. I was afraid. I was hopeful. I had an idea
and I had a good purpose and that's why I made works of art."
—FELIX GONZALEZ-TORRES

Your hidden creative talents will soon be revealed.
03 15 24 32 40, 18

good **THINGS** 16 FEB 04
- chicken pho + vietnamese iced coffee
- basquiat
- painted sky & meadow
- watching tulips stretch and twist across the room
- late-night snack (rhot, hri kisses) delivery
- finding the creativity in cooking
- mexican stew
- much-needed rain. eating a big bowl of udon when it does.
- curling up with a pile of magazines, falling asleep with the light on.
- a basket of fresh strawberries from helen and her reminder to wash them first
- complete maganda archives
- matinee records' speedy service
- mid-day vent session with tania
- 50 first dates
- china town adventure with stella & francesca
- art night with rama

polly's is my new secret place.

We Proudly Serve
LINGLE BROS. COFFEE
Fresh - Brewed Decaf
POLLY'S

coronado island | 25 july 04
rama, me, and two old ladies

GOOD LOVELY FANTASTIC BEAUTIFUL THINGS

THE DELICIOUS & DELIGHTFUL DINNER RAMA MADE, AFTER MY TRYING & TRYING NIGHT IN BEVERLY HILLS. ESPECIALLY THE "for my love" INSCRIBED BROWNIES. MALLORY CAREY'S CANDOR, EXPERIENCE AND COMPLIMENTS. GOOD CUSTOMER SERVICE FROM LADY AT PACBELL. PENELOPE'S DEATHWEED FRIENDSHIP. THIS PEN (THE PILOT HI-TEC C IN 0.4). ALCOVE'S FRENCH FRIES AND CRÈME TRAY. THE FACT THAT, DESPITE THE FRUSTRATING LOAN PROGRESS, I COULD BE SELF-EMPLOYED—FINALLY—IN APRIL. BELIEVE IN ME. A BOSGW IN THE TEMPLE. AND SO MANY TALENTED AND RARE PEOPLE AND A GLIMPSE AT CYANS... SOCCA SUNSHINE ON STEPS WITH SOCCA AND BRIGHT ORANGE AND ICE CREAM AND ROAD TRIPS!

RAMA HUGHES

Rama grew up in Florida, went to the Maryland Institute College of Art and now lives in Glendale, California, with his wife, Christine Castro Hughes. He is an art teacher and freelance illustrator. For more of his work, visit www.ramahughes.com.

I've drawn for as long as I can remember. I never had strong feelings about it. I just did it. I stayed home to draw when my friends went out. One day, a friend of my grandma's looked through my sketchbook. She said, "Your talent is a gift from God." I was surprised that it took me so long to acknowledge that. I doubt that my interest in drawing is a gift to the world, but it truly is a gift for me. I love it. It's been like a best friend to me.

My mom started buying me sketchbooks when I was in elementary school. I drew cars in them. I copied drawings of superheroes and Dungeons & Dragons monsters. I drew comics about Transformers and firefighters. Around middle school, I thought that my sketchbooks were childish. So, I stopped drawing in them.

In high school though, I was encouraged by my art teacher to keep a sketchbook again. I did it for fun, but it became pretty popular with my friends also. As you can imagine, that was a big ego boost for a high-school student. The more I drew, the more people wanted to look at my book. It was fun. And my artwork got better and better and better the more I drew.

When I went to art school, my sketchbooks also became notebooks. I would scribble notes from class or ideas for artwork. I did a few small experiments in my books, but my sketchbooks remained very separate from my Artwork (with a capital A). That separation continued after I graduated. I worked out all my big projects on scraps and loose sheets of paper. My sketchbooks were never involved.

I did have one sketchbook that I was determined to use as a laboratory. I filled the whole thing with experiments, and it is one of my favorite books to look at. But experimenting didn't satisfy me any more than drawing did. So, as I got busier, I stopped experimenting for experimentation's sake.

As I did more and more artwork, my sketchbooks sort of died. I was drawing more for a living, so I didn't have as much time to draw in my sketchbooks. All my preparations for illustrations or big projects were drawn on loose sheets of paper. I threw them away when the "real" piece was finished. My brother got upset about that. He liked the sketches very much and always harassed me about saving them.

One day, I realized that I hadn't drawn in my sketchbook for almost a year. I felt bad about it. Taking my brother's advice, I started working out projects in my sketchbook. That's what you'll find in my sketchbooks now: lots and lots of studies for illustrations and comics and paintings I want to do. But the great thing about working in my sketchbooks is that they are always around. So, I play in them a lot more too.

If you look through my current book, you will probably find the thumbnails, sketches and tight pencil versions

of every illustration that I have done this year. I like the preparations, but I am usually more proud of the "finished" inked and painted pieces.

I keep my sketchbook in my backpack and take it anywhere and everywhere that I might be able to draw—friends' homes, the zoo, the airport, grandma's house. If I notice something I want to draw, I just leap up and grab my book. That usually means a demand to my friends: "Freeze. Don't move. Hold that thought!"

I have always enjoyed the experience of books: holding them, turning the pages, having them! As an object, a book is a beautiful thing. Sketchbooks tell a story because we perceive them page by page.

I really look forward to the first page of a new book. It's kind of like going back to school after the summer. I approach it with the feeling that "this book is gonna be different! In this book, I'm gonna be … " whatever it is that I want to be at that moment. I usually have that grand idea for the first page or two. After that though, it just becomes my sketchbook again, which I don't mind honestly.

My wife and I like to play little art games together. I have whole pages of drawings done in one minute, for example. On the first pages of my most recent sketchbook, I wanted to draw my wife over and over again. So, she sat for me a few times each day until the pages were full.

There is a performance aspect to drawing, when I draw strangers or new friends especially. If I draw one person, another person asks to be drawn. Drawing becomes something like a party trick. I drew one of my students once, and every other student wanted to be drawn. I ended up drawing eighteen students in just a couple of hours. My hand was killing me. Fortunately, I really love doing it.

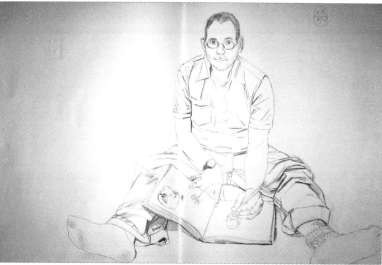

I can always remember the moments that led up to the drawing and what was said while it was drawn. The books are like time capsules for me.

I have tried many books over the years but my book of choice is the traditional black sketchbook that you can find in any art store. I like the standard 8" × 10" and also keep a super big one for when I need to draw something giant. I draw mostly with #2 pencil and occasional watercolors and ink.

Every page of my books carries memories of the minutes or the hours that I spent drawing it. I can always remember the moments that led up to the drawing and what was said while it was drawn. The books are like time capsules for me.

Even if you have never drawn before, keeping a sketchbook will open you up to the world in a way that you

cannot imagine. Even if you don't like the physical results, drawing slows you down and helps you appreciate things that you would never notice otherwise.

My experience of everything is impacted by drawing. I pride myself on really looking at things. I really study faces and details when I do anything. When I draw, though, I see in a different way. My seeing becomes almost meditative. I am in the moment. I notice things I never would if I didn't have a pencil in my hand. And I grow very fond of whatever or whomever I am drawing.

rama hughes

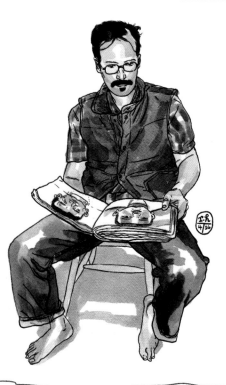

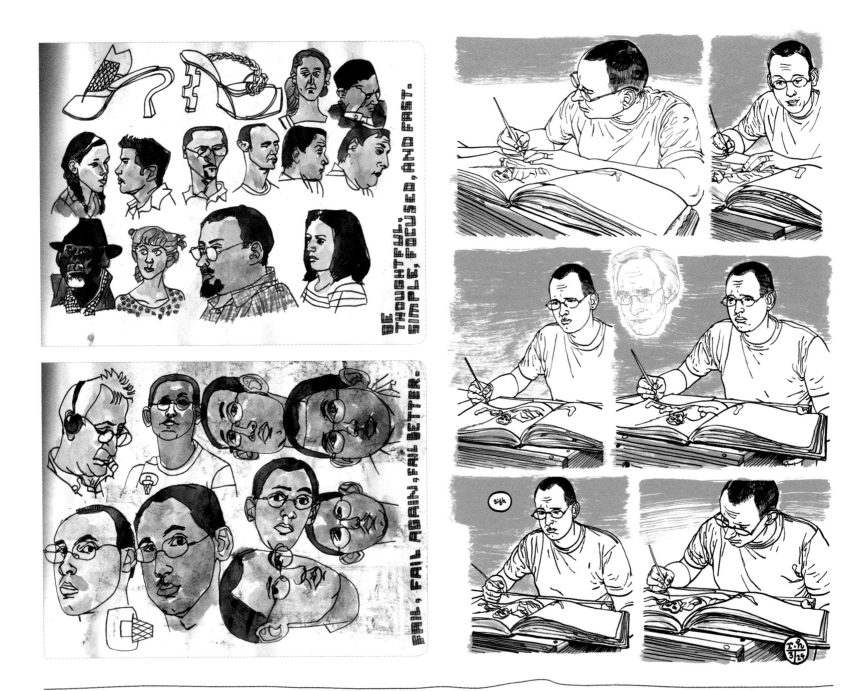

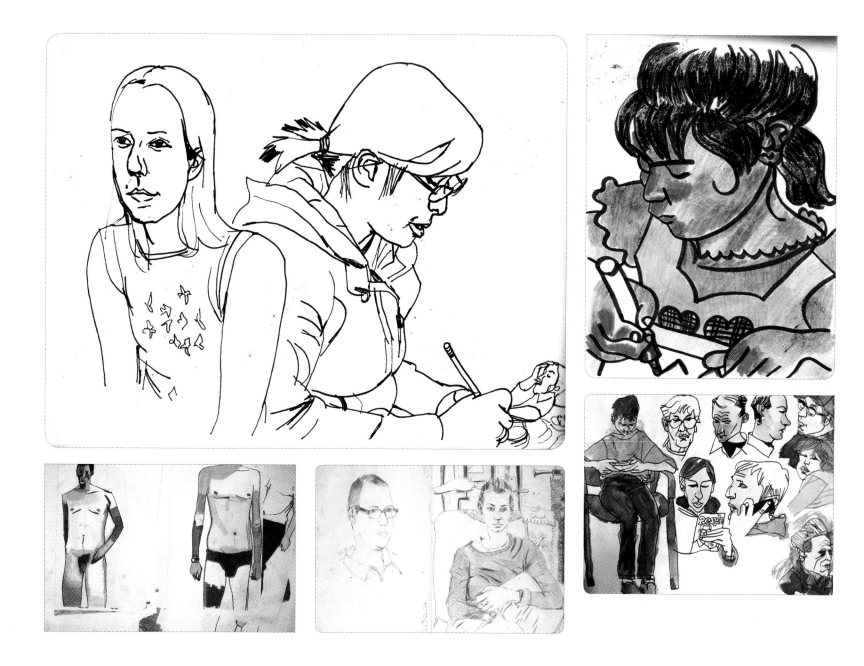

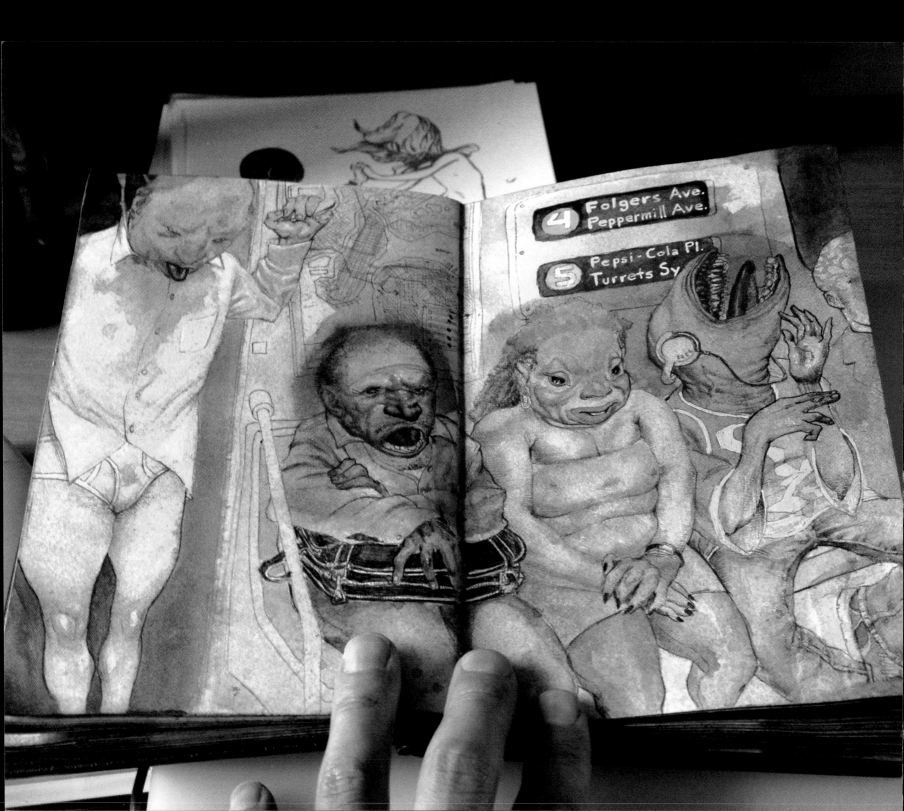

JAMES JEAN

James grew up in the heart of New Jersey, received a BFA from The School of Visual Arts in New York and currently lives in Los Angeles where he is an artist and illustrator. His work has been collected in two volumes called *ProcessRecess*, and can also be seen at www.processrecess.com, www.politewinter.com, and www.jamesjean.com.

I started keeping sketchbooks at art school. They have progressed from pencil studies to fully painted journals to their current incarnation, which is done more simply and lyrically.

Since the drawings are bound, they are more intimate in a way, shielded from view, and viewable only in chronological order. So the sketchbook occupies four dimensions, width, height, depth and time, as opposed to the two-dimensional nature of a painting or a piece of paper.

My sketchbooks are the antithesis of the other work I produce, that is, they do not have a specific function. I suppose they can be described most accurately as a journal. Each drawing is dated, and there is a scrawl of text describing some moment of the day. I don't consciously design the pages, since I like how the drawings grow organically in unexpected ways.

I take the sketchbook with me when I'm traveling. When I'm at home, I'm too busy working on paintings or illustrations. Lately, the only time I've been able to sketch has been at the airport.

I've gone to many places to sketch. Most recently, I was able to make some sketches in Buenos Aires and Iguazu Falls. I prefer photographs in terms of documentation. More than a record of the experience, the drawings are a window into the dreams and thoughts of the moment, rather than an accurate depiction of whatever it was I was looking at.

I like to use nice cotton rag books from New York Central Art Supply.

Lately, I've been using a lot of ballpoint pen, though I've used everything from acrylics to oils to gouache in my old sketchbooks.

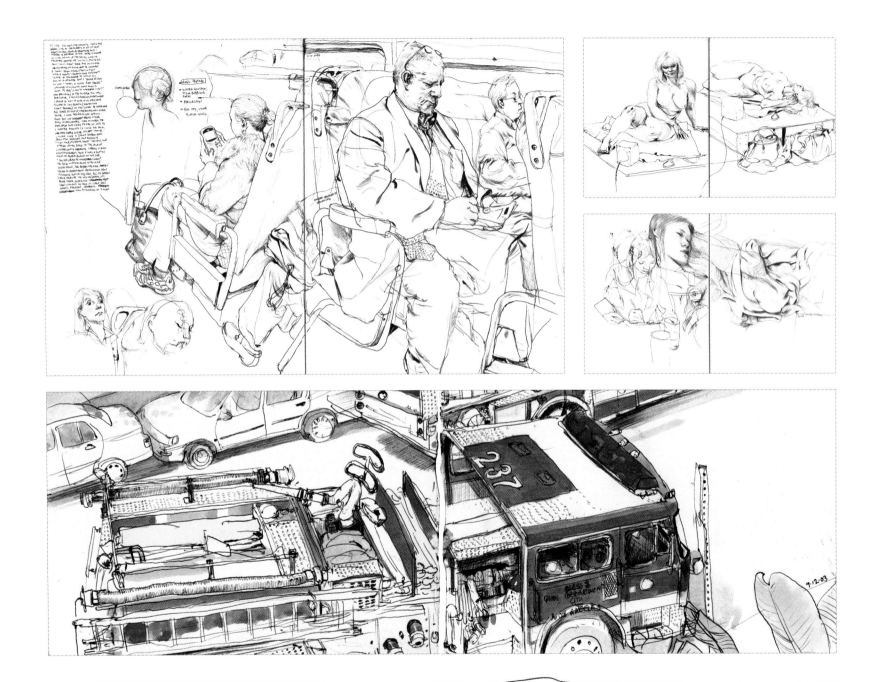

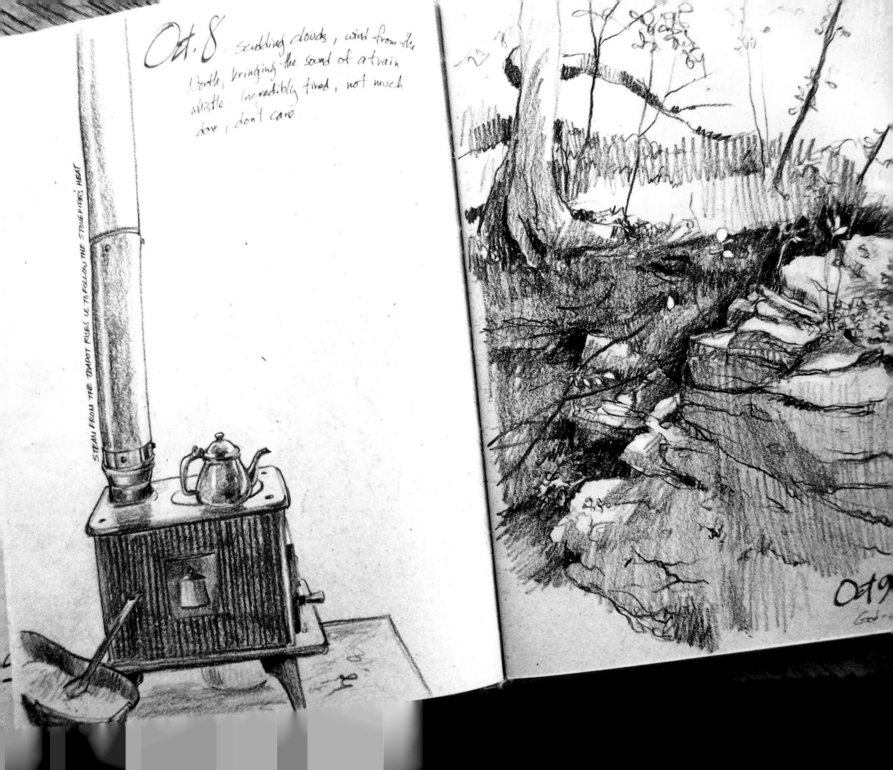

Oct. 8 — scudding clouds, wind from the North, bringing the sound of a train whistle. Incredibly tired, not much done; don't care.

STEAM FROM THE TEAPOT RISES UE TO FOLLOW THE STOVEPIPE'S HEAT

Oct 9

CATHY JOHNSON

Cathy Johnson is a painter, author and teacher who grew up in Independence, Missouri, and now lives in a small town near there. She took a few evening and weekend classes at the Kansas City Art Institute as a young woman, but is otherwise completely self-taught. She has authored eight North Light books, as well as *Sierra Club Guide to Sketching in Nature*, *Sierra Club Guide to Painting in Nature*, and writes for *Watercolor Artist* magazine. You can see more of her work at www.cathyjohnson.info.

Back in the late 1980s, my old friend and fellow artist/journal-keeper, Hannah Hinchman wrote a wonderful book called *A Life in Hand: Creating the Illuminated Journal*, which really changed how I thought about the way I kept my sketchbooks.

Before that, I kept one for nature study and observation, one for planning future paintings, one for commercial assignments, one for doodling, one for designing clothes or things for my magazines. Added to my written journal and a tablet for shopping lists, minutes of meetings and so forth, I was getting pretty fragmented! Now, everything is together in one place, in one book. Much easier to find that way … and life feels more whole.

The true purpose of my sketchbooks is to help me celebrate and truly experience my life.

If I don't have my journal with me, I invariably miss it. It just goes where I go. I'd say I work in it pretty much everywhere, even at parties or concerts! I've drawn just before surgery when the anesthetic was taking effect to keep from being nervous before a CAT scan, at farmers markets, at a boring meeting, in the desert, at a café, from a plane window, while waiting for my car to be worked on—it's all fair game!

My husband-to-be is extremely supportive. Some of my family thinks I'm a tad obsessive, since I've even taken my journal to openings of their art shows and sat on the floor sketching! (My eldest godchild snapped a picture of me doing that—she called it "Floor Flower"!) Sometimes I try to hide what I'm doing from strangers if I think they'll be uncomfortable with my drawing them, and sometimes I chat them up if they're interested.

I try to draw everything I possibly can when I travel, even to the point of drawing out the car window (assuming someone else is driving). I want to know the place, and one of the most important, visceral ways I experience life is through my sketchbook. I can go back to my sketches and remember everything—not only what I saw, but what I heard, what birds were nearby, what scents were on the air, what I was wearing, who I was with—years later. Looking back through them makes me feel as if I've really lived. As if time stands still.

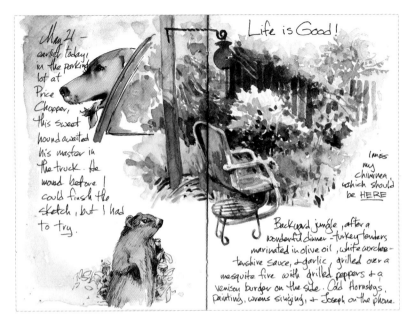

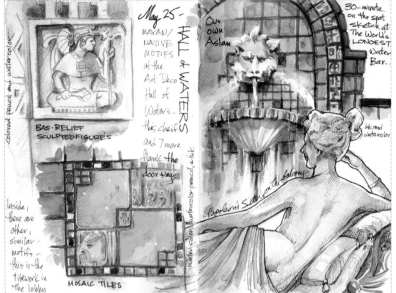

When it comes to design, my rules are that there are no rules! Sometimes, I work across the gutter, even quite asymmetrically, leaving one side almost blank and allowing that space to balance the subject. And sometimes, I'll fill a page over a period of a day or two, with little vignettes, arranged either in a random fashion or trying to find a thread that ties them together. I use all kinds of mediums, even acrylic. Sometimes I do exercises, test mediums and even whole paintings. No rules, though I do usually date the entries, just for continuity.

I often do the early stages of a work-for-hire in the sketchbook, but basically there is a difference. The sketchbook is often for exploration; it is almost an adventure, sometimes. I'm experimenting, playing, observing, trying out new things, testing new materials, comparing mediums, *living*! If I'm doing a professional illustration, I tend to use more quick-and-dirty, to-the-point methods. It is more professional, less exploratory.

If I draw in a book—preferably hardcover, preferably one I've bound myself—it's freed from commercial considerations. It's just for me, for my own edification, for the sake of making art, really—even if it has plans for a future painting in it. If it's on a loose sheet, and it turns out well, it's liable to be matted and framed and taken to my gallery, or listed on eBay—and gone forever. The purpose of my sketchbooks is to keep those moments of my life … as I said, to celebrate it, to learn from it.

The first page of a new book is a little daunting, and so is the last. I hate to finish a book; it's got so much of my life in it. There are a lot of changes in my life right now and moving to a new book and leaving that one behind feels odd. I often try to do something meaningful on the last page, just in case. "Just in case" what, I don't know!

I love looking at other peoples' sketchbooks. I collect published ones, even nineteenth century and before (Leonardo, nineteenth century naturalists, etc.), and now

I share sketchbook sessions with friends. I love to see how someone else sees the world and our fellow humans. I'm humbled sometimes, and I feel it's a great privilege to be allowed into their most private, creative lives.

I used to work exclusively in black and white, on purchased sketchbooks. Then color started to creep in, using colored pencils or watercolor washes, but the paper frustrated me. Now I bind my own so I can have paper I love—watercolor paper, tan, black—and I often work in color now. I even go back later and add color. I started doing this seriously sometime in the '70s. Dinosaurs were still roaming the earth.

I much prefer using my own hand-bound books, usually with Fabriano hot press paper for watercolor and drawing, but I'll draw on anything handy. I can always paste it in later, if by some sorry event I've forgotten my book!

December 17, 2006

Why not finish this journal which has seen so much change, both joyful and sad, with an unfinished self portrait?

FINIS, though I am not — this one is for "I"

Steel Blue Graphitint pencil with a touch of Derwent

May 27, morning up in Siloam Mountain Park — starlings, bluebirds, and a wakeful owl...

The catalpa trees bloom again glorious this year — clean as wanted!

I sat in the grass and painted till the need for coffee forced me to quit...

May 28

Relate Fritillaria today...

Scandinavian Country ceiling — tin, made with the original molds, gorgeous!

Some of Susan Theroff's lovely faux work — the sketch doesn't begin to do it justice.

Scandinavian Country
A Home & Garden Destination

May 26
the Pizzawhistle
Wabash BBQ —
once the spur line from Kansas City

This Cody was left from the day I took Joseph to the airport...

Delicious coffee — sat captains while John dealt with advertising

May 5

After my cat scans, I needed to go make art

Coffee at Scandinavian Country with Susan — lovely pots of pansies out front

December 15

Moggy Views...

Kreiner Pigments

she sat on my lap while I worked

I hate to finish a book;
it's got so much of my life in it.

I draw with just about everything—ink, graphite, colored pencil, watercolor pencil, watercolors, acrylics, you name it. Everything except oils or pastels. I like Pigma Micron pens, Zig Millennium, and Koh-I-Noor Nexus, in various colors—this week, Payne's Gray or Burnt Sienna. I mostly use a mechanical pencil with an HB lead, sometimes changing it out for a H2B if I can find it. I love those soft white erasers. (Yes, of course I erase sometimes!) A #2 office pencil is fine too, of course, if that's what's handy—so is a ballpoint pen.

I mostly use Winsor & Newton, Daniel Smith and M. Graham watercolors, and mostly Albrecht Dürer watercolor pencils, with Derwent a close second. Colored pencils are almost always Prismacolor, an old favorite.

My books are pretty much all over the house. Some are neatly shelved, some are on the coffee table, some share the bed with me.

I once almost missed a plane when I realized, in our rush to get on a late flight, I'd left my journal at the check-in. I bolted off the plane, to everyone's chagrin, as we were almost ready to take off! Must. Have. Sketchbook.

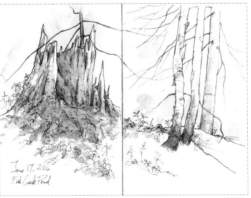

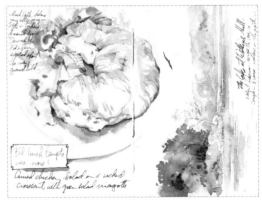

SKETCHBOOK COVERS

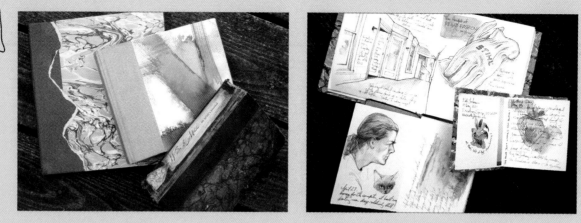

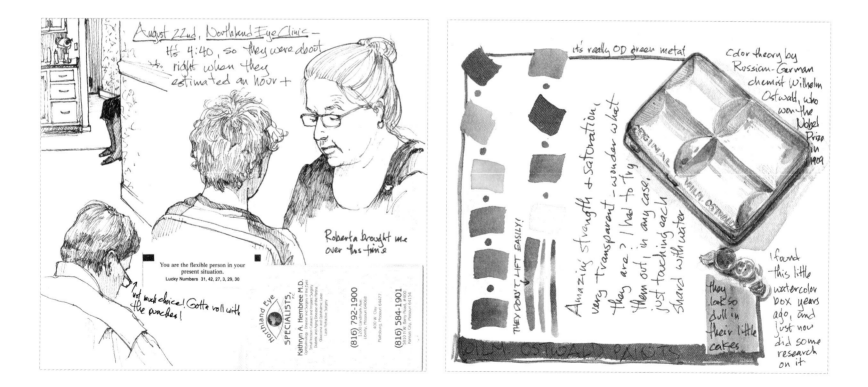

NOAH Z. JONES

Noah grew up outside of Chicago and attended Syracuse University and the Pacific Northwest College of Art. He is a freelance author/illustrator/ animator and works out of his house in Camden, on the coast of Maine. He has published several children's books with Candlewick Press, and his work can be seen at www.noahzjones.com and www.almostnakedanimals.com.

When I was three years old, my family moved out of a condo and into our first actual house. I scrawled bats (the flappy kinds with teeth, not the baseball variety) of all shapes and sizes on all the moving boxes I could. This bat-obsession lasted until I discovered dinosaurs a year or so later. I've always drawn. I can't sing. I certainly can't dance. But I can draw the hell out of just about any silly thing you ask me to.

I tend to get lost in thought as I'm scratching away in my sketchbook. Oftentimes, in meetings with clients, I find that I'll fill pages and pages with drawings while they're talking. At first, I thought that I had some sort of Attention Deficit Disorder, but later realized that, in a weird way, drawing helps me focus on what the client is saying and the issues and problems particular to a project. I think that doodling is a way for my brain to focus my wayward imagination.

I have a completely different relationship with my sketchbook than I do with most of my commercial art. With my sketchbook, I'm not beholden to anyone else's conception of what the art I create should look like. No fixes or tweaks, no revisions or complaints. I'm my only audience.

The sole purpose of my sketchbooks is to have a place where I can let out all manner of weird little notions and doodles without having to show it to anyone. Sometimes, these silly little drawings will become ideas for projects, but most of the time they don't go beyond being a quick little drawing.

They are much more "playground" than "illustrated journal." I do consider the drawings in my sketchbooks to be much closer to me than the sort of work I do for books and whatnot. I work in many different styles, but I don't think I've ever tapped into my sketchbook style for any commercial projects.

One thing I've noticed is that, oftentimes, the creative process is like following a roadmap that erases itself after awhile. I'll look at drawings from years ago and I'll know that, at the time, I was tracing a very tenuous thread of creativity, and I know that it would be nearly impossible for me to retrace those steps without thinking about it very hard.

Even though I do it for a living, I draw to relax as well. It's not uncommon to have put in a thirteen hour day on some project and then crack open my sketchbook just to let my mind wander freely. I try to cram as many scrappy little doodles into as much of each page as I can before I move on to the next one. Doodling—that's all I really do. I don't think I've ever filled a sketchbook page with an entire, single, completed drawing.

I take my sketchbook with me when I do any sort of traveling. I usually bring along a thick black pen and

I can't sing. I certainly can't dance. But I can draw the hell out of just about any silly thing you ask me to.

a mechanical pencil to draw with. With those two utensils, I'm ready for just about any emergency drawing situation. Usually, I make do with any sort of black pen. Lately, I've been drifting towards the nice thick ones. Sometimes, I'll keep a drafting pencil on hand to do some subtle shading, but that's about as sophisticated as I get.

I will use any sketchbook I can find around if I have the urge to draw. My current favorite sketchbook is my Super Deluxe Sketchbook that says "Super Deluxe Sketchbook" in nice, big, silver-foil letters on the cover. The paper has a nice tooth and thickness.

The most important thing about sketchbooks being in book form is that it keeps everything together. I have piles of scraps of papers with little drawings covering them, but they're always shoved into drawers where they get all crumpled up and then eventually thrown

away. The drawings in sketchbooks at least have a fighting chance against my disorganization.

I've never had a problem with anyone looking through my sketchbooks. There's nothing to hide, and they are fairly entertaining. I do get a kick on the occasion that someone is flipping through one and starts giggling. However, I've never gone out of my way to share them with people.

I love looking at other people's sketchbooks. Mostly because I am fascinated with how different they all are. It's easy to assume that they'd all look like mine, but I am in awe of people who can spend hours on a single sketch, rendering it beautifully and then adding splashes of color.

I keep all of my finished sketchbooks on a shelf in my studio. It's nice to have them all huddled together. My sketchbooks haven't changed noticeably in the past fifteen years. I've gotten a little better at drawing people with arms growing out of their foreheads, but really that's about it. Maybe the drawings have gotten denser, but they're just as idiotic as ever. It's weird to look back through old sketchbooks because so often it seems like they are drawings I've just laid down even though they might have been created years ago. It's like I can see the ghosts of my fingers tracing the curves and circling out eyeballs of all these strange faces staring back at me.

'You complete me'

When I visit schools and libraries to talk to kids about what a career in art is like, I do performance drawing. It's madcap and off-the-cuff, but kids and adults alike seem to love watching a few lines and squiggles take shape. I try to make art entertaining in hopes that one of these kids will go home and instead of turning on the television or plugging in a video game, they pick up a pen and just go where their mind takes them.

The one actual thing I try to teach the kids is the importance of keeping sketchbooks to practice drawing in. I tell them about the professor I had who said that everyone has a million bad drawings in them and the sooner they get them out on paper the sooner they'll get to the good stuff. One of the best things that I've experienced in these school visits was when this one kid came up to me after my presentation with a sketchbook filled with all of his wonderful little drawings. He couldn't have been more proud to let me leaf through and ask him all sorts of questions about the creatures and creations he had drawn. As it turns out, he had been at a presentation I had done almost a year prior and that day had gone out with his mom to buy a sketchbook. Who knows what that kid will end up doing, but knowing that he might have a tattered sketchbook at his side as he grows up makes me pretty happy.

TOM KANE

Tom grew up on Long Island, studied art at SUNY in Buffalo, New York, and has spent the last thirty years in Manhattan working as an advertising art director. His work can be seen at www.tommykane.com.

When I went to art school, I dreamed of being an illustrator. Every drawing I did was done on a piece of bristol board and rendered with a Rapidograph. No color, only black and white. When I got to New York, I set up a fancy drawing table in my apartment. It would swivel up and down, had the beautiful clip-on lamp with the swing arm, the expensive chair on wheels. I built shelves right next to it to have all my equipment within reach. I drew every spare moment after work.

At some point, I came to the realization that I wasn't going to become an illustrator. The illustrators I admired were geniuses, and I was just pretty darn good. It didn't stop me from drawing. I just did it for my own pleasure.

One day, when I was about thirty-five, a little thought came into my head: I've never tried to do a painting, I think I'll try to do one just to see if I can. I didn't know the first thing about painting. I went to an art store and bought a small premade canvas, some acrylic paints and a few brushes. I struggled through my first painting, and I do mean struggled. I hated the result and the whole process. I was done with painting. The painting I did wasn't too terrible, but it wasn't up to the level I thought it would be.

About a week later I thought, maybe the canvas was too small. If I worked bigger I could add more detail. I gave it another shot. To my surprise, I actually liked my second painting. I figured, let me try another. I started stretching my own canvases, bought tons of brushes and a little easel. Somehow, I got hooked. I painted a lot of images from my childhood, superheroes, pop icons and cartoons. I framed the finished canvases myself with oak. Slowly, I dismantled the shelves and gave away the drawing table and chair. I only painted. It was not

about any ambition to be in galleries or anything like that. They were fun to hang on my wall as decorations. I could make my own paintings instead of buying someone else's. Many years passed and all I did was paint. I would probably never draw again and didn't really care if I did or not.

Then something happened that changed my life. I found the Everyday Matters blog on the Internet. I saw all these drawings you were doing. They were full of writing. I'd never really seen anything like it before. Drawing in a little sketchbook that you carried around. It took me quite a few times of going to the site and rummaging around until it started to make sense. I went out and bought the book *Everyday Matters*. I scoured the pages. Then it hit me like a lightning bolt. I COULD DO THIS.

How come I never thought of this before? It made so much sense. Was I an idiot not to figure this out? I felt like a person who, for years, kept running as hard as I

could into a brick wall with my head. As I lay there all bloody and beaten, someone just walks up and turns a doorknob next to the brick wall and easily walks out of the room. Duh. Why didn't I think of that?

So I bought my first Moleskine book. The second the pen hit the paper I knew what you were talking about. I couldn't stop. The thing went with me everywhere. But it was not just the drawing, it was also the writing. It was better than crack. I seemed to have found my calling. I still painted, but over time, less and less. My shelves are now filled with empty drawing books. I have tons of Prismacolor colored pencils, all sharpened, tiny watercolor tins and waterbrushes, and two folding stools to

use on the streets. I have basically stopped painting, and journaling is to blame. All I can say is, thank you.

I love the freedom I have now. Before, I needed the stupid drawing table and bristol boards and ink and special pens and tracing paper and blah, blah, blah. Now I can whip a little book out of my pocket and draw anywhere. There is a great feeling of drawing life as it happens. The smells, the rain, the heat, the people, the sun. It's great to draw not being cooped up.

When I hit the streets to draw, sometimes I have an idea in mind, but more often than not, I don't. I do know something when I see it though. I am always on the hunt, especially in my neighborhood, because I have drawn every square inch of it. Although I have lots of rules and self-regulations about drawing, I have no rules about what to draw really. That I give very little thought to. The first thing that interests me slightly, I sit and start drawing. The same can be said for the

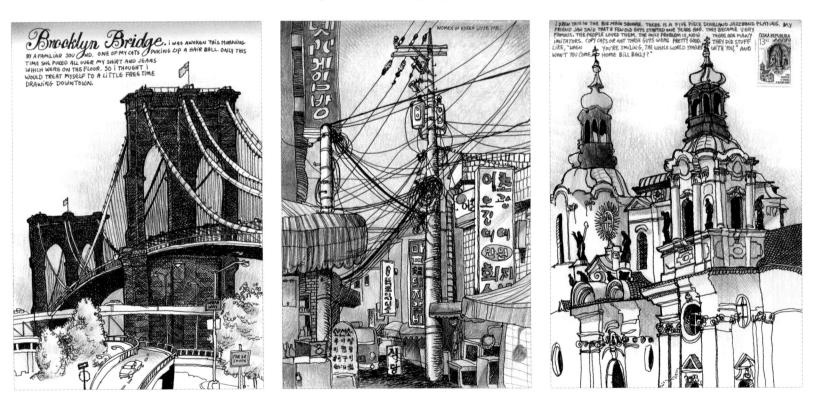

HONG KONG

TRY THEM ON YOUR DENTIST

FAKE

i PLAN TO EXPAND MY COLLECTION

WHENEVER i WEAR THESE THINGS, YUN GOES CRAZY. SHE HATES THEM FOR SOME UNKNOWN REASON. BUT i CAN'T STOP MYSELF. YOU GOT YOUR BUCK TEETH, ONE TOOTH MISSING, YOUR BASIC SWISS CHEESE AND OF COURSE, THE OLD CANDY CORN.

1.

2.

3.

4.

BE SURE TO CHECK YOURSELF OUT IN THE MIRROR

Ⓑ

TOP VIEW

JUST INSERT OVER TOP TEETH AND THEN WAIT FOR THE LAUGHS

EVERYBODY NEEDS A HOBBY

Ⓐ

TEETH

i LOVE TO WEAR THIS CHEAP FAKE TEETH. i BUY THEM IN A GUM BALL MACHINE FOR FIFTY CENTS A PIECE. THEY HAVE THEM IN TRUCK STOPS ALONG THE NEW JERSEY TURNPIKE. MY FAVORITE TRUCK STOP IS NAMED AFTER CLARA BARTON.

TODAY IS YUN LEE'S LIFELONG DREAM, TO GO ON THE SOUND OF MUSIC TOUR IN SALZBURG, AUSTRIA. THAT'S WHERE THE MOVIE WAS FILMED. SHE KNOWS ALL OF THE WORDS.

writing I do in my books. I don't think about it at all. When I finish my drawing, I just write the first thing that pops into my head. I don't dwell on it or sit there looking at the sky—"What should I write about?" I take about thirty seconds to literally blast out whatever is on the tip of my brain. I try to draw as fast as possible, and I include the writing as part of my drawing, so I need to do that as fast as humanly possible, too. Each of my sketches takes from fifty minutes to an hour and a half. So my actual physical journaling is something I do very fast with very little thought process.

When I was a little kid, I loved the Yankees. I used to keep scrapbooks about them. I would clip out drawings and stories of Mickey Mantle and Joe Pepitone. They were very organized, and I loved these books. They were my treasures. I would go through them over and over. Somewhere in my brain is still that anal-retentive little kid who is obsessed with making perfect scrapbooks.

After I finished all the drawings in my first Moleskine book, I knew I wanted to have different ones for different reasons. I kept one in my office at work. I would log on to a news web site each day and draw some news event from the day. I was practicing my caricatures, but I was also practicing my writing skills, honing my wacky opinions. The book took on its own personality. I felt someone could pick this up in a bookstore and

want to buy it. It was not just a book of random drawings. It was its own succinct piece of art.

I bought a beautiful bound book in Venice, which I began to fill with portraits of all my friends and family. Again, it became its own work of art. I have specific books for drawings only of my travels. I have books I only do watercolors in. I have one book just of drawings of my friend's farm. Keeping in mind my preoccupation with themed books, I also fill every inch of the page of the book perfectly. I never start something and then say, "I don't like the way this is going, I'll try the next page." If I start a drawing in a book, I finish it and make it as great as I can. I think of the book as a whole work of art and not as individual pages. Each page is not so much its own unique drawing. They are little parts of the entire piece of art.

When a writer writes a novel, he or she doesn't try their best for a few chapters and then experiment for a couple. If they make mistakes or ramble on a few pages of gibberish to get the old blood flowing, they don't just leave that in their final draft. For some reason, I treat my sketchbooks the same way. It is as if I am writing a novel from beginning to end in a pre-bound book where there is no margin for error. This helps me raise my game. It is a kind of self-imposed pressure to always try my best. Always give 100 percent. Every page matters. Of course there is room for screw-ups, mistakes and blunders. I do them constantly when I draw. My rules help me to compete against myself to always do better. To care.

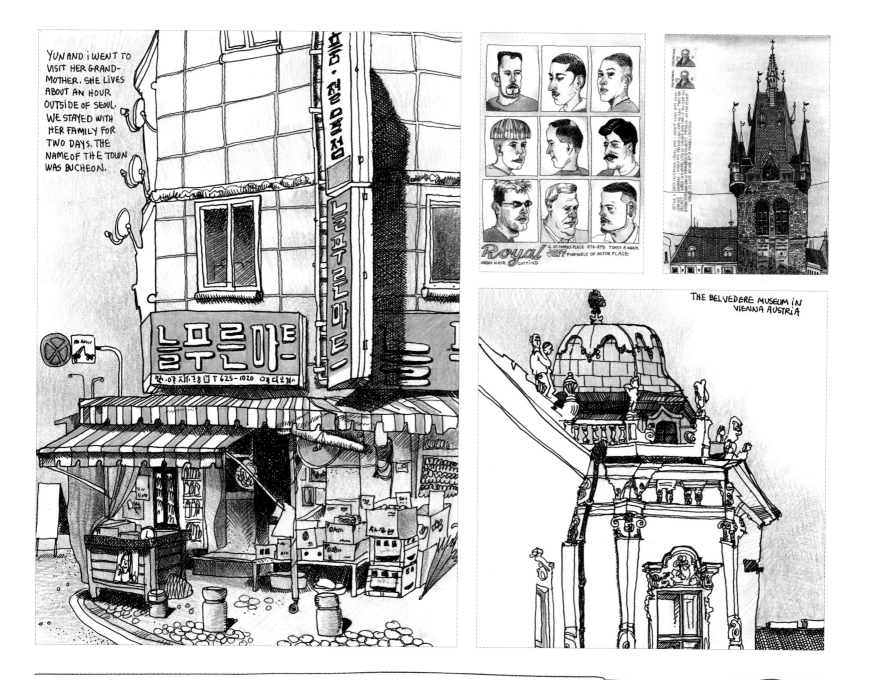

YUN AND I WENT TO VISIT HER GRAND-MOTHER. SHE LIVES ABOUT AN HOUR OUTSIDE OF SEOUL. WE STAYED WITH HER FAMILY FOR TWO DAYS. THE NAME OF THE TOWN WAS BUCHEON.

16 ST. MARKS PLACE 473-8791 7 DAYS A WEEK
Royal
UNISEX HAIR CUTTING
JEFF FORMERLY OF ASTOR PLACE

THE BELVEDERE MUSEUM IN VIENNA AUSTRIA

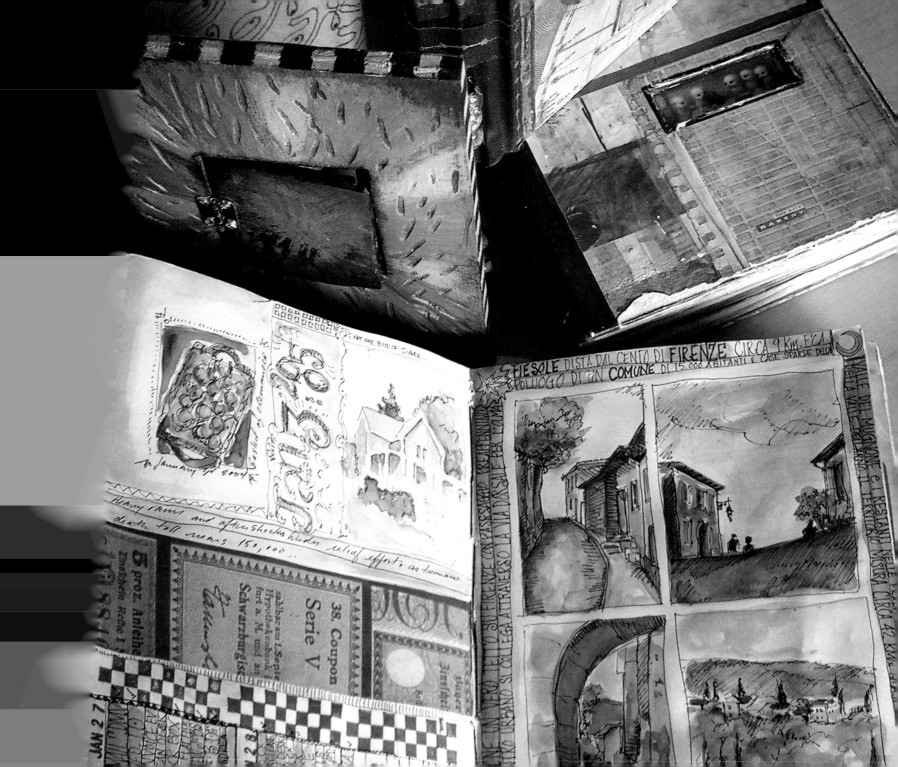

AMANDA KAVANAGH

Amanda grew up in Dobbs Ferry, New York. She majored in illustration at Syracuse University and now lives in Brooklyn, New York, where she operates her firm, ARK Design. To see more of Amanda's work, visit www.amandakavanagh.com.

I'm relatively new to journaling. I only became serious about it four years ago. Two things happened to get me going. First, I was reading your first book (*Everyday Matters*) at the time and was very inspired to start keeping a journal of my own life.

Second, my mother passed away. She was a brilliant letter writer and had lived all over Europe before and after she was married. I inherited dozens of boxes of her letters and took on the massive task of sorting and filing them in binders. I realized I had this incredible record of her life, things I had never known about her, about her travels and her experience of historic events. It dawned on me that I never wrote letters anymore or kept a journal of my own. I could barely fill one binder of my own memorabilia. It really inspired me to start a journal, a record of my days, something that I could pass onto my own daughter one day. And since I'm not a writer, it seemed natural that this record should be an illustrated one instead.

I have always drawn. Making art was strongly encouraged in our family. My father was an artist and an art director and would always come home from work and dump handfuls of magic markers and pads of storyboard paper on the living room floor. It was the greatest feeling to dive into that pile. Drawing has been one of the greatest joys of my childhood and adulthood. To this day, I still get a rush just walking into an art supply store. I don't think I can express who I really am in any other way.

Keeping an actual book to house all my sketches has been very important to my development and habit of drawing. I realized after I started keeping my first hardcover book just for sketching how much more productive I became. Something about seeing the pages filling up really keeps me motivated. I had often brought art supplies along on vacations, but I never got serious about making personal art until I kept a journal. Regular drawing also helps me to be more

observant of the world around me, to try new techniques, new drawing tools.

I admire people who can make time every day for their journals. I'm just not that disciplined. I don't have any rules about when to draw. It just happens when the mood strikes me. Life gets chaotic sometimes (more so than ever since my daughter was born this summer), and I do have to stop journaling from time to time. But I have many online friends who also keep sketchbooks, and they help to keep the pressure on me.

I try to do everything in the book—doodle, grocery lists, job notes, appointments, finished paintings. It all helps to make the book more interesting and more of a diary.

I try not to get too precious, but some days the designer in me takes over. But I think there is room for every kind of approach. That's what the book is all about: experimentation.

I think my only rule is that if I don't like a particular page, I'll keep working on it until I do—even if that means painting or collaging over the whole thing and starting over. Often, my favorite pages are the ones that are overworked and chaotic.

My journals cover my professional as well as my personal life. I often use them to sketch out design ideas and keep client notes. On the flip side, I think that my years as a graphic designer have influenced the way I approach my journal pages. I pay a fair amount of attention to factors like color, composition, use of text

as a design element, etc. Sometimes, that training can be a benefit, and sometimes, it hinders my spontaneity.

I'm more serious about my journaling when I travel. I'm so inspired by being in a new place, it's hard not to draw. It also helps me to see and understand the place

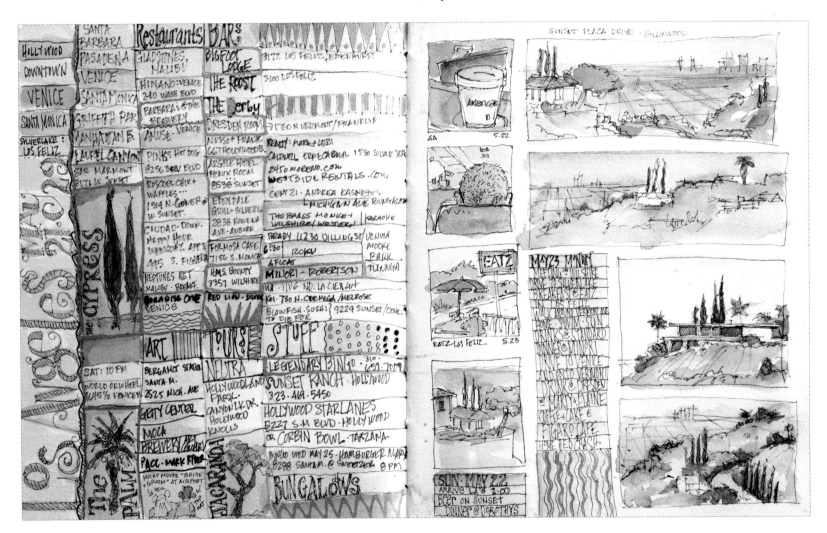

I think my only rule is that if I don't like a particular page,
I'll keep working on it until I do—even if that means painting
or collaging over the whole thing and starting over.

I'm visiting. I pay much more attention to my surroundings: the people, smells and sounds. It enriches the whole experience for me.

I love being able to look back on trips and events with so much detail that I know I would have forgotten otherwise—like the chipmunk that terrorized my dog one summer. And the nonsensical stories my little niece dictated to me. I really regret that I never started this earlier in my life. I also love to see the changes in the way I approach my art now. I am much looser and experiment more. My journals give me a pressure-free place to play around.

My family and friends are very supportive of the time and attention I put into my journals. But sometimes, I do withdraw into my book when I maybe should be interacting more with the people I'm traveling with. It's best if I go off by myself to draw. I don't feel as much pressure.

At first, I hesitate to share my journals with others. It's a bit of a violation of my privacy, and it makes me slightly uncomfortable. However, I also love to share my work and get feedback. I don't keep anything deeply personal in my journals (not that you could decipher anyway) because I know eventually someone will see them. I love looking at other peoples' books. And I love watching other people sketch: how they hold their tools, how they view their subject, the lines they make, the way they mix colors. I learn a lot watching others draw and get inspired to try different approaches in my own journal.

I have a journal in my bag at all times, along with pens, pencils, a waterbrush and a small watercolor set.

I change sketchbooks all the time. I also love bookbinding and, for a long time, I was making my own books using different papers. I don't have quite as much time these days, so I've been buying books,

mainly Moleskines. I order them online or run into Pearl Paint whenever I can.

I'm an art supply junkie. I think I have every brand of watercolors, pens and pencils. But I mainly use my tiny

My journals give me a pressure-free place to play around.

Windsor & Newton Bijou Box when I go out for short trips. I'll take a larger palette with me if I'm traveling to a special place. I generally use Niji waterbrushes instead of regular watercolor brushes. And I love my bleedy Rotring Art Pen and, for finer line work, Rapidographs.

I keep all my journals together on my bookshelf. They are very precious to me. If there was a fire in the house, I'd have to grab them (along with my family and my pets) before I jump.

A lot of people tell me they want to keep a journal but they can't draw. I don't think visual journals have to be about drawing skills. I tell them it's about recording your days. Just start a journal and keep it handy and convenient. Get into the habit of taking it with you everywhere. And don't think too much about what you want to draw or whether it is technically a good drawing or not.

For inspiration, take a look at the work of Candy Jernigan or pick up a copy of *Drawing From Life: The Journal as Art*. There are no rules. No one has to see this except you. Just have fun and enjoy yourself. You'll be amazed how you look at the world differently and how your book will eventually take on a life of its own.

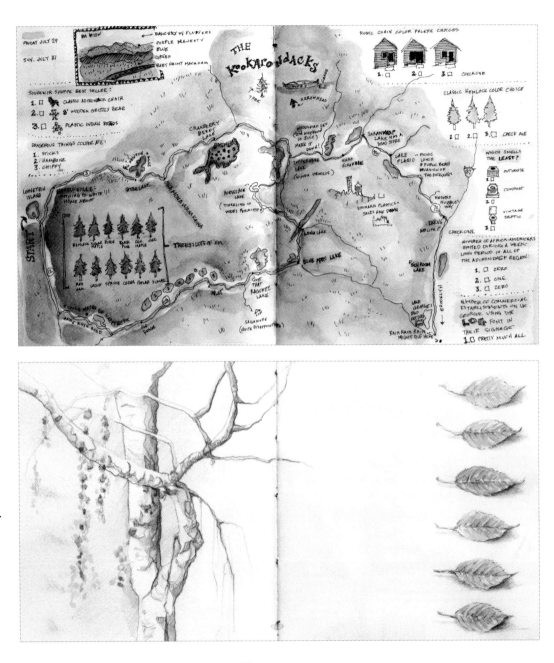

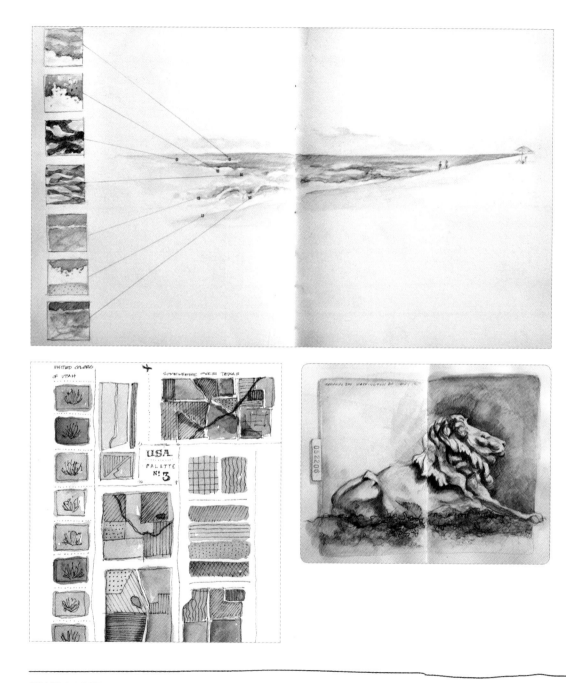

AMANDA KAVANAGH

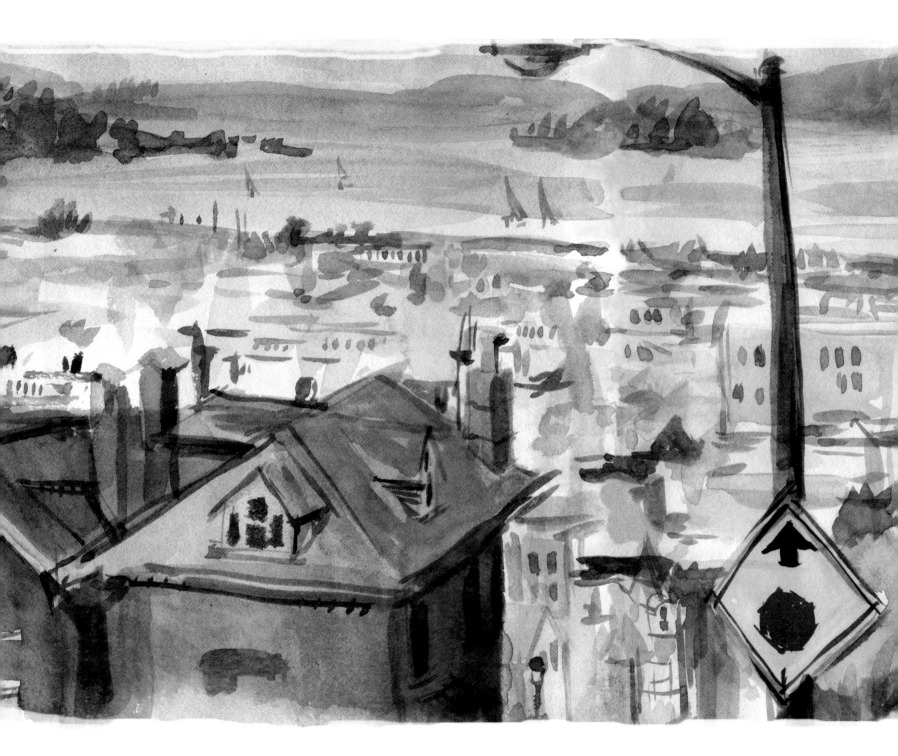

DON KILPATRICK

Don was born in Bountiful, Utah. He studied art and illustration at Utah State University, the Illustration Academy, and most recently at Syracuse University. He is an illustrator and educator and teaches illustration at the College for Creative Studies in Detroit, Michigan. He has just illustrated his first book, *You Can't Go to School Naked*. For more of his work, visit www.drawger.com/donkilpatrick.

My sketchbooks are where I can really allow myself to explore and not feel the pressures of being the sort of artist that someone else wants me to be. I am learning to trust my instincts more and more by constantly drawing. I find that if I haven't been diligent in drawing in my sketchbook, my other work suffers. My sketchbooks help me keep my mind in a place where I don't try and over-control the artistic process.

I have found that when I have stopped using my sketchbook for a time, it is usually when my work is getting repetitive and when my subject matter isn't interesting me as much.

Sometimes great ideas come when I am doodling on napkins at restaurants. I just take those drawings and paste them into my sketchbook. I organize my thought processes this way. I keep all my ideas in my sketchbook so I have record of everything. I will pack two to three of my most recent sketchbooks with me when I travel because I refer to them so much.

I try to take my sketchbook everywhere with me. When I lived in the San Francisco Bay Area, I took my sketchbook every time I rode the train. I'd see the passengers around me like models holding short poses. Sometimes I would have a "model" for five minutes, sometimes for thirty minutes. I love the fact that I never know what "model" I am going to get to draw; there are always all types of people on the train, a real variety.

I am finding that my sketchbooks are influencing my illustration work more and more as I evolve as an artist. It is becoming seamless for me. Most of what I have done in my sketchbooks has found its way into my professional work for clients. I have started to use my sketchbooks for color studies for finished illustrations for clients and for color studies for my personal work.

I use my sketchbook as a way to test new ideas and directions of where my work is going.

I keep all of my drawings in my sketchbooks and try not to have a particular book set aside for figure drawing, another for concept drawings, etc. When I did this, it stifled my thought process, and nowadays, I am not concerned with making a pretty drawing. I am most concerned with the idea or whatever it is I am observing.

Blank pages used to intimidate me a lot, but they don't as much anymore. I find a fresh start more exciting than intimidating. I buy expensive sketchbooks to help me overcome this, to help me not be so concerned with how precious the material is that I am drawing on or too caught up with how good my drawings are.

I hand bind some of the sketchbooks I use, and the others I usually buy at New York Central Art Supply

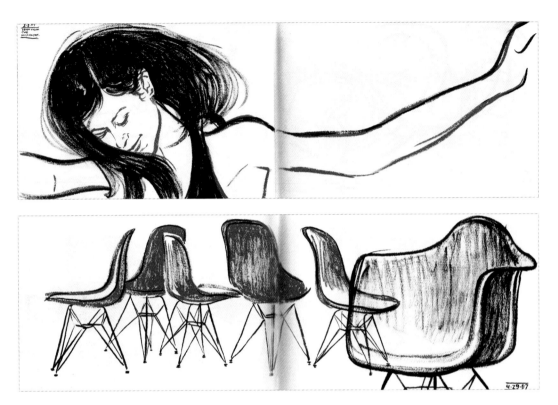

Blank pages used to intimidate me a lot, but they don't as much anymore. I find a fresh start more exciting than intimidating.

in Manhattan. I am picky with the type of paper in the sketchbook. In the books I make, I use 80 lb. Strathmore drawing paper and the books I buy have Arches text laid paper in them. It is so versatile and can take any media thrown at it.

I have been using brush pens with permanent ink in them. I also use fountain pens when I work. I have found that Noodler's ink is the best ink out there in terms of its versatility. Noodler's ink can be used in both brush pens and fountain pens and not clog up.

I also use a Winsor & Newton watercolor sketch box for on-location landscapes, etc.

I tell myself not to "live in your sketchbook" and forget to create art outside of its pages. Don't be concerned with making precious drawings. Do your best to observe what you are drawing and communicate your ideas. We learn so much by putting marks on paper. Drawing connects us to the world we live in.

Don Kilpatrick III

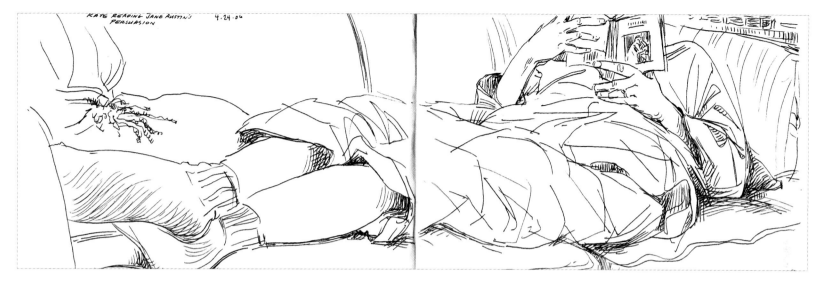

JAMES KOCHALKA

James grew up in Springfield, Vermont, earned an MFA from the Maryland Institute College of Art and now lives in Burlington, Vermont. He has published many books of his comic strips, two volumes of his daily illustrated journals, titled *American Elf* and, most recently, a children's book: *Squirrelly Gray*. His band, James Kochalka Superstar, has released half a dozen records. To read his daily diary strips, go to www.americanelf.com.

Since October 1998, I have kept a daily diary in a comic strip form. I wanted to explore the rhythm of daily life, to become more conscious of what it really means to live.

My sketchbooks were always intended for publication. They were meant to be my "great work," the work that proved to the world my level of ambition and my importance in the field of comics.

What they turned out to be is the thing that keeps me sane! People need some kind of structure in their life. Going to work at some job gives most people the structure they need. For me, all I've really got is drawing this diary comic strip every day.

I draw in my journal every single day. If it wasn't daily, it would lose much of its power. I could do it at any hour of the day, but it's usually in the evening. It's better if I

do it earlier because it's harder to remember the events of the day when I'm tired. Although, occasionally, you get the late night drunkenly incoherent strip, and that's always special.

During the second year of drawing the diary comic, it began to feel too difficult. I felt it was taking too much time away from working on my other books, and, also, I couldn't find a publisher for it. So I quit.

But I didn't get more work done on my other books—I got less. I didn't really do any drawing at all for a couple months. I just played videogames. It turns out that drawing in my diary every day actually makes me more productive. It gives me energy to keep going.

I usually draw from memory, rarely from life. My journal can stay at home while I venture out around town, and I don't need to take it with me unless I'm traveling.

I post the strips online every day. But when I'm traveling, I just wait until I get back home to post them. Eventually I'll probably try to get a laptop and a portable scanner so I can really keep the web site up-to-date wherever I go.

The thought that other people are looking through my sketchbook can be a little embarrassing. Still, I'm used to it. All my friends and some of my family read the strip online every day. It's one of my main ways of reaching out to the world and the people around me.

My sketchbook has way more to do with my internal life than with the places I go. I would say traveling affects my diary very little, but bringing the diary with me definitely affects my traveling. There's no such thing as a vacation for me; I'm always working on this book.

I like to use Winsor & Newton India ink, the kind with the spider on the bottle, not the kind with the dragon

on the bottle. The kind with the spider on the bottle has shellac in it. I used to use a size zero brush, but switched to a size 1. Unfortunately the brand I like (the Maestro Gold HG made by Holbein), has been discontinued. I've tried many, many brushes and can't find one that I like. It's a really big problem, actually.

The online version is in color, but it's drawn in black ink in the sketchbook. I color them in Photoshop for the web and for the print collections. The coloring is a very important part of the process now, but that occurs completely outside the sketchbook itself.

I draw in my journal every single day. If it wasn't daily, it would lose much of its power.

It's very important to me that I record my diary in a book and not just a loose sheet of paper, but I don't know why. People have offered to buy individual strips that they liked, but I refuse to cut any pages out. I've had to turn down a couple exhibition offers for the same reason.

I use the Cachet Classic Black Cover Sketchbook, 11" × 8", landscape. I actually don't think it's very good; the paper is not good quality. But it's what the local art supply store carries, and it's the perfect size and shape for me.

I only draw on the right-hand side of the page—to make scanning easier. The curve of the page near the spine makes anything drawn close to it difficult to scan, so I stay far away from that part.

I don't like blank pages in my book, but this year more have crept in, and I've also aborted certain strips half-

I can't believe how much work I've put into this, and I wonder if I can possibly continue for the rest of my life. But how could I quit?

way through and then started over with some different idea. If you looked through my sketchbook from this year you'd find a few incomplete strips that will never see the light of day.

I've filled about twenty-nine and a half sketchbooks and they fill an entire shelf. I can't fit anymore, so I guess I have to start on another shelf.

I can't believe how much work I've put into this, and I wonder if I can possibly continue for the rest of my life. But how could I quit? Since I put them online, and I've got paying subscribers, there's also a strong financial incentive to keep going. I don't make a lot of money off the diaries, but every little bit helps—I couldn't afford not to draw them at this point. I couldn't afford the loss of that subscriber income, as meager as it is.

If you're wondering if you should keep your own illustrated journal, I say "Do it!" A lot of people have begun doing daily diary comic strips, inspired by my own, and most have found it an amazing experience. I know of dozens, and I'm sure there are more that I don't know.

JAMES KOCHALKA

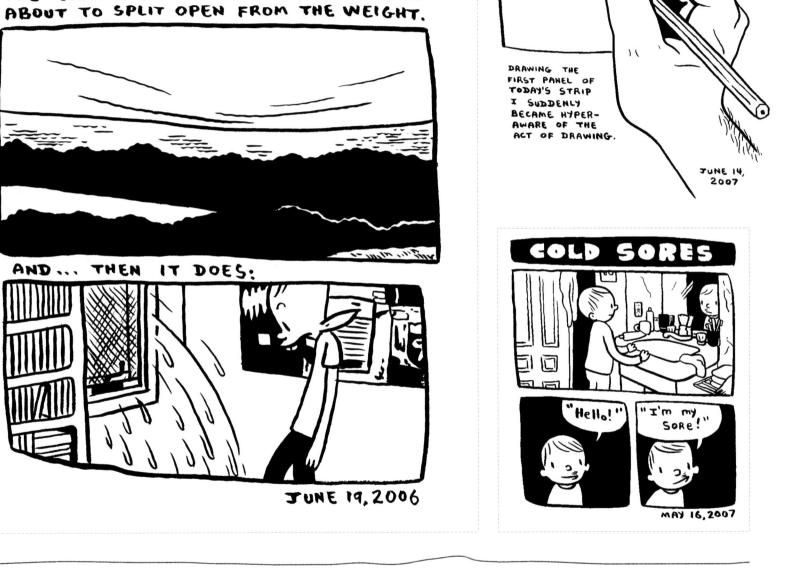

PAPER TOWEL

THE SKY HUNG LOW LIKE A WET PAPER TOWEL ABOUT TO SPLIT OPEN FROM THE WEIGHT.

AND... THEN IT DOES:

JUNE 19, 2006

DRAWING THE FIRST PANEL OF TODAY'S STRIP I SUDDENLY BECAME HYPER-AWARE OF THE ACT OF DRAWING.

JUNE 14, 2007

COLD SORES

"Hello!"

"I'm my SORE!"

MAY 16, 2007

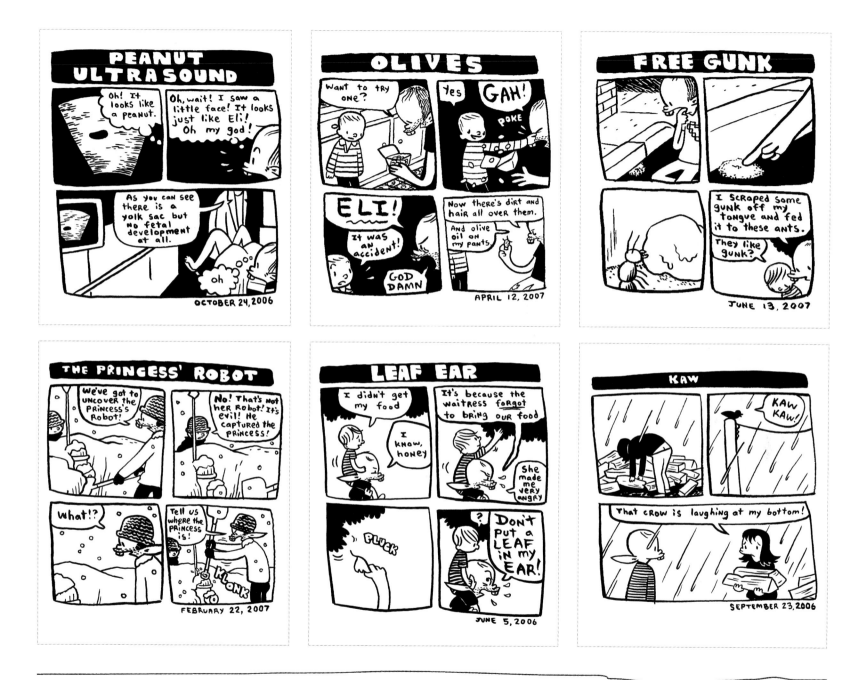

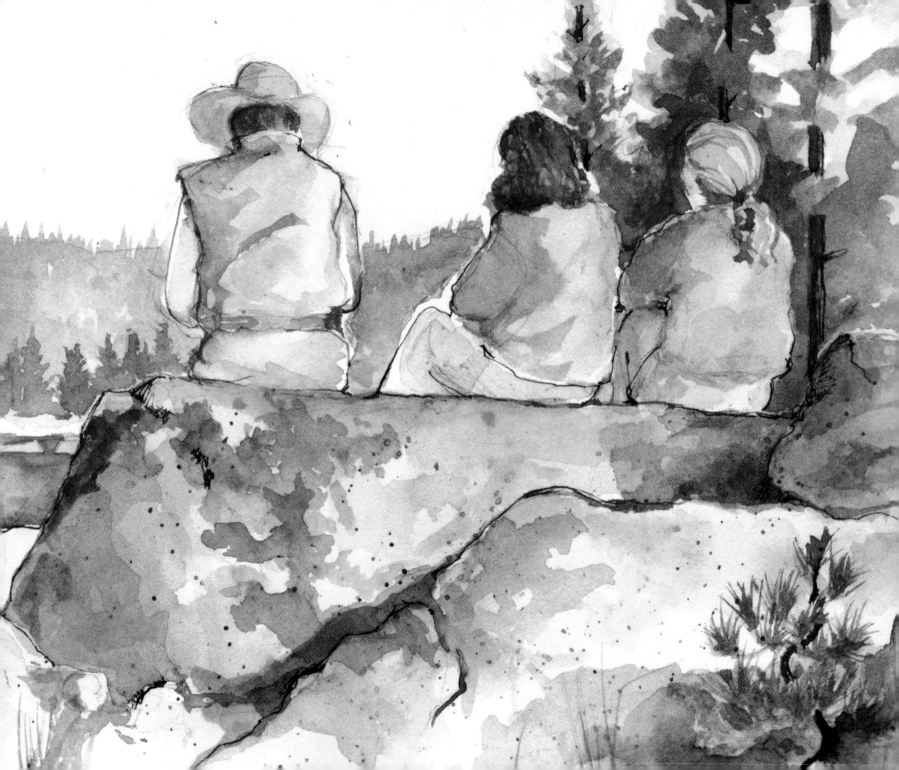

GAY KRAEGER

Gay grew up in the Santa Cruz Mountains of California. She earned a degree in graphic design and now has her own business as a designer and illustrator. She also teaches illustrated journaling with Christina Lopp. For more of her work, go to www.watercolorjournaling.com and www.wildwaysillustrated.com.

I love sharing my journals. It happens all the time. People say, "I wish I could do that," and I say, "If I can, you can." I find that many people just have to see me journaling and they become inspired to start keeping journals themselves. I always encourage people to look through my book if they are interested.

Teaching has become one of the most important results of my journaling. I love seeing how our students drawing skills improve as they keep practicing and how passionate some of them become. I also really like being able to see how differently the students see the same things, to see other people's lives through their eyes.

The hardest thing Christina and I teach is to get over the fear of drawing and the fear of making a mistake. I don't think there are any journal mistakes. It took me a while to get to this point. Even though I have a degree in art, for years I was afraid to draw in a journal for fear of making a mistake.

I stopped drawing after I graduated from college and started working as a production artist (before computers). The work was not very creative. Lots of wax and X-Acto knives. I had to spec type back in the days when that was a whole industry. That meant I had to do math, a very hard thing for me. I also had small children, built a house and had all that other life stuff like divorce and remarriage happen. I kept all the supplies from my college art classes thinking, someday, I would draw and paint again. The kids grew up, the house got finished (well, sort of) and then

Christina came back from a trip to Paris with her first journal and it got me over my fear. I loved seeing Paris through Christina's eyes. Even though it wasn't perfect, it represented her trip way more than her photos. I will always be grateful to her for sharing her journal with me and changing my life.

I love the way I see the world differently since I started drawing. I like seeing how everything relates to everything else. I am scared of writing. Even writing e-mails to clients is traumatizing for me. I have to force myself to write, but it is easier in my journal because I keep reminding myself it doesn't have to be perfect. I always misspell something on a page.

The main purpose of my sketchbooks is to make me happy. I find myself looking at something and figuring out how to capture it. Drawing is slower than a camera but more fun. A by-product of all this is that I have a

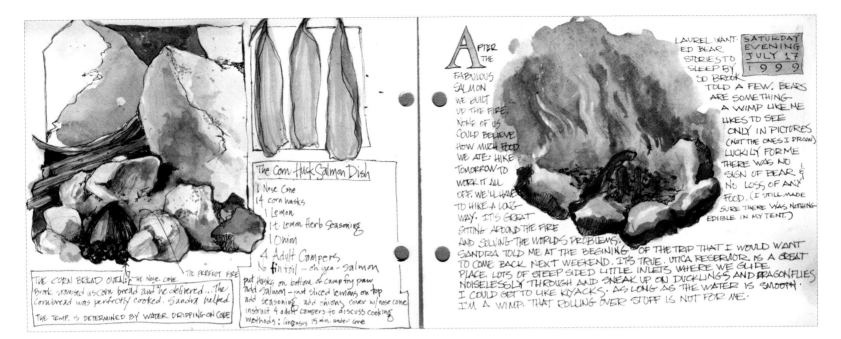

The journal entry within the image reads:

The Corn Husk Salmon Dish

1 Nose Cone
14 corn husks
1 Lemon
1 t. Lemon Herb Seasoning
1 Onion
4 Adult Campers
No tin foil — oh yea — Salmon

put husks on bottom of camp fry pan
add Salmon — put sliced lemons on top
add seasoning, add onions cover w/ nose cone
instruct 4 adult campers to discuss cooking
methods; fingensus 15 min. under cone

THE CORN BREAD OVEN: THE NOSE CONE
Brook promised us corn bread and he delivered... The
Cornbread was perfectly cooked. Sandra helped.
THE TEMP. IS DETERMINED BY WATER DRIPPING ON CONE
THE PERFECT FIRE

AFTER THE FABULOUS SALMON WE BUILT UP THE FIRE. NONE OF US COULD BELIEVE HOW MUCH FOOD WE ATE: HIKE TOMORROW TO WORK IT ALL OFF. WE'LL HAVE TO HIKE A LONG WAY. IT'S GREAT SITTING AROUND THE FIRE AND SOLVING THE WORLDS PROBLEMS. SANDRA TOLD ME AT THE BEGINING OF THE TRIP THAT I WOULD WANT TO COME BACK NEXT WEEKEND. IT'S TRUE. UTICA RESERVOIR IS A GREAT PLACE. LOTS OF STEEP SIDED LITTLE INLETS WHERE WE GLIDE NOISELESSLY THROUGH AND SNEAK UP ON DUCKLINGS AND DRAGONFLIES I COULD GET TO LIKE KAYACKS. AS LONG AS THE WATER IS SMOOTH. I'M A WIMP. THAT ROLLING OVER STUFF IS NOT FOR ME.

LAUREL WANTED BEAR STORIES TO SLEEP BY SO BROOK TOLD A FEW. BEARS ARE SOMETHING A WIMP LIKE ME LIKES TO SEE ONLY IN PICTURES (NOT THE ONES I DRAW) LUCKILY FOR ME THERE WAS NO SIGN OF BEAR & NO LOSS OF ANY FOOD. (I STILL MADE SURE THERE WAS NOTHING EDIBLE IN MY TENT.)

SATURDAY EVENING JULY 17 1999

I love the way I see the world differently since I started drawing. I like seeing how everything relates to everything else.

record of my life. A review of past journals can return me instantly to some place or event from my past.

The only thing that changes when I travel is that I'm away from the pressures of ordinary life and have more time to work in the journal, and I fill more pages. I draw in the car (not while I'm driving) while on road trips. I rarely go somewhere just to draw it unless it is work-related. I just draw where I am. A student told me that drawing uses more than one sense and therefore makes a deeper neurological path in our brain so our memories are stronger. I have found that when I read one of my pages, I am instantly back in that place. Not just the visual memory, but the sounds and smells as well. Pretty cool.

I love books. I like the way they feel. I like that everything is all together in one place and consecutive. Plus it is much harder for me to lose books. I am very good at losing things, so that is important to me. I like the fact that the pages are small. I am intimidated by large sheets of paper. I do like seeing all my journals on the shelf, ready to relive my life whenever I want.

I love my Brenda Books. Brenda makes books to order for me so I get the paper I like. I have her make the books with a mixture of hot press and cold press 140 lb watercolor paper. She can be reached at www.brenda-books.com.

I carry a permanent pen (brands change as I find different ones I like), a mechanical pencil, Niji waterbrush and half pan Yarka watercolors. The Yarka kit is a little heavy but I like the colors. I have stuck in a couple of other paint pots. I use tube watercolors in the studio for work, but sometimes find myself getting my Yarka kit out of my purse for a certain color I want.

I keep my journals on bookshelves in my office/studio. I can't believe how many I have filled up. When I was working on my first one, I thought what a milestone it would be when I filled it. Now I can't wait to pick out a new book and get started.

Gay Kraeger

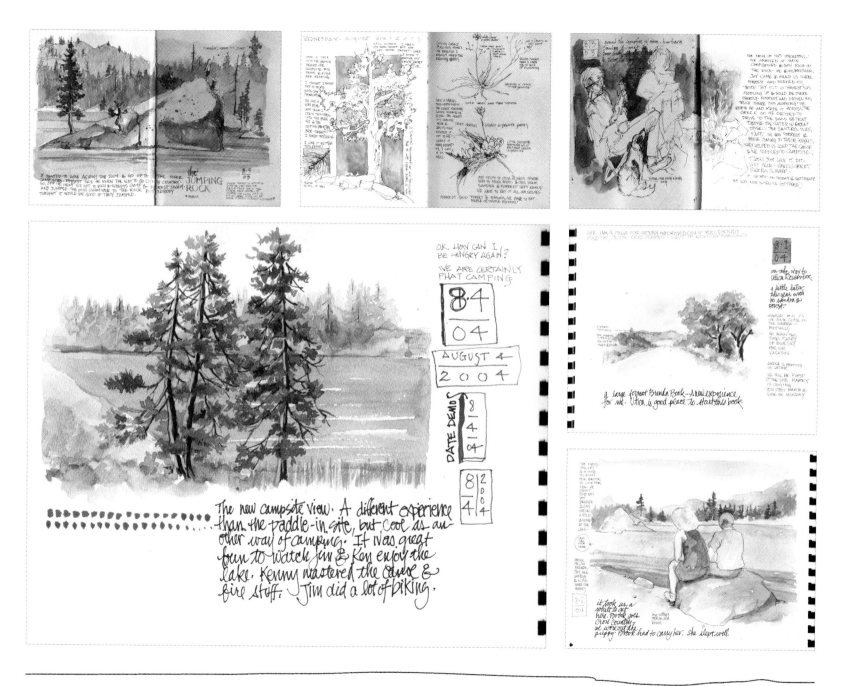

The new campsite view. A different experience than the paddle-in site, but cool as another way of camping. It was great fun to watch Jim & Ken enjoy the lake. Kenny mastered the canoe & fire stuff. Jim did a lot of biking.

OK. HOW CAN I BE HUNGRY AGAIN!?

WE ARE CERTAINLY PHAT CAMPING

AUGUST 4 2004

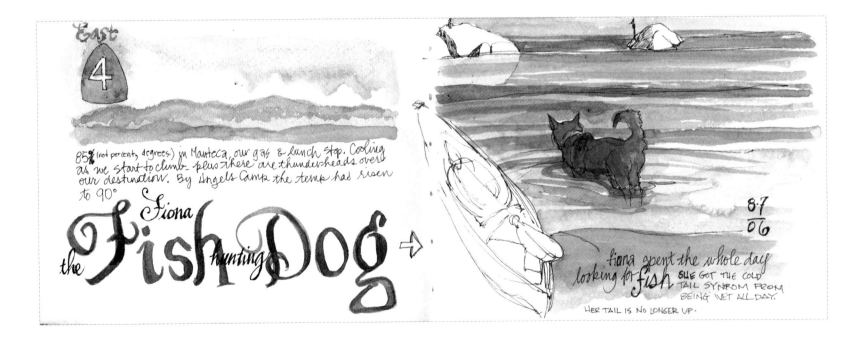

East

4

85% (not percent, degrees:) in Manteca, our gas & lunch stop. Cooling as we start to climb. plus there are thunderheads over our destination. By Angels Camp the temp had risen to 90°

the Fish hunting Dog →
Fiona

8-7
06

Fiona spent the whole day looking for fish SHE GOT THE COLD TAIL SYNROM FROM BEING WET ALL DAY.

HER TAIL IS NO LONGER UP.

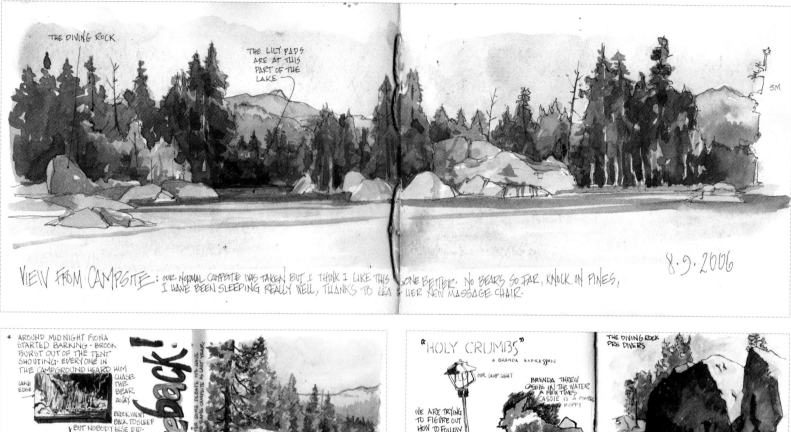

THE DIVING ROCK

THE LILY PADS
ARE AT THIS
PART OF THE
LAKE

3M

8·9·2006

VIEW FROM CAMPSITE: OUR NORMAL CAMPSITE WAS TAKEN! BUT I THINK I LIKE THIS ONE BETTER. NO BEARS SO FAR, KNOCK ON PINES, I HAVE BEEN SLEEPING REALLY WELL, THANKS TO LEA & HER NEW MASSAGE CHAIR.

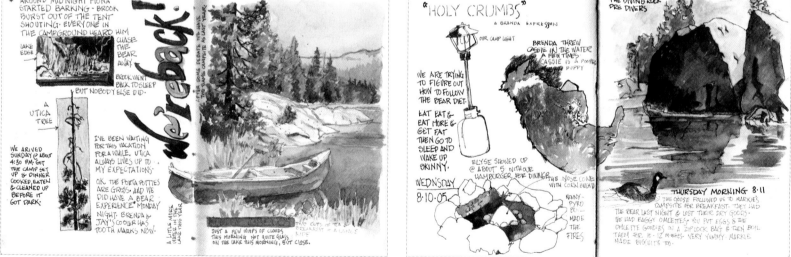

* AROUND MIDNIGHT FIONA STARTED BARKING - BROOK BURST OUT OF THE TENT SHOUTING. EVERYONE IN THE CAMPGROUND HEARD HIM CHASE THE BEAR AWAY.

LAKE EDGE

BROOK WENT BACK TO SLEEP BUT NOBODY ELSE DID.

We're back!

A UTICA TREE

WE ARRIVED SUNDAY @ ABOUT 4:30 PM. GOT THE CAMP SET UP & DINNER COOKED, EATEN & CLEANED UP BEFORE IT GOT DARK.

I'VE BEEN WAITING FOR THIS VACATION FOR A WHILE. UTICA ALWAYS LIVES UP TO MY EXPECTATIONS.

OK, THE PORTA POTTIES ARE GROSS, AND WE DID HAVE A BEAR EXPERIENCE* MONDAY NIGHT. BRENDA & JAY'S COOLER HAS TOOTH MARKS NOW.

A LITTLE MORE WATER IN THE LAKE THIS YEAR.

JUST A FEW WISPS OF CLOUDS THIS MORNING. NOT QUITE GLASS ON THE LAKE THIS MORNING, BUT CLOSE.

TWO CUPS OF TEA & BREAKFAST - A LEMON BAR

"HOLY CRUMBS"
A BRENDA EXPRESSION

OUR CAMP LIGHT

WE ARE TRYING TO FIGURE OUT HOW TO FOLLOW THE BEAR DIET.

EAT EAT & EAT MORE & GET FAT THEN GO TO SLEEP AND WAKE UP SKINNY.

BRENDA THREW CASSIE IN THE WATER A FEW TIMES. CASSIE IS A POOPED PUPPY

ELYSE SHOWED UP @ ABOUT 5 WITH OUR HAMBURGER FOR DINNER.

WEDNESDAY
8·10·05

THE NOSE CONE WITH CORN BREAD

KENNY PYRO - MADE THE FIRES

THE DIVING ROCK PRE DIVERS

THURSDAY MORNING 8·11
THE GOOSE FOLLOWED US TO MARKIE'S CAMPSITE FOR BREAKFAST. THEY HAD THE BEAR LAST NIGHT & LOST THEIR DRY GOODS. THEY HAD BAGGY OMELETTES. YOU PUT EGGS & THE OMELETTE GOODIES IN A ZIPLOCK BAG & THEN BOIL THEM FOR 10-12 MINUTES. VERY YUMMY. MARKIE MADE BISCUITS TOO.

Nov 25. Got these @ the farmer's market yesterday. They look gorgeous in my plate from Patzcuaro's corner market. We've got lovely fall weather this weekend.

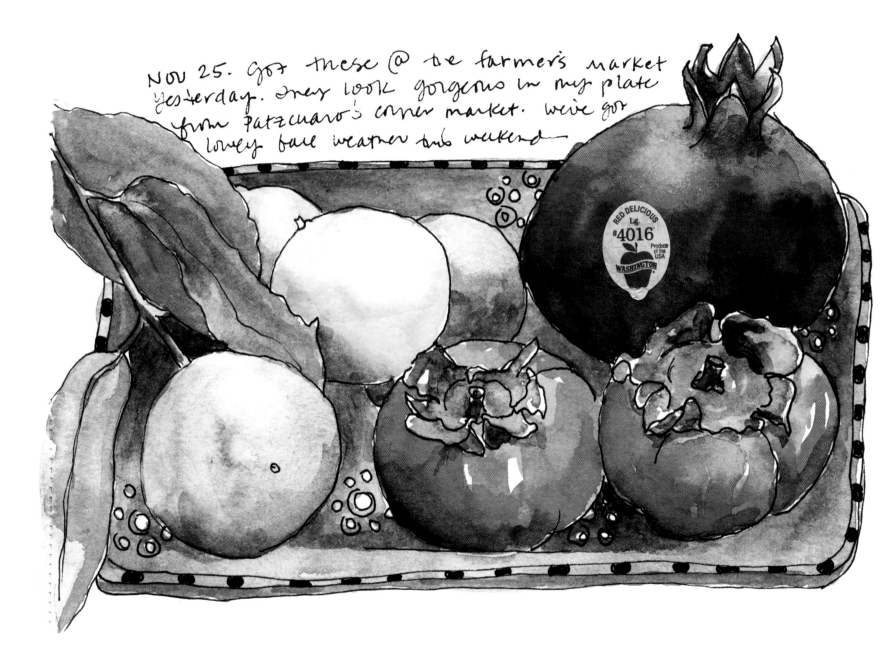

JANE LaFAZIO

Jane grew up in the San Francisco Bay Area, then married and moved to Oregon, South Korea, Los Angeles and now San Diego. She has degrees in graphic design and Asian studies and has taken many classes and workshops. She is an artist and teacher whose work has been published in various magazines and books. She recently received a yearlong grant to create a program to give free art classes to low-income fourth and fifth graders. Visit www.mundolindobeautifulworld.blogspot.com to see the children's art. See Jane's art at www.plainjanestudio.com and www.janeville.blogspot.com to see her work.

Art healed me after the serious injury of my spouse. In 1992, my then forty-six-year-old husband had a brain aneurysm. Brain surgery, hospitalization, rehabilitation and therapy—years of language therapy—followed. He had to learn to talk, read and write all over again. After the first six months of caring for him twenty-four hours a day, I found a three-hour a week drawing class that helped me find "Jane" again.

I started by drawing—frameable stuff that I worked on for hours and hours. Then I started keeping sketchbooks and became more loose and experimental, drawing just to draw!

I enjoy the "right brain-ness" of drawing and how it is a total escape from whatever else is going on. It's just me and the object or scene I'm drawing. It's a breath of fresh air, somehow, to just sit and do one thing and draw. My sketchbook is a playground, a place and time that I reserve for myself, strictly for my pleasure to chronicle the little moments of my life, and to practice my craft of drawing. I'm always surprised that my style is so much my style. I believe how you sketch is how you do it, unique to *you*, just like your handwriting.

I make art every single day, whether it's in my book, for a class lesson I'm going to teach or for exhibit. My sketchbook is just another manifestation of my artistic life. I like hand-sewing too; I think it's a similar activity of just sitting and concentrating on only one thing.

It's very important that my journal is in book form. It makes it a sketch vs. a painting. If I were to draw on a separate sheet of paper, that would mean it's for sale and needs to be framed or whatever. It would be totally different.

I started my first sketchbook in October 2005 and have nearly completed ten Moleskines since then. I'm so proud that I've stuck to it. My books are totally precious to me! The finished ones are all together on a shelf in my studio. On the first page of every Moleskine, there is a printed line for the reward I'd offer if it is lost and returned. I have written things like: "My firstborn," "A million dollar lottery ticket," "A latte and my undying gratitude," and "A ga-zillion thank yous."

I always take my sketchbook on trips. Drawing adds so much to the experience of travel. You really, really see something by drawing it, and you discover so much more about it. And you never forget it—what it looks like and how you felt drawing it and the smells and sounds at the time you were drawing it. I definitely make time just to draw when I travel. Early morning works well, or right before cocktail hour.

I like to share my books with others. That's part of their purpose: sharing my view with others, and of course, posting the sketches online. I don't write anything personal or secret because my sketchbooks are created knowing they will be seen.

It's better to draw with someone who is also drawing; it makes it easier to concentrate on drawing. I'm not self-conscious, and I find it fairly easy to draw around strangers.

I started with a big, spiral-bound [notebook] that was given to me, but it just wasn't right—too big and messy. So I found the Moleskine sketchbook, and now I am totally loyal. All my journals are the same size Moleskine. They're like a surprise package: plain on the outside and wonderful and colorful on the inside.

I have different rules for my different books. I only use watercolor and pen ink in my watercolor Moleskine, and I only draw on one side of the page. I hold out the

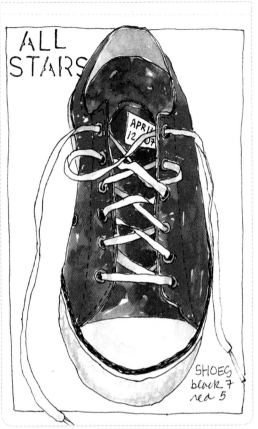

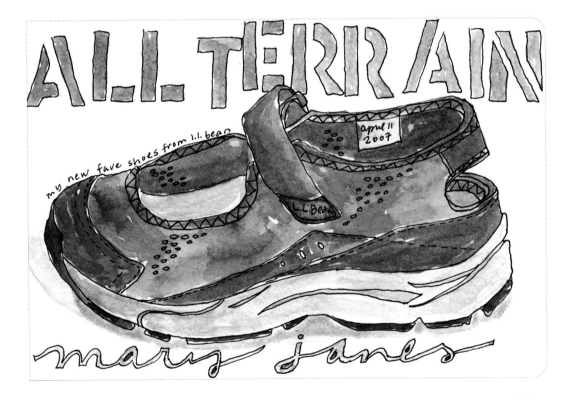

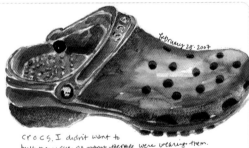

January 3. Same pomegra nate but dryer. Succulent like we gave as gifts.

2007

September 9. Escondido 2nd Saturday painting with Jeannie 5-8 pm

Hollie Heller suggests take an object (say, a pomegranate) to the paint store. Select at least 5-7 paint chips representing the colors in the object. A cut artichoke would be cool. or swiss chard or eggplant.

POMEGRANATE #3127 Product of U.S.A.

Monday Jan 22. my kitchen window.

hope that someday my paintings will be pulled out and framed and sold for zillions of dollars!

Nearly anything goes in my sketchbook Moleskine. I fill both sides of the paper with pen, color pencils, water-soluble crayons, collage, fruit stickers, pressed leaves and notes from the many workshops I take.

My sketch bag is always packed and ready to go. Inside are two different Moleskines, the sketchbook and the watercolor versions, Faber-Castell Pitt Art Pens (black, extra fine), a pencil, a pencil sharpener, a kneadable eraser and a plastic palette filled with my fave watercolors from Windsor & Newton and Daniel Smith.

At home, I also use Caran d'Ache water soluble crayons and Prismacolor colored pencils in my sketchbooks.

I've starting doing occasional one-day workshops called "Illustrating Your Journal With Watercolor" and, really, what I teach is the joy of sitting and seeing and taking the time to draw. I also do a workshop with a yoga-teacher friend called "A Day in the Park: Yoga & Art." I wanted to combine two of my favorite things! You know, when you sit and draw, your shoulders hunch over and you stay in one position for a long time. Yoga is great for getting those kinks out. The class starts with yoga, then sketching, then yoga, then lunch, sketching and finishes off with yoga. Way fun!

I'm a total evangelist about sketchbooks! I try to encourage everyone to keep one! Practice seeing is the number one thing I tell people, then just take the time to do it—to sit and sketch.

Jane LaFazio

december 6

Can you tell we've decorated for Xmas? My girlfriends are coming over for holiday cheer tonight.

Little Buddy rests after chasing BeBop all over the house. Is he dreaming of Santa? Wishing for mices + treats?

wooden snow man from Seattle

this little Santa is 3" tall + hand carved wood. from Sweden. I think.

Oct 20. gathering my artwork for the show @ Boehm. Wish I done more paintings...

This is the drinking glass I use in my bathroom. I love it

I think it was quite expensive. $34. But Pamela has a whole set of 12 from this artist!

Husb was so thrilled when he found this first of fall leaf, that he brought it to me while I was in the shower!

OCTOBER TENTH

Husb and I bought this stone bird in Mexico, in Cancun, about 20 years ago. It's still one of my favorite things.

he four of us spent the day
at HAPUNA Beach, it was a
Sunday and with the tide low
and the beach nearly gone,
there were more people there
than I've ever seen, at least
100 people in the ocean at a time.
We played and talked in the
waves for hours!

for sustenance, dealt ...
Havi to buy some postcards
and check out the lookout at
Pololū - beginning of sunset
and beautiful sunset
at Māhukona.

HAVI

HAWAII

Kona

Māhukona 8
Kawaihae 19

Kapaʻau 2
Pololū 9

HAVI FEELS A LITTLE LIKE HONOKAA

KOHALA
COFFEE
MILL

Downtown Hawi
HAWAII

HAWAII

ANDY'S FAVORITE PLACE
IN HAVI, right next to
As Havi Turns'- this place
makes amazing Vanilla
Tahitian espresso

CHRISTINA LOPP

Christina was born near the Santa Cruz Mountains in California and still lives there. She has had no formal art training and is a designer and teacher. See more of her work at www.watercolorjournaling.com.

I started this kind of illustrated journal on a trip I took to Paris with girlfriends in 1995. I didn't consider myself an artist at all, but I wanted to visually remember the trip since it was my first time in France. I had a small watercolor kit, a watercolor book with spiral binding and a small jar for water. That trip and those pages made me realize that I didn't have be a professional artist who puts her work into a museum to make art for myself! That was the beginning of a great new relationship with myself, the artist. I have been getting to know her ever since. My drawing skills have improved and my understanding of watercolor has improved over time. I learn something new (or find a deeper understanding of something) every month or so—it is amazing to me.

Drawing feels like a really raw, honest way of expressing myself. I am not able to make it look glossy and realistic. It is my way of expressing my view of the world and that makes it really personal and real. It also makes me feel

special and unique since my drawings are a part of the uniqueness of me. I know that sounds corny, but it is true for me. I feel like I don't have to make any excuses for my drawings because, really, they are just for me. It took me years to figure that out, and now that I know it, I never forget it.

I drew a lot when I was in elementary school, but then I had friends in high school who could draw realistically, so I figured that wasn't for me since my stuff was unsophisticated and rough. When I started studying graphic design, I asked in the first class if I had to know how to draw to be a professional designer. Luckily the teacher said, "No, you don't have to know how to draw, but it helps." So I continued to study design knowing I'd be hampered but able to continue. As I learned how to draw on my own, I have found that I really appreciate how it helps me see the world around me and how everything is related to everything else. I appreciate my unsophisticated view of the world when

I draw, and I am glad that my drawings inspire others to start drawing too.

I've always had a fear of the blank page. I felt like I had to draw something really good on the first page of my first sketchbook, and so I'd never really start. Then I just skipped that first page, promising myself that I'd fill it in later when I was better at drawing. (I never did fill that page in!) After the feeling of success from filling that first book, I started buying loads of blank books with the promise to myself that they would be much more valuable to me if I just filled them up with my life. Then I wouldn't worry about wasting the pages. That has worked out well, since now I love filling up pages in my books, and I feel so happy to start a new book.

I think the "bookness" of my journals is one of the most important parts of the whole journaling process. I love that it is a small space to draw—so much less

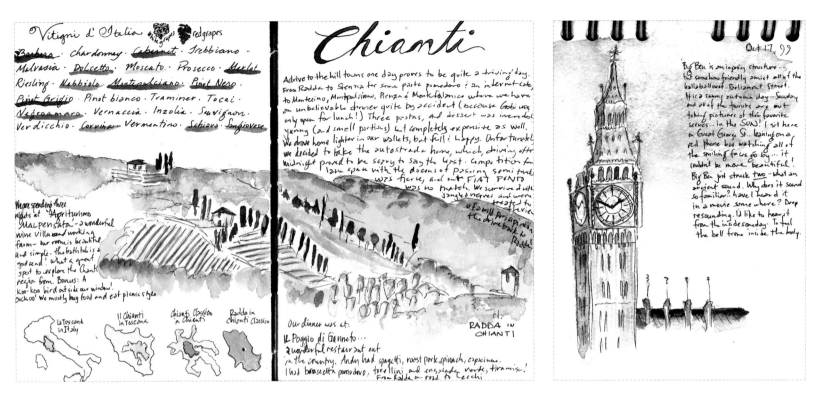

Drawing feels like a really raw, honest way of expressing myself.

intimidating than a whole sheet of watercolor paper. I love that it feels personal and intimate while I am drawing in it. I love that I can open it up and share, and then, too, I can close the book and easily put it away if I don't want to share it.

When I am working on lots of web projects at once, I find that taking visual notes in my journal really helps me figure out what the client wants. They see me drawing the screens for the web and the navigation, etc., and they get a better understanding of what I am there to do for them. I found that it helped get the ideas flowing to work in a visual way instead of just writing. I have

created some visual shorthand for the brainstorming process in web design that has been very helpful for me with clients and projects.

I found when I am showing my journals to people who are interested in the "art" part of my journals, I would skip past these "work" parts with the explanation "this is just my work." I realize now that work is just another aspect of my life, so it deserves to be there in my journal just like the more arty stuff.

I think that journaling is one of the most calming things I do, and my favorite way to do it is to draw

while with a group of friends who are either drawing as well, or just sitting and talking over a meal. I feel like I can be a part of the conversation, but can also capture it (or at least the bread on the table).

It is funny when people look through my journal. Usually, I can't just sit there and watch them look through it; it feels too personal, like my internal workings are made visible to people. I find it is easier to have them look without watching them, otherwise I find I am analyzing what they are thinking while they are looking.

Travel journaling is my favorite. I love the opportunity to feel like I am connecting with a place by drawing things that seem particular to it. I like to start a new

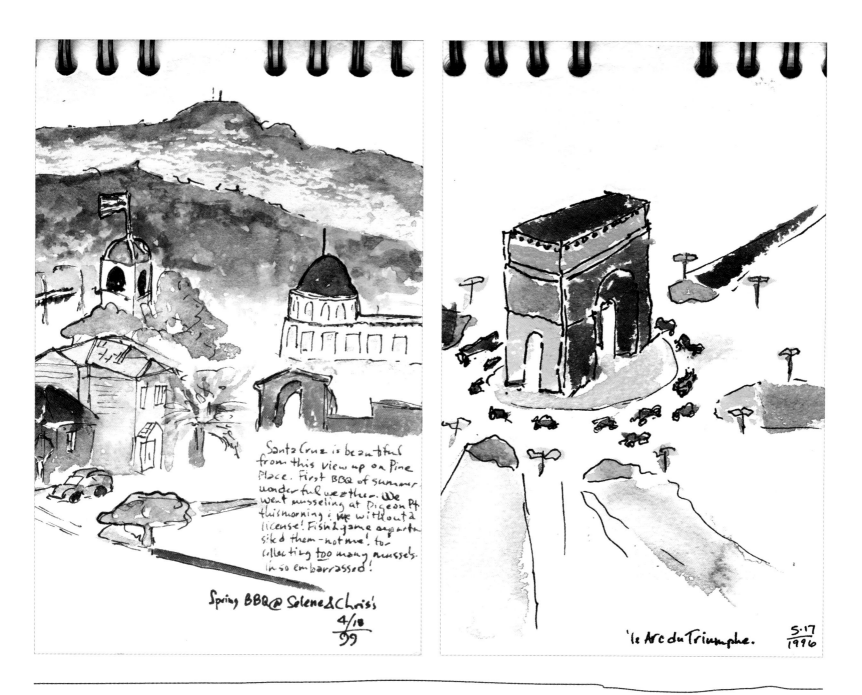

Santa Cruz is beautiful
from this view up on Pine
Place. First BBQ of summer.
wonderful weather. We
went musseling at Pigeon Pt
this morning & me without a
license! Fish & game asked
sked them – not me! for
collecting too many mussels.
I'm so embarrassed!

Spring BBQ @ Solene & Chris's
4/18
99

'le Arc du Triumphe. 5·17
 1996

journal when I am going on a long trip and fill the whole thing up before I get home. I tend to think of things to draw while I am traveling, sometimes making a list of things I'd like to draw while I am there. I like to find places that are beautiful, where I can sit

and be served a drink and a meal. That is the ideal place to draw.

When I draw a place, I find that I remember it oh-so-well. I remember sights, sounds, the temperature

and the smell, even if I didn't put all that into the journal page. Drawing expands my ability to soak up the surroundings. I become a sponge for my senses. I love it.

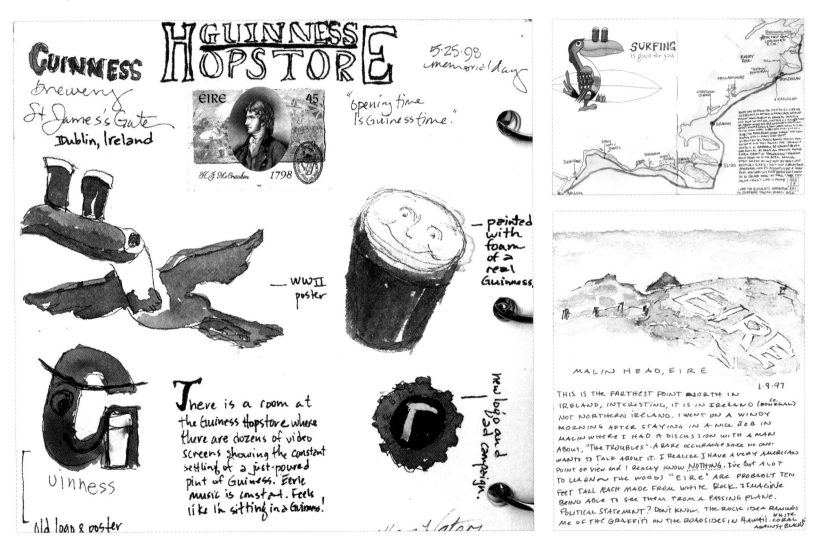

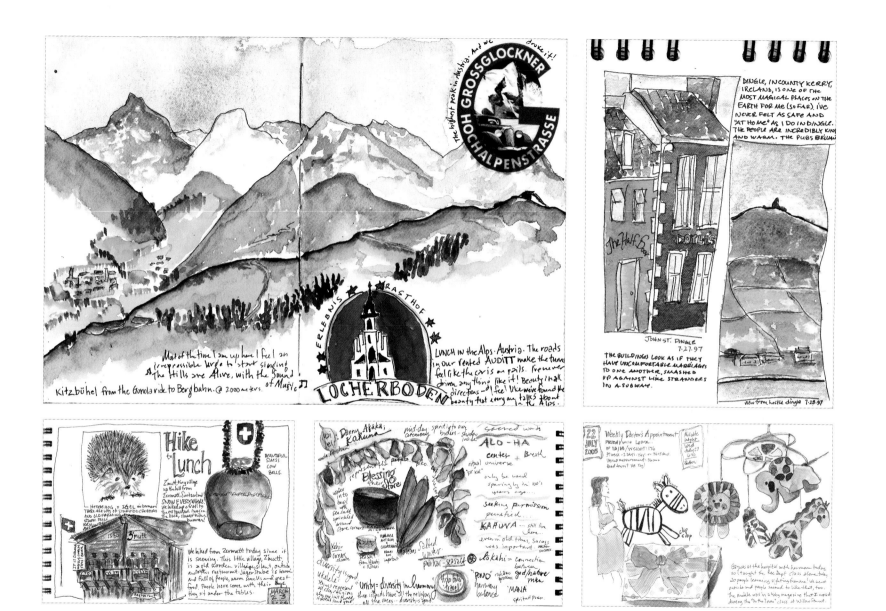

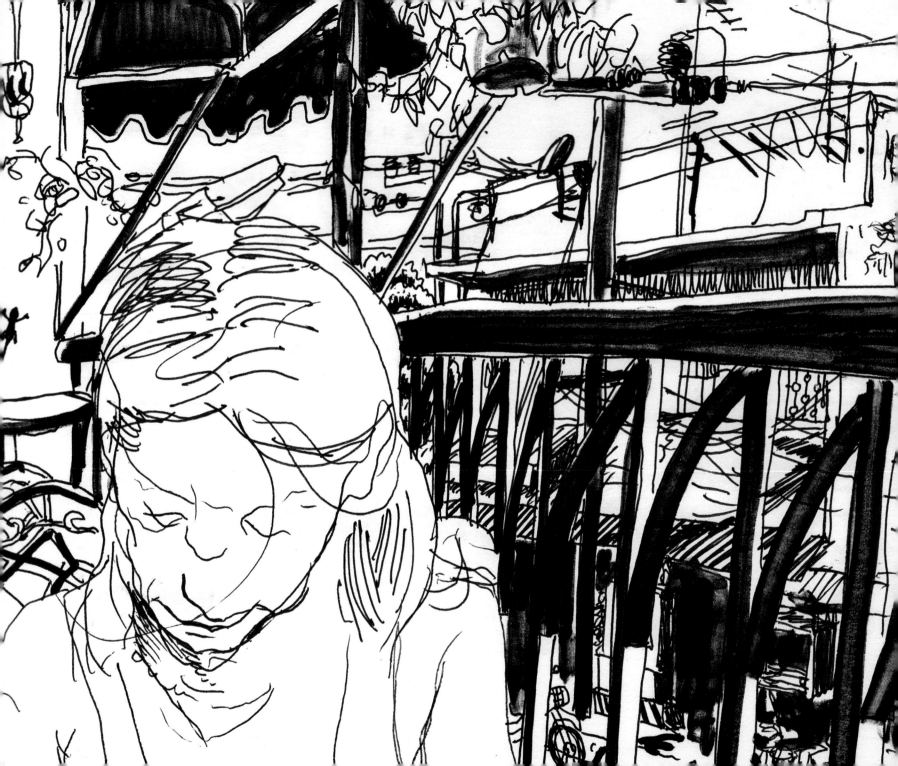

PAUL MADONNA

Paul grew up just outside of Pittsburgh, Pennsylvania. He received a BFA from Carnegie Mellon University, majoring in drawing. He now lives in San Francisco, where he is an artist and writer. He publishes a weekly piece in the *San Francisco Chronicle* called "All Over Coffee," and primarily makes his living from the sale of the original pieces, which he shows two to five times a year in galleries, museums, restaurants and cafés. In 2007, City Lights Books published the first collection of "All Over Coffee." Other work can be found in the *Believer* magazine, *ZYZZYVA, A Writer's San Francisco* by Eric Maisel and projects for 826 Valencia and the California National Parks Conservancy. Paul's work can also be seen online at www.paulmadonna.com.

For the past four years, my primary work has been "All Over Coffee," and the nature of that work is jotting down ideas and quick thoughts rather than drawing in the book. So the books are small notebooks rather than sketchbooks. My drawings these days are all finals. I do very little to no sketching, which I occasionally feel guilty about, because sketching is like stretching. It helps you stay loose. But I'm a firm believer in following my process, and this is how I'm working right now.

My notebook is with me always, always, always. It is an extension of my mind. I believe the brain can only hold so much. I let my mind wander and pay attention to where it goes. This is, in part, how I practice creativity. Once an idea is chosen as an idea, to hold onto it freezes that creative movement. By putting it down on paper, getting it out of my mind, I am free to wander.

These days, my ritual is to jot an idea down no matter the circumstance. As weird as it may appear, I'll stop in the middle of a conversation, movie, dinner to write something down.

My friends have learned to accept that just because I'm writing something down doesn't mean it's about them. And that takes them getting over their insecurity or arrogance. Many people find the discipline I have with note taking as something awesome or annoying. Either

way, it's a respect. Some are jealous because it represents a commitment I have that they may not. Others revel in my beaver-like need to be always working on my dam, so to speak.

I adore books as objects, so I think the fact that my notebook is a book is quite dear to me. The materials—soft or hardbound, size, number of sheets, etc.—of that book changes with the necessity. I date and number all of my books for ease of access, and I love seeing them on my shelves. Books from the past year are always within reach, and all the others are on a high shelf since I don't need to access them very often. They always need to be visible, though. I sometimes

just stare at them. Their presence soothes me and is calming. Some of the tattered books next to those in better condition remind me of how my relationship with my work changes, and I find a great deal of comfort and inspiration from that. I find inspiration in the record of discipline. I am proud when I look back on fifteen years of books because they're a private record of dedication.

I don't think of sketchbooks as sacred, though. They are rough materials. And in that is where I find beauty.

They are the structure and foundation of work. They are interesting and beautiful objects in the way that bloopers and deleted scenes are interesting from your favorite movie. But you have to have seen and loved the movie first.

I had this thing for a while that the first idea I write in a book was always crap. And I came to that because it seemed, when looking back in my books, that was the case. So I started writing in each book: "The first idea is always crap" and then I'd move on. I did that

in several books, and will probably do it again. A joke to myself.

I go through a notebook about every three weeks. They're small, soft cover. When I was younger, there was a real sense of ceremony starting and finishing a book. I think that's because I used larger, hardbound sketchbooks. I would draw on the covers and they very much represented eras. These days, I cruise through them so fast that one is no different from the other, and I like it that way.

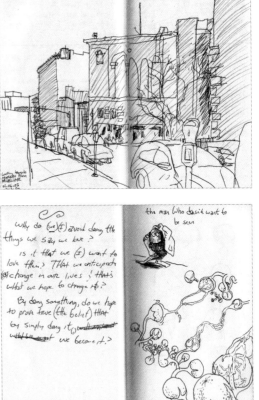

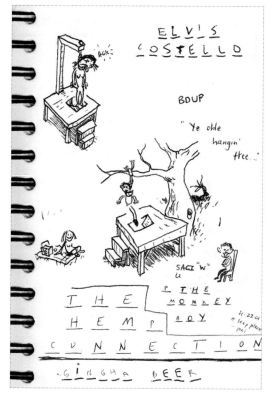

It is the ugly things that teach us, that are the backbone of all the beauty we may one day make.

I use mostly pen in my notebooks. Sketchbooks differ with whatever material I'm into at the moment—ink washes, watercolor, marker, paint, pencil, whatever.

If I need to tear out a sheet, I do. In fact, the little Moleskine soft covers I use have perforated pages. The beauty of these objects are their function.

I do have this thing where I start ideas in the front, but put phone numbers and any reference material, like books I want to read, movies recommended, publishers to submit to, etc., starting from the back. So often I'll meet myself three-fourths of the way through and be done with the book.

I don't like people looking through my sketchbooks or reading my notes. The honesty that I give to my books would be undermined if I thought people would be reading them. I suppose I hold a secret desire that some-day the books will be poured through and appreciated,

PAUL MADONNA

like the deleted scenes of a movie, but those are just daydreams of grandeur, and I don't work in my books with that in mind.

I'm suspicious when others' sketchbooks look like finished works or only the finished works are there. Being one who worked on the road, essentially, for years, I get the idea that the sketchbook becomes the final object. But I often find that those people rip pages out because they don't hold up to the "finished scrutiny," or if they don't remove pages, they tell you not to look at something that they don't like and hurry you past those pages. I feel as if they missed the point of having a scratchpad, are unable to see the beauty in the ugly things that inevitably come out of even the most

incredible of draftsman. It is the ugly things that teach us, that are the backbone of all the beauty we may one day make. And that's why, if I am to hand over a book, I'm aware of showing that ugliness, and the person looking must know the importance of the mistake, the beauty in ugly.

I love looking back through my sketchbooks and seeing how oblivious I was about some things and how that oblivion was laying the foundation for work that I'm doing now. I'm sometimes shocked to see how I was on the verge of fusing two ideas together, and that when I did, this magical transformation occurred and I grew intensely and quickly.

I had a really great art teacher in middle school who required sketchbooks from everyone, but I didn't like keeping them. I liked working on loose sheets because each time I wanted to make something, the size and material changed. Rather than enforce the rule for the sake of enforcement, he allowed me to not keep a sketchbook, but I had less leeway because of it. I made a lot of work, though, so it was okay.

A couple of years later, when I began keeping a sketchbook in high school, I appreciated that he hadn't forced it on me. I loved my sketchbook because I wanted what it offered at the time. I've religiously kept some form of book since, for the past seventeen years.

SKETCHBOOK COVERS

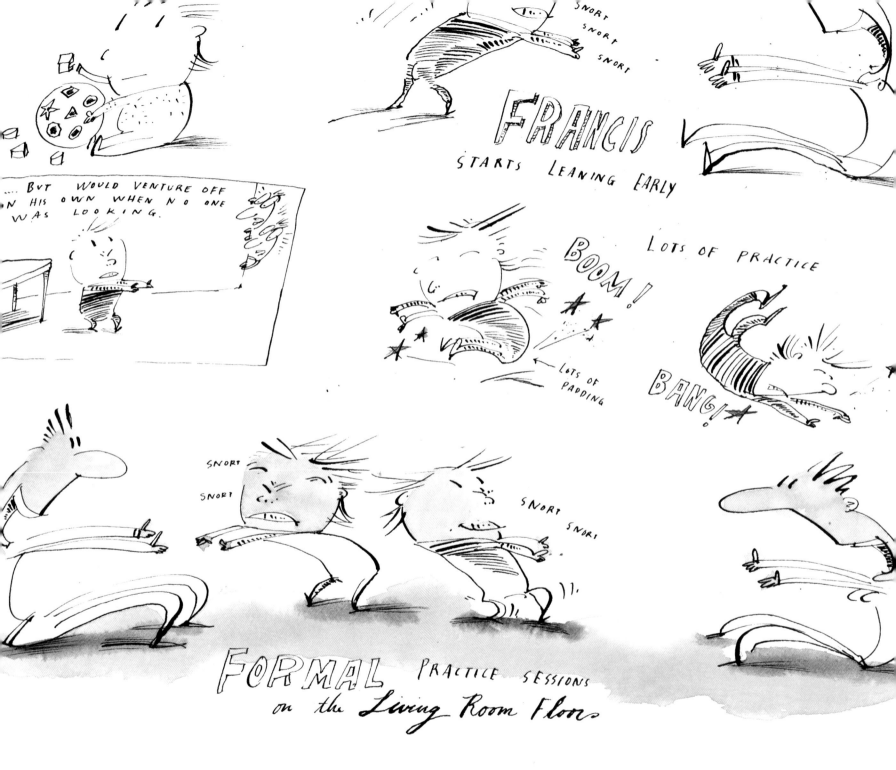

HAL MAYFORTH

Hal grew up in Burlington, Vermont, and Hudson Falls, New York, and majored in art at Skidmore College. He has been a freelance editorial illustrator for the past twenty-five years and works out of a studio over the garage attached to his home in East Montpelier, Vermont. You can see more of his work at www.mayforth.com.

My entire career is predicated on sketchbooks. My style of cartooning evolved gradually over years of expressing myself in my books. I try out stuff, keep some of it and reject a whole lot of it. The important thing is the act of doing it. You never know when lightning will strike. The more you draw, the better the chance that the sublime idea will occur while you are drawing. I think the quality of my work has become better over time, but my approach is virtually unchanged.

Anything goes in my books. I guess the only thing that I do is to only draw on the right-side pages. But I wouldn't say I "doodle" because I consider doodling mindless drawing. I try to be very mindful when I draw in my sketchbooks. I make a concerted effort. Doodling is saved for scrap paper when waiting in the seventh ring of hell for tech support.

My sketchbooks serve a number of purposes. First, they act as a graphic diary of my life and career. Secondly, they serve as a playground to explore new ideas and techniques. Some ideas have gone on to be paintings and promotional pieces for my illustration career. But most have yet to be seen by anyone else. I often think that my books are art in and of themselves, but the problem is exhibiting them.

I have a number of books going. One is primarily my daily studio drawing book that I try to draw in every morning as a prelude to my workday. Ideally, I try to meditate for twenty minutes before drawing for an hour or so every morning. This is what I shoot for, but work and other obligations sometimes infringe on this time. I consider drawing a ritual.

I also have a job book going at all times, to sketch out assignments, and a project book where I work on animation and book projects. I draw my self-generated assignments in my project books. And my books for work are filled with illustration assignment sketches. I prefer my personal books to be more organic. I may go back in and rework a drawing for promotional purposes.

In my travel books, I record the humor and tribulations involved with traveling. I usually include some drawing from life to give a taste of the trip, but most of my drawings are about the personal journey. I would never embark on a trip because the drawing is good. It's more like, " … we're freezing our asses off here. Let's get to the tropics!"

I've never been hung up about blank pages. It all begins with making a mark and ensuing marks. The beauty of this is you never know where it's going to go. I always decorate the opening page of a new book with my name and the date. I'll incorporate design elements that I've

been exploring in the preceding book as a way of tying books together.

My pages are designed in a very spontaneous manner, unconsciously. I am so comfortable with the sketchbook format that there is virtually no barrier between my mind and the page.

My sketchbooks are uninterrupted since I was assigned to keep one for a drawing class my junior year of school in 1974. I may have missed a week or so here or there, but it has been the one constant in my life. I consider sketchbooks a major part of my life.

Prior to keeping sketchbooks, my drawing could be found in the margins of my school notebooks. I was quite possibly the best note taker in class you could imagine for the first ten minutes. Then I would start drawing. I also

play guitar and am pretty serious about that too. I find that if I'm playing music regularly with people and the drawing is happening, I'm a pretty fulfilled person. The music definitely balances the solitary aspect of making art. Music is fleeting, and the time spent drawing is not. Often, however, it's a lot easier to pick up a guitar and play rather than get down to drawing.

I try to be the Johnny Appleseed of sketchbooks. I'll show them to anyone with an interest. I also present my work at elementary schools and high schools whenever I'm asked. Teachers tell me that I've made an impression on a number of students who were creative, but didn't fit the mold. That was me in school.

When I speak with students, I often emphasize that drawing is beneficial on a number of levels. One, it's

terrific for self-confidence, and a lot of times, the ones that gravitate towards art are the "round peg in the square hole" types. You draw well and word gets out that you are good. Secondly, there will always be job opportunities for people that can draw, and even though technology is running rampant, there are and will be a number of fulfilling jobs that can be pursued if one has an ability to express oneself graphically.

My advice: Draw and do it often. To parents, I'd say buy a carton of sketchbooks. Write your kid's name and the date on the first one and give it to him or her. Encourage the child to turn off the computer and TV and draw. Play drawing games while waiting for food in restaurants. When the book is done, take the book away, and put it in a box in the attic. Repeat writing the name and date and give the kid a new book. It's important

I try to be the Johnny Appleseed of sketchbooks.
I'll show them to anyone with an interest.

that the finished books disappear, however, if you want them in their natural states.

If there's one thing I've learned, it is never fall in love with an art supply. Because chances are at some point they'll discontinue it. My favorite books were Sennelier linen covered books that had beautiful cream interior pages that I used and fell in love with for about fifteen years until they stopped making them. This news put me in a bit of tailspin, to be honest. I scrambled around talking with different suppliers and trying out different

books. I finally found a suitable replacement. A book made by Fabriano. The paper's thicker and has more sizing, but I've almost completed my first book and have adapted quite well.

I primarily draw in pen and ink. My main pen tip is a Hunt 102. I never sketch in pencil, even in my commercial books. I blast away in indelible ink. This has made me a lot surer of my line and has made me a lot more fearless. I also use colored pencils (Prismacolor) for color primarily for ease of use. My commercial work is

watercolor, and I'll use that in my books, too. Since my sketchbooks are for experimenting, I've also used bamboo pens, brush and ink, and a ton of collaged elements.

I keep my books in a bookcase in my studio. I consider them very precious. They are a history of my adult life. If there was a fire, I'd be grabbing as many as I could heading out the door. These and my original '63 Fender Strat. They are functional also because, from time to time, I'll look through them for a drawing I remember. They are basically a vast repository of ideas.

Hal Mayforth

SO PLEASD TO MEET YOU

Pig

JELLO
MOLD

chicken
what

ADAM McCAULEY

Adam comes from an artistic family and had a rich and varied childhood. He was born in Berkeley, California, grew up in Portland, Oregon; Ethiopia; Columbia, Missouri; and Palo Alto, California. After graduating from Parsons The New School for Design, he moved to Oakland, California, and finally to San Francisco's Inner Mission. He is now a commercial illustrator and designer working on adult and children's books, magazines, advertising and corporate work. He and his wife, designer Cynthia Wigginton, have collaborated on many picture books. For more of his work, visit www.adammccauley.com.

I mainly use sketchbooks when I travel. They become my camera. I find them much more useful in retaining my emotional connections to places than photography. If I'm inspired to, I'll write in the books as well.

I don't like to think of them as an obligation; the sketchbook is there when I need it. It's a great time killer, too—airports, cafés, sitting around the campsite; beats reading trashy magazines or depressing world news.

When we traveled to Egypt in 1997, I decided to dedicate a complete book to one place. At the time, I had been doing a lot of illustration work for Salon.com, and the travel editor wanted to make a special feature of my book upon return—a perfect way for me to write off some of the trip! When we were there, a horrible terrorist event happened in Cairo, and Salon.com decided to cancel the feature. All of a sudden, Egypt wasn't a travel destination! Luckily, *Print* magazine ended up running some pages from the book. It was a really intense trip.

I kept a very intense private journal in high school that was full of teen angst, dark poetry, grim drawings—probably my first "sketchbook." At Parsons, the first real sketchbook discipline began—two different teachers, Bill Clutz and Mrs. Morfogen, insisted we keep them. Both were strict about it and regularly checked our books for progress. It was great because we were sort of forced into drawing all the time.

After school, I got lax about it, using my books mainly as a place to draw sketches for assignments. At a certain point, I developed sketching assignments using tracing paper and typing paper, so the sketchbooks became more of a place for non-work-related picture making.

I still like to give myself challenges. I'll do things like, "hmm, it would be more interesting to draw this forest scene using three colors of felt pen than make a watercolor." Stuff like that forces you to think differently. It's like in art school, when they have you draw the model using both hands at once. In general however, I don't like to overthink in a sketchbook. Instinct—and the trust of it—is an important chop to develop and maintain, too.

Generally, my sketchbooks are a place to experiment, but I also like to use them as a sort of discipline to keep

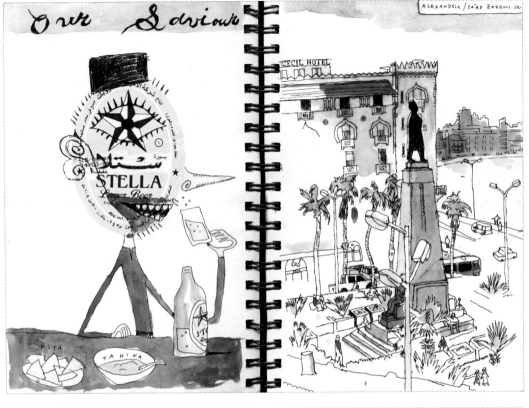

up my chops, both hand/eye-drawing skills, as well as composition and picture making. It's a great place to let your hair down and experiment or to set up in more disciplined tasks and stir it all together.

Sketching dictates its own picture making. Generally, I do end up working a page as a design; picture making is important as a discipline, as important as draftsmanship, value and color. That said, if I'm just doing a quick sketch of a museum object or something, I'll later add "snippet" sketches, collage in ephemera, etc. to make a practice with composition.

One of my favorite pages recently was when I made a torn-paper collage in collaboration with our friend's eight-year-old son, Angus, while we were camping. We used the previous night's Scrabble scorecards and glue stick, then drew on the top. Kids are awesome to make art with.

My sketchbook has to a be good traveler. It has to be practical with serviceable paper quality, able to hold a watercolor wash and slip into a backpack with ease. For many years, I'd sketch using whatever I had on hand, but time has helped me commit to keeping a

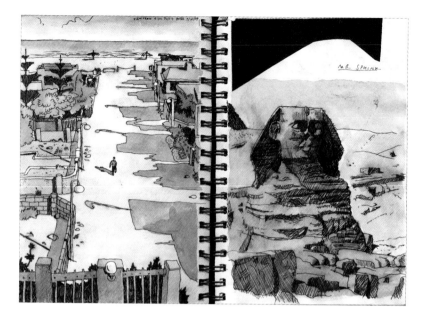

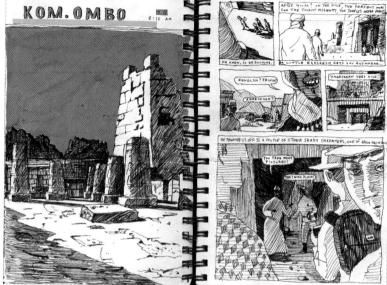

basic setup. Now I carry around the book, a variety of ballpoint pens, a tiny set of collapsible scissors, a glue stick, a few paper napkins or toilet paper and a small watercolor kit.

I've learned to like a smaller book, but for some places a bigger one is demanded, such as New Zealand, which has absolutely breathtaking vistas. I can no longer tolerate cheap paper (although I do have an affinity for cheap materials in general) and prefer spiral binding.

I love ballpoint pens, just plain old Bics. I also like colored pens—red, blue, brown, whatever. Colored line helps to define space and is more flexible in designing the picture. I generally use a Winsor & Newton watercolor set, but I also like a little Japanese set. In desperation in Cairo, when I ran out of a few colors, I tracked down a little horrible set of cheap watercolors, and

Instinct—and the trust of it— is an important chop to develop and maintain, too.

enjoyed the struggle of making them work for me. In Greece, I found some killer little ballpoints in amazing Mediterranean colors. I wish I had bought more. In Athens, we also found this tiny art supply store where they made beautiful inexpensive watercolor sketchbooks; I bought two.

I doodle mostly on scraps of paper, envelopes, that sort of thing. Doodling to me isn't all that interesting. I may do a cartoon or something, often to express an experience or idea, but doodle books to me are less valuable in reflecting upon my own work.

That said, my sketchbooks are not at all precious. I like to fling them around, spill coffee on them—it's all part of the life of the thing. I still always try and utilize whatever local ephemera I can find—scraps of packaging, pens from the hotel, pieces of local vegetation—because it's part of what I'm experiencing and brings its own value to the picture and book.

My finished books are packed in my closet. Some are precious, but only because they're records of important times in my life. Others are just workhorses.

Sometimes, I'll look through a really old one and have a lot of fun. The trip books always bring me back to specific memories. They make me feel very fortunate to have had the opportunity to travel so much and be healthy and able to really observe and document my experience.

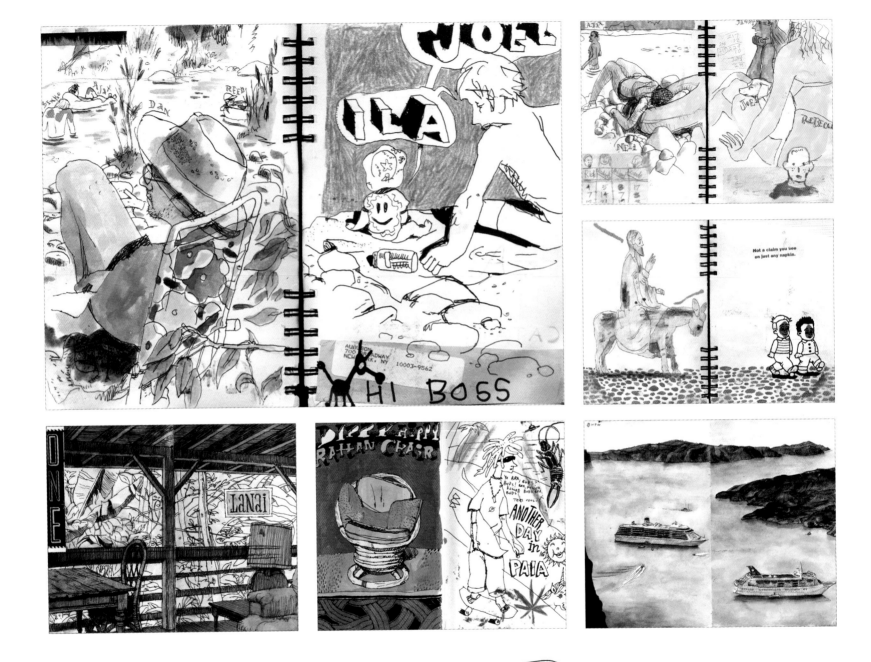

SKETCHBOOK COVERS

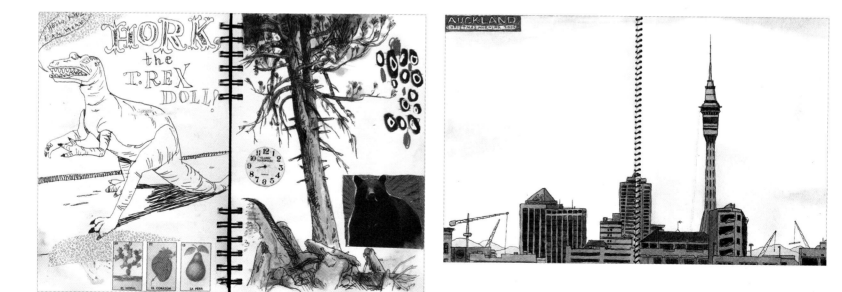

The memories of today, left on paper

I have kissed with my eyes & walked these ancient stones with my bare feet.

MAHA SHIVARATHRI

PRASHANT MIRANDA

Prashant was born in Quilon Kerala on the west coast of South India and grew up in Bangalore. He studied animation film design at the National Institute of Design in Ahmedabad, India. After animating several children's series, he is now a full-time artist, spending his summers in Toronto, Canada, and winters in Varanasi, India. You can see more of his work at www.prashant.blogspot.com.

Very often my sketchbook is my connection with the Divine. I'm just a vessel or medium through which what I draw or write gets put down. Not only do my journals chronicle my spiritual growth, they also reiterate the wonderful journey that I am on.

My sketchbooks act as reminders for a forgetful man like me. Beautiful, poignant, simple moments every day are documented in my sketchbook. They also document ideas, concepts, dreams, recipes, songs, faces, meetings, and act as a calendar to keep track of my daily encounters.

I've always thought of journalkeeping as capturing the essence of the moment. It need not be a realistic drawing, but even a simple line or dot or a found object stuck to a page can convey a message or a feeling that can be very powerful.

My sketchbooks are my true art form, as they have grown and evolved over the years and encapsulated all that is me.

My book travels with me everywhere I go. It is my constant companion. While I'm in Varanasi, I do morning meditation watercolors, which are peaceful, calm and focused. But, I also take my journal to a bar or a park and take it out to jot down an e-mail address. I've even taken it to the loo!

As an artist, I have begun to separate the work I sell and the work I do for myself. My sketchbooks I cannot sell. I have no problem displaying or sharing them with others, but they are a part of my life that can't be sold. But my paintings are often in the vein of what's in my sketchbooks. Also, a collection of pages, whether it is bound or not, acts as a package for that part of my life. I go between phases where I like the chronological

aspect of my days to be chronicled sequentially. I also like it when the pages get shuffled so that my life story is told differently every time.

I've drawn since I was a kid. I LOVE DRAWING. I draw every day. The translation from how I feel to what I draw on a page has become easier as compared to me playing the piano or cooking for instance, which I love too.

Since I travel without a camera, I feel the need to document things as my horizons are expanding. I love how portable watercolors are, and if I see something of interest, I draw and paint it immediately lest the moment be lost forever. Spending time, looking at and drawing a monument, a face, a tree, whatever, enhances my experience of the moment, and even years later the memories, smells, sounds are quite vivid. In this fast-paced life, I like spending time and slowing things down.

My sketchbooks I cannot sell. I have no problem displaying or sharing them with others, but they are a part of my life that can't be sold.

It's been about twelve to thirteen years since I seriously started keeping a sketchbook. Before that, I just kept a diary/journal with only text. I used to bind my sketchbooks, and then it evolved to stitching pouches out of leather or cloth with loose pages in them, then to boxes (memory boxes). People give me books, which I try to use, and I adjust my colors accordingly.

I am particular about the kind of paper I use. I like Arches 140 lb. cold-pressed watercolor paper to make my books. But if people have given me books, I try to use them and integrate my watercolors in them.

I usually use pen and ink and watercolors. Rotring Isographs 0.3, 0.5 are the pens I use. For watercolors, I've used Pelican artiste watercolors, and now I'm using Liebetruth Student Transparent Watercolors.

I keep most of my books at my parents' house, as I live in a little room downtown. They are all over the place, on bookshelves and desks and in drawers, but I do

remember where they are. My sketchbooks are precious, but I do believe that they should be felt and touched and rummaged through to add character to them. I have lost a couple of my sketchbooks, but it's part of letting go.

I usually look back at books of the same season from completely different years, and I see similar themes with an evolution of thought or even style. But patterns emerge and they are wonderful reminders of who I am.

Prashant - M

Selbstgemachtes Armband,
dass wir in Le Mans gefunden
haben.

Claudia

in La Baule, 20. Juni 2005.

7. Juli, 2005.

CHRISTOPH MUELLER

Christoph grew up in Landgraaf, Holland, and Aachen, Germany where he now lives. He recently graduated with a degree in graphic design from Aachen University and is now developing his art and working as a waiter, selling sausages and fries. His work can be seen at www.muellersjournal.com.

I am thinking about having my work bound in my own skin once I have passed on. That's called anthropodermic bibliopegy: books bound in human skin. Maybe I could even have the title tattooed on my body sometime before I am dead …

My sketchbooks are kind of the purpose why I live. They give the time I spend on this planet—in this life—a texture. They prove that I was here, that I created something. I wouldn't have the feeling that my life was worth living if it wasn't for these books.

Their main purpose is not to work up ideas or designs. It's more about creating something that helps me cope with life better, to somehow put this chaos called life in some order. It calms me down. It gives me

the feeling that I created something and prevents me from feeling worthless. I also use my books to explore myself in further detail. I look at and observe my obsessions as well as my fears, in a way like therapy.

Important? Precious? Hell yeah!! Most precious! Many times they are the only thing that give my life meaning. I really treasure them. I always keep them together. I always keep them with me.

I mostly draw in my book at home. I tend to feel very uncomfortable when someone watches me while I draw—something I still have to work on. But, yeah, it's mostly all happening in my apartment where I hear my music and can really get in this certain mood, this state where I am really in touch with myself. Music is very important for this. Music and loneliness. Oh, and coffee of course. I draw and dig deeper inside myself. I really must not be disturbed while "digging." Some-

times, I don't even answer the phone while drawing. That's all so damn distracting.

A book is a narrative thing, you know, you always go through it from one side to the other. Even though most of these drawings don't really tell a story from one page to another, you always know that a page symbolizes a certain amount of time in this person's life. It really gives time a texture. All these things that happen in one's life, they are all gone so quickly and all that remains are memories and those tend to fade. A book will always help to bring back these memories just by looking at them.

The sooner I draw something on the first page the better. Because then it's not just some blank book, it is a part of me. And it doesn't even have to be something good. I rarely leave a page blank. Actually I never do that. You know, I think the sooner you fuck up the page the better, because then it can't intimidate

you anymore. You rather feel sorry for it and start to improve it. At times, I get frustrated and depressed when everything I draw looks like shit. But that's the good thing about a book: just turn the fucking page, as in life. Keep on making it down the road, keep on filling those pages no matter what.

When I was about twelve my father showed me one of R. Crumb's sketchbooks and that was really a very special moment for me. It showed me how drawing can help you to cope with life, how it can be a used as a tool in life. Drawing is my way to explore myself, to put my own chaos of feelings, desires, sorrows and longings in some kind of order.

I have always wanted to get some kind of positive feedback from people who look through my books. Recently, I discovered that, whether or not I get positive feedback, it won't change the way I draw and what I draw at all, so it doesn't really matter anyway. Positive feedback or not, I just cannot change myself; I will draw what I draw.

Actually it also tells me more about them than about quality of my work.

Some stuff I found out lately: Drawing is your redemption, Mueller. Drawing will make you feel good, eventually; first you'll feel really bad, though. A drawing a day keeps the blues away. As Crumb said: "Persistence pays off!" And that's really the bottom line. You must keep on filling those pages. You must keep on drawing. Find out what inspires you, what makes you draw, and pursue it. Face yourself when you draw. Find out who you are and what gets you going. As far as I am concerned, that's what makes it art, or at least something that is worth doing. And as Joe Coleman said to me: "The process of finding out what's inside, Christoph, is painful, but that's the prize. It should be painful. Most things that are worthwhile in life are painful."

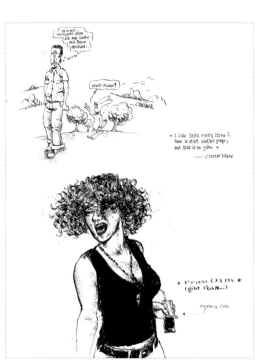

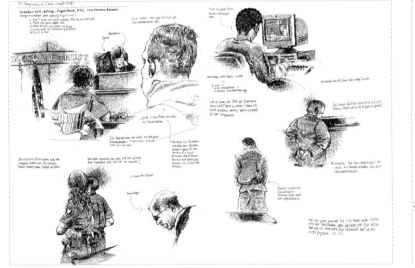

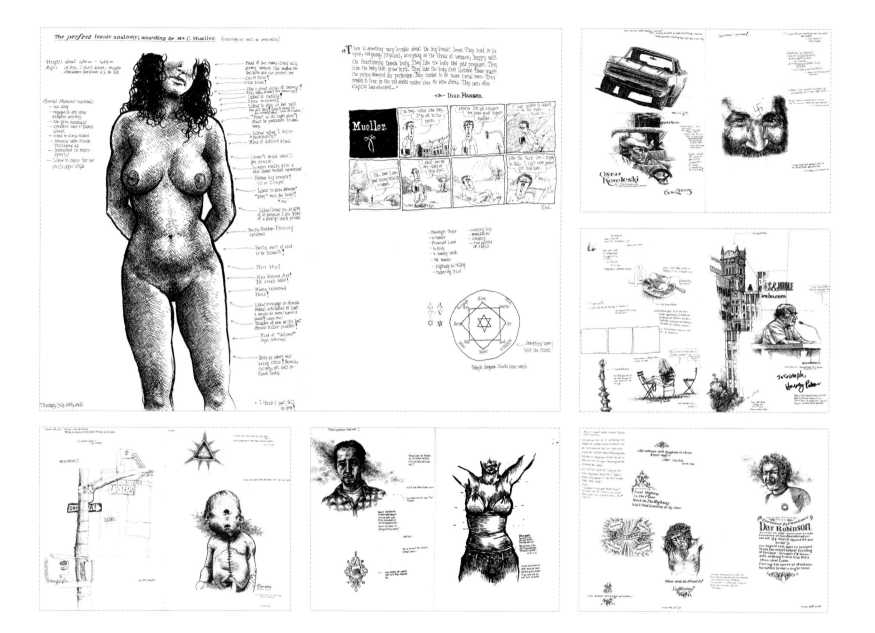

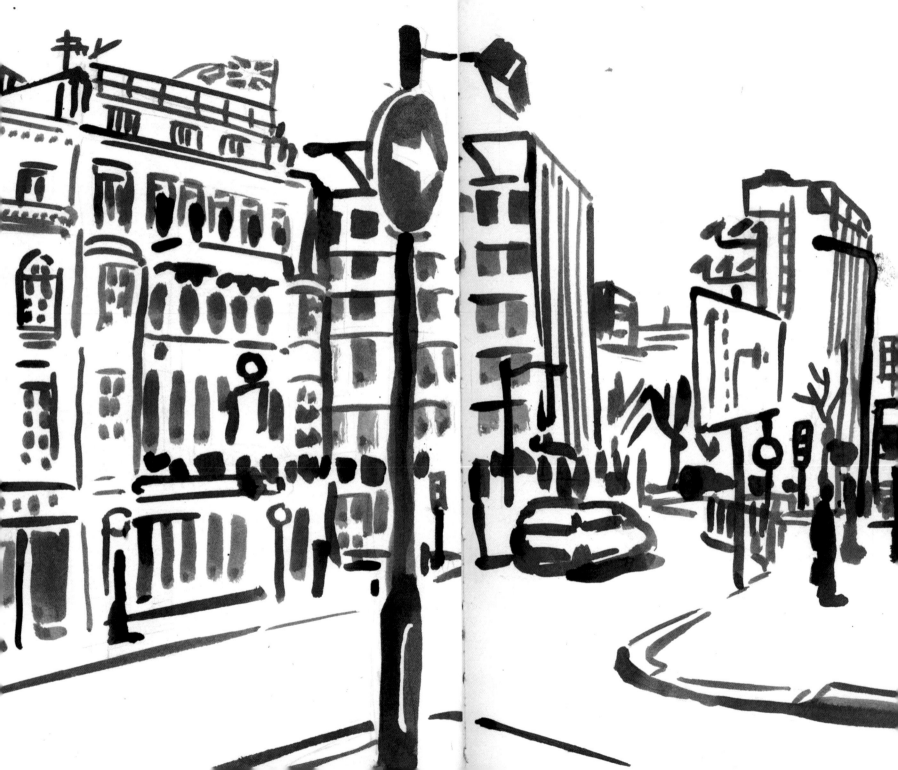

CHRISTOPH NEIMANN

Christoph grew up near Stuttgart, Germany, and now lives in New York City. He earned a master's degree in graphic design from the State Academy of Fine Arts in Stuttgart. He is an illustrator, designer and animator. To see more of his work for the *The New Yorker* and his children's books, visit www.christophniemann.com.

My sketching is very separate from my professional work. Obviously, sketching is a necessary exercise for an illustrator, but when I travel somewhere and just draw a funny boat in some random harbor town I have absolutely no professional ambition with it.

My philosophy as an illustrator is that form always has to follow function. I deliberately do not sketch in books when I work on my "professional" assignments and just work on loose pieces of paper. But when I do personal work, my biggest challenge is to let go of all fear and see what happens, which, of course, means that every once in a while, the composition gets all messed up. The big problem with sketchbooks is that I insist on keeping an eye on how nice the overall book will look. I find this vanity restricting.

There is always that temptation to comment on your own sketches ("bad tree", "really f#$@ed up this cloud"). I haven't done that in a while, but I always find it VERY annoying in retrospect when I see such comments in my own books (as well as in other peoples' books).

I love the form of a book, how you can quickly browse through a fairly large number of drawings. I have a rather disquieting tendency to be messy, so books are a very easy way to stay organized and neat, at least with my sketches.

I prefer drawing with ink or watercolor, so I like to have a certain thickness of the paper. I have a lot of the plain black sketchbooks, but over time my favorite sketchbooks are ones that have been given to me by other people. The best one is from Dia:Beacon. It has a gray, felt cover. You almost want to cuddle with it. I love the Moleskine books, but they don't really work as sketchbooks for me (too small, paper too thin).

Sketchbooks take me back to the roots so I can just draw for drawing's sake. I never draw in them at work, rarely at home, but always when traveling. I try to consciously take time to draw when I'm traveling, to take advantage of the periods when I have to wait for a train or a plane. It is a great way to be more conscious of my surroundings. Also, it is quite a lot of fun to look at old sketchbooks and remember a particular moment in a foreign place.

Recently, I have come to enjoy self-imposed assignments more and more. Like filling an entire sketchbook in a consistent technique; for example, a book of drawings just in red ink on white paper. Or filling an entire book within a certain time limit. I filled the London sketchbook within thirty-six hours.

The longer I have a book, of course, the more and more attached I become to it.

... When I do personal work, my biggest challenge is to let go of all fear and see what happens, which, of course, means that every once in a while, the composition gets all messed up.

I have one or two books that aren't filled up yet, but I don't dare take them on trips anymore. I once lost a pretty filled-up book in Toronto, and since then I have become more careful.

N I E M A N N

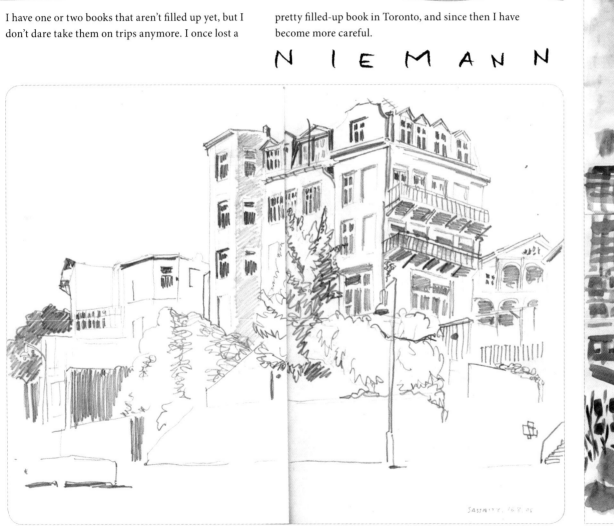

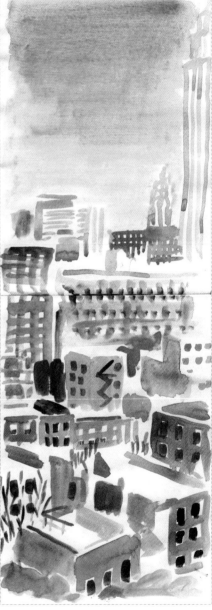

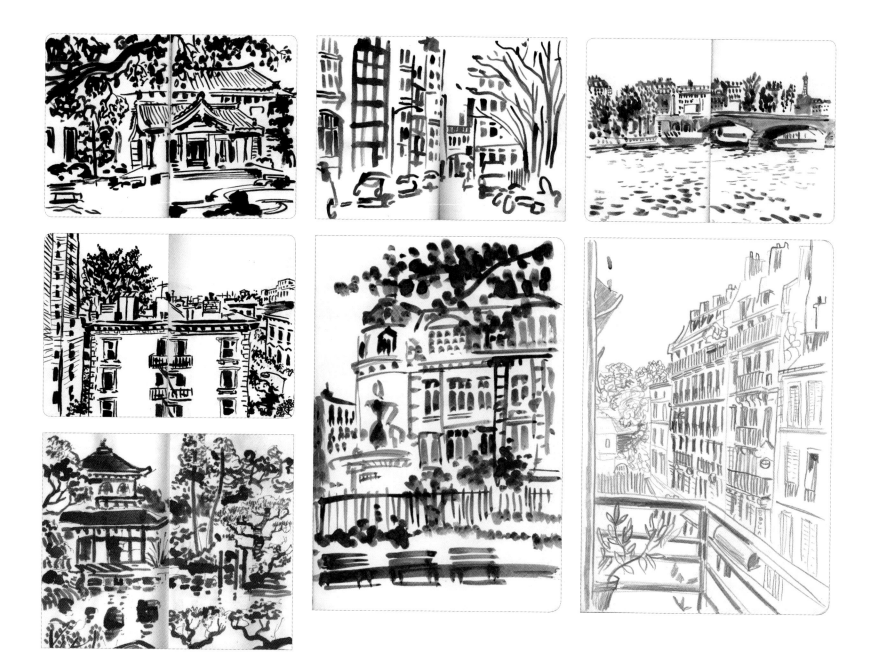

EIGEN FORK EERST

'OET

OUD 'DET
(OLD HAT)

IS ANY REPRESENTATION OF

A WELL-ORDERED WORLD
B E A U T I F U L

TINY WRITING :
LOOKING FOR A
NEW IDEA

BRODY NEUENSCHWANDER

Brody is an artist and world-famous calligrapher. He grew up in Houston, Texas, and Ulm, Germany. He received his BA in art history from Princeton University and his PhD from The Courtauld Institute of Art in London. He lived in Welsh Borders for six years and now is based in Bruges, Belgium. *Textasy*, a monograph on his work, was published by Imschoot Uitgevers, Ghent in 2006. His calligraphy can also be seen in the films and projects of Peter Greenaway. For more of his work, visit www.bnart.be.

The main purpose of my sketchbooks is to get a visual sense of a word. A word or a group of words might, in my head, seem very interesting as the basis of a work of art. But I need to see how the shapes of the letters actually work—which forms follow on which forms. And once the word becomes visual, I need to see what resonances and associations it will have. These can come out only partially in sketches, since the final effect is also dependent on color, scale and materials. Sketches serve to make language visible so that I can see the image/text tensions.

Sketches are not my true art form, and I do not make them for all works. I use my sketchbook in fits and starts, depending on inspiration, pressure of exhibitions, my state of doubt. This last is the most important, since I usually start to draw words when I am ready to give up on my work.

Calligraphy, conceptual art and text art are very difficult media to live with. Calligraphy has no serious place in our culture, so its use fills me with apprehension. I draw in order to find links to more serious traditions of visual language, like Chinese calligraphy, graffiti, typography, advertising. My drawings are often an attempt to integrate several of these traditions into one word—and then to give it the calligraphic dynamism that I like to see and do.

When in a state of doubt, which usually precedes a few days of making lots of new things, I draw lots of words in various shapes and styles. This is not just to find out how they look and work, but also to convince myself that it is worth doing. These doubts might torture a painter as well, but for different reasons. A painter has to contend with a large and heavily populated past—masters and

geniuses lurking around every corner, all better than himself. I have no such competition from our Western tradition, no problem of "painting is dead." Calligraphy was never born in the West, only decorative writing.

My competition (though I really don't experience it like that) is from the great Chinese and Arabic masters and, more importantly, from the social and political role of their work in the societies they lived in.

When I draw, I am thinking about how some kind of intensity of meaning can be brought to a genre that has no receptive field in our society. And how to slice off a chunk of the conceptual art world's receptive field to use for my calligraphic purposes. It is really not easy.

My first sketchbook started when I was fifteen and actually served for nearly *twenty* years, with pages

I just keep plowing until something decides to grow.

added in. It is a record of my love of the past, of medieval manuscripts, Italian frescoes, all the beautiful things made before 1800, to which I was magnetically attracted. When it stopped, I started to think about being an artist instead of a craftsman. Someone gave me a new sketchbook at that moment. It was full in a year. And now my sketches are on anything and then get stuck into the books.

I prefer drawing in a book simply because it unifies all sorts of disparate things and keeps them in the same

order (until it falls apart and I start sticking it back together in the wrong order). I fill any available space, tear out, paste over, glue pages together if I really do not like them. I keep my books on a very dusty shelf next to my work table so I can grab them when I need an idea.

Long ago, I saw calligraphers trembling with fear in front of blank paper and realized that this attitude does not help. So I got rid of it. I am not very sentimental or ceremonial—if you live a while in Flanders, you get a sense of ritual and refined manners stomped right out

of you by the descendents of Brueghel. It does not show in my sketchbooks, but I have developed an infinitely re-workable technique using layers of rice paper, white-wash and pigment that allow me to look at a sheet of paper not as a virginal field awaiting its stain of ink, but as the back forty that has been plowed many times. I just keep plowing until something decides to grow.

Brody Neuenschwander

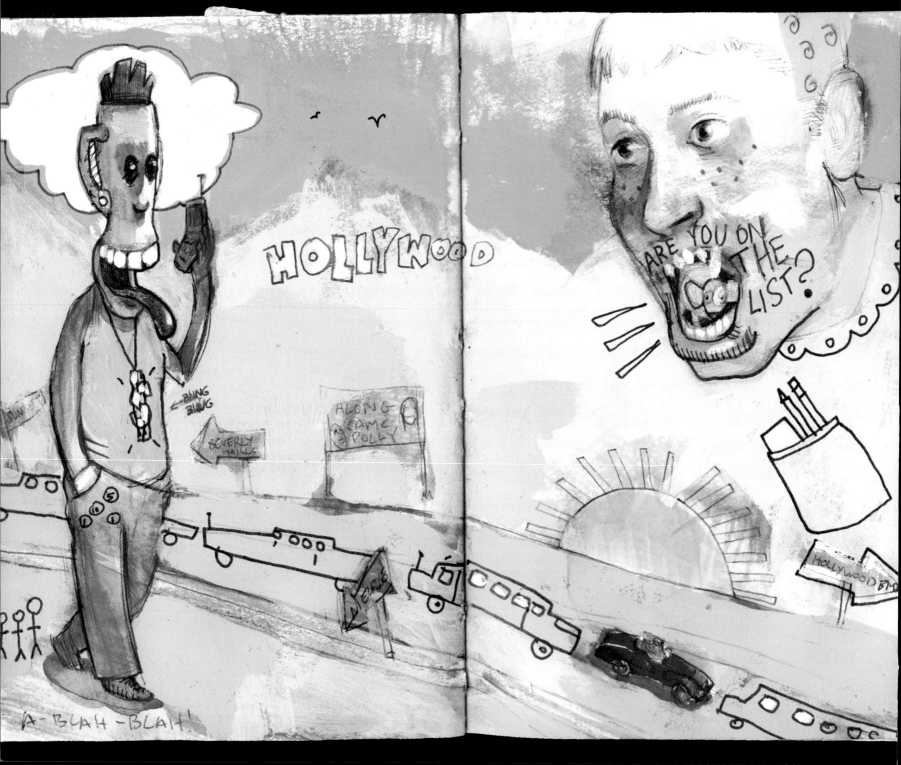

MARILYN PATRIZIO

Marilyn is from Bensonhurst, Brooklyn. She graduated with a BFA in illustration from the School of Visual Arts in New York and is a freelance web illustrator in Brooklyn. Her drawings, handmade toys and vector art have been featured in magazines worldwide. You can see more of her work at www.mpatrizio.com.

My sketchbook is an anxiety killer, mind clearer, to-do list holder, idea launcher, friend, but not really a journal because of the lack of organization and randomness of the sketches. In some sketchbooks, my focus is on studying a specific environment that I am in. Some others are purely ideas, inventions or designs that I want to realize. And in others are memories or sudden visions that I want to capture like a photograph. I love, love, love the fact that it is a book, that it is contained, that it can be hidden from view in a moments notice, that there is a lack of commitment and that there is freedom of experimentation.

My sketchbooks generally have had a consistent mix of ideas that I want to develop (character designs, illustrations, paintings, products), notes about people or places that I want to research, sketches of my travels on the NYC subway and a testing ground for new drawing and painting mediums. Some of my sketches influence my com-

mercial work, and some of my commercial work leads to new ideas, which I try to develop through my sketchbook.

Sketchbooks should be the one place without rules. I used to feel the need to cover every centimeter, but through the years, I have learned to let go and let a simple drawing occupy a whole page by itself. However, I do edit and design my books a bit. I usually go back weeks or months later to cover something up that I didn't like or to collage a piece of scrap paper over something I wrote or drew that I found unattractive or didn't want to relive again in any form. I definitely allow myself to doodle, but then sometimes I end up masking it by painting something over it or gluing a piece of scrap paper over it. I think, in the end, the layers add interest.

I've been consciously drawing pictures and saving them since I was a teenager. I started keeping organized, dated books about nine years ago.

I've been drawing since I can remember. I have mixed feelings about drawing though. Sometimes I love it because of its simplicity and sometimes I hate it because of its simplicity. Don't get me wrong, I truly appreciate the unpretentiousness of a 4b pencil or a Paper Mate pen. But my true love is color and working with paint and design.

I always take my book with me when I go on vacation or even short trips where I know I will be alone and will have the time to draw/write in it. I have taken trips specifically to draw the location. It makes you appreciate it. Makes you appreciate life. This is the true meaning of art: to see something and be able to translate it to a viewer in a way that makes him truly see and appreciate it. To do it well is really a gift from the gods! P.S. I don't think I have this gift, but I'm workin' on it!

I'm not a complete sketchbook snob. I guess I mostly choose my books by shape and the thickness of the

Sketchbooks should be the one place without rules.

paper inside. I always want to select paper that, if I apply paint to it, won't shrivel up like an old hag. If I tell you where I get them I'd have to kill you. Okay, okay, fine … I try to buy new sketchbooks when I am on vacation/traveling. My shiny new book will have

the dual-purpose of being both a souvenir and also a functional surface to store my scribbles.

I am pretty open-minded when it comes to mediums. In fact, I just tried sewing things into my book with my

sewing machine. Pretty interesting results! I sewed in a little pouch to hold my pen! Yes, I'm so cool.

I try to keep my sketchbooks together on my bookshelf. I consider them to be very important objects. I hold them in equal respect to a set of old photos or a big box of cash.

Marilyn Patrizio

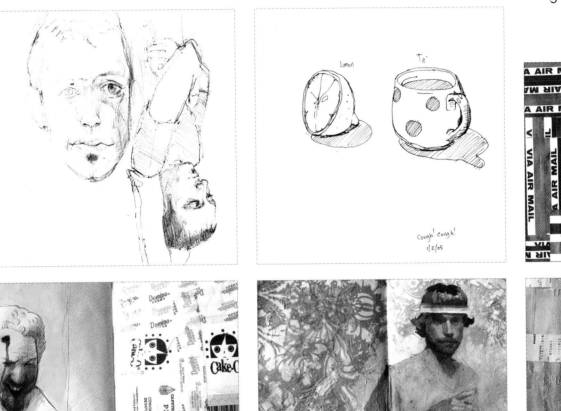

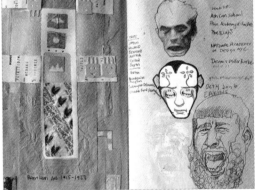

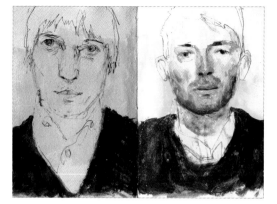

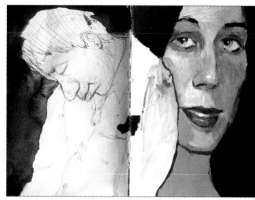

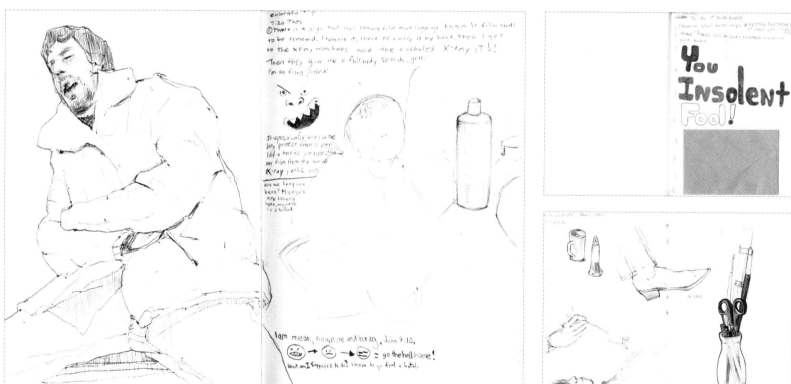

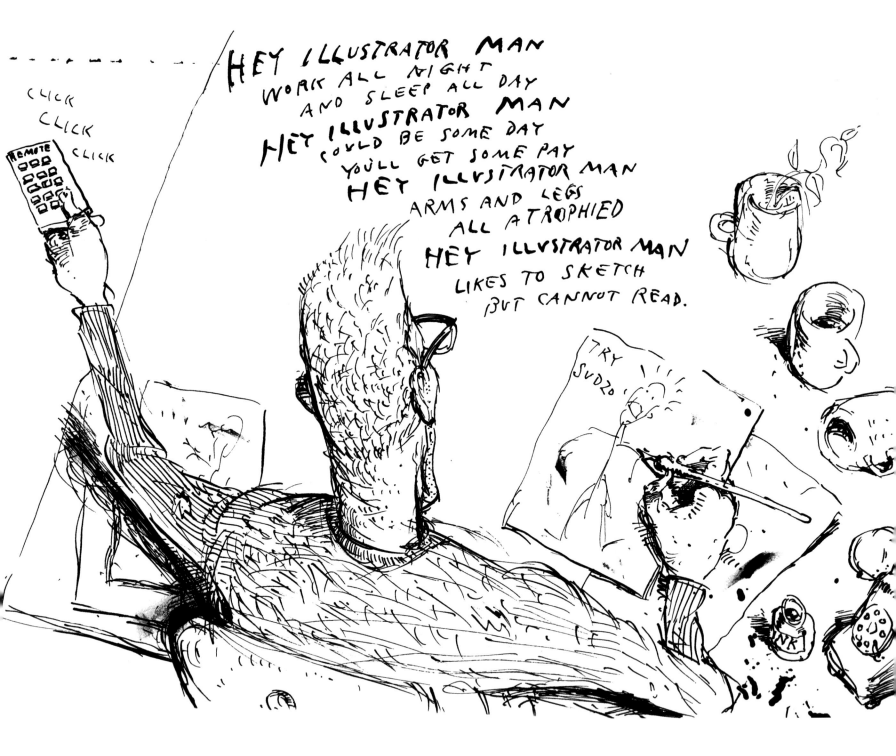

EVERETT PECK

Everett grew up in and still lives in Southern California. He has a degree in illustration with an emphasis on art history. He primarily creates and produces animated television shows but is also an illustrator, cartoonist and painter. For more of his work, visit www.epeck.com.

I believe keeping a sketchbook is the single most important thing you can do as an artist, not only for developing drawing skills but also for developing a point of view. My books tend to generally be less about where I've been and more about what I'm thinking. Very often, larger ideas and projects will spring from my sketchbooks.

I've been keeping a sketchbook for over thirty years. Over that period, my relationship with my sketchbook has gone through several modes. There are times when I take it everywhere I go, and there are other times when I don't touch it for quite a while. Over the last twelve years or so I've been doing a lot of animation-concept sketching, so instead of drawing in the book, I work on individual pieces of paper. Although I sometimes draw in my book at my studio, I most enjoy sketching in public with it. Illustration and painting tend to be very solitary, and sketching in public is a much more social experience.

The fact that it is a book totally defines the experience. I have a rule to never tear out a page. If a drawing is say, "out of character," I simply turn the page and start again. If it's a bad drawing, I just turn the page and start again. Even Picasso did a bad drawing once in a while, I think. The fact that it is a book allows you to do sequential drawings (drawings that evolve over several pages), sequential stories and bits (a drawing on one page can play off the drawing on the opposing page), and double-page spreads. Plus, taken as a whole, you have a sequential gestalt of your drawing experiences over a given period of time that you don't really get when doing individual pieces. Finally, everything is self-contained in one neat package. I've used sketchbooks as a complete portfolio.

I try to keep my sketchbook drawings somewhat "pure" and free from commercial concerns. Having said that, I'm surprised by the number of times a rough sketch turns into an element in a painting or an idea for an animated show.

Getting started on any art project, sketchbook or otherwise, is always the hardest part for me. Sometimes, I just dive in and ruin the first page, get it over with and move on. Other times, I procrastinate.

There have been periods when I haven't touched my sketchbook. I'm not sure why I go for sometimes quite long periods without drawing in my book. It's not because I don't enjoy the process, and it's not because I don't think it's important; I do. I'm always drawing on something. I guess when I draw in my book it's generally about drawing a realized idea. When I'm simply "searching" for an idea or a character, I generally draw on a pile of paper. Then one day, I'll grab my sketchbook and head for a coffee shop, and we're old friends again.

I only use Winsor & Newton 10" × 12" books. They have sort of a dark red cover, and I find the paper in them holds up well to most any drawing medium. They can

Plus, taken as a whole, you have a sequential gestalt of your drawing experiences over a given period of time that you don't really get when doing individual pieces.

usually be found at the larger art supply stores. When I do run across them I buy several.

I use all kinds of media in my books. I will often use some kind of rollerball marker when I'm drawing in public. When I'm in my studio, I usually use a bottle of ink and a dip pen with a Falcon 048 point. When I paint in my books, I usually use gouache. I often use collage as well. But I'm open to anything.

I love to have other people look at my book, especially if they are artists, too. A lot of my work is about trying to make people laugh, and having someone go through your sketchbook is about as close to having a live audi-ence as possible. You really get a sense of what works and what doesn't.

When I get together with like-minded friends, I usually pass the book around. When I give talks to groups, usually a large number of the images are from sketchbooks. I guess it's about as close to a performance that drawing gets with the possible exception of doing caricatures in a public place.

When I take my book on a trip, the things I draw become more about the things I'm seeing. More about things coming into my head and less about things going out, sort of the reverse of the usual process. I don't usually go someplace just to draw it; I prefer to stumble onto things. Although the first time I went to New York, I had to do a drawing of the interior of Grand Central Station. That New York City is something else; I think it's going to catch on.

E PECK

WORKSPACE

ON SECOND THOUGHT, RALPH OL' BOY, MAYBE WE DO NEED A BOX OF DOGIE YUM YUMS.

天児牛大

VENANTIUS J. PINTO

Venantius grew up in Bombay, India. He studied advertising, design and illustration at the Sir J.J. Institute of Applied Art, then communication design and computer graphics at Pratt Institute in New York. He now works as a digital artist. His work can be seen at www.flickr.com/photos/venantius/sets.

The purpose is indeed to depict the metaphor that resides fleetingly in my mind's eye. My books give clarity to the thoughts that come to me. I believe that we do not come by our thoughts; they come to us!

The books are documents of understanding and resolution, or MOUs (memoranda of understanding) with myself if you will. They are a *budo*, a way of life. "Illustrating Understanding," or "Illustrating to Reveal" would be more my cup of thought. In a sense, they are an art form unto themselves and are indeed stand-alones. I am not averse to incorporating aspects into other works, though that has not happened as yet. They are trenches of visual thinking where one works out processes and emotions, and learns to overcome fear.

The nature of my drawing is not about documenting the day-to-day. It's about helping me understand ideas that come to me, and drawing is a vehicle to help me register my absorption of those thoughts. In so doing, I attempt to understand what it is that moved me. In that sense, it is not always about me to begin with. "We do not come by our thoughts; they come to us" is something that I deeply believe in. This is very significant to the way we understand things.

My first and only rule, or obsession, is rigor. So the work must have a place, a reason that it was attempted and for which it will be finished—to contribute significantly to the discourse on analysis, form, color, technique and so on. That is all I care about. I am not interested in effects or fancy manipulation. Having said that, I must add that I am abundantly blessed and have refined my techniques.

A book functions as a repository of the mind, a compact, portable, narrative mural. One moves to the next page only after being satiated with the current one. One carries and adds to the understanding gained from page to page. The sharing commences from something being stirred, and then the feeling dissipates, at which point enough has been revealed.

I am in the process of making a set of three large books, and I like the idea that a book can be closed after it has been shared. To me, drawing on loose sheets of paper does not have the togetherness of a book. I would prefer to keep even a loose set of drawings in a box. But scraps of paper have their own dynamic, particularly those that do not conform to logical shapes.

The consistent thread in my work has always been the pursuit of thought. Everything else shifts. There is a certain line quality that is consistent, but I must say that too is subservient to the idea at hand. Nothing subordinates the idea and the understanding of it.

This is my second phase in my sketching, with a lull in between of almost fifteen years, during which I only did thumbnails. I began sketching when I was in the seventh grade but have nothing to show for it. My second phase began in 2001, and I have a ton of work since then. I am very happy with the way things turned out. The subjects that I work on are complex and have required me to impart a high degree of skill and technique to realize them. I will soon be working on long scrolls. There have been short periods when I stopped drawing in order to spend time thinking without paper and marking tools.

I drew as a child, beginning around age three. My first drawing was on the threshold of our company apartment in Mumbai, India. My entire lived movement is based on line. I would not be egotistical in saying that every move of mine is akin to drawing. Lines move me, and a hurried line kills me.

I prefer accordion books. I also like books that are tightly bound and ring bound books from Maruzen. I buy the accordion books in Japan and at Kinokuniya on Forty-ninth Street and Soho Art Materials on Grand Street, New York. Other types of books I buy at Pearl Paint and at New York Central. I have bought books in Lahti (Finland), India, Berlin, Mexico, etc.

I draw with ballpoint (biro), pen and ink, silverpoint, pencils, various inks (including walnut and sumi), various watercolors (including Gansai), goldleaf, gouache, fingers, etc.

I use cases to store the books. It's a pretty impressive experience when customs in various countries have asked me to open my case(s), and all they see is the books. I had a Swiss border policeman ask for prices. I was traveling via train from Cremona (Italy) to Stockholm. In Stockholm, airport security asked

It's revealing how much I learn about possibilities, which in turn strengthens my resolve to keep moving toward more intriguing directions.

One moves to the next page only after being satiated with the current one.

me to open my case; and it was a sight to witness the awestruck smile of the agent, who I am sure, was of Sri Lankan origin. The others had stopped what they were doing to watch! I feel they regarded this as something special—a cargo that had to be with me.

When I look back through my books, frankly speaking, it's hard to believe I did them. I keep certain books together, my script drawing books for instance. I also always have one book that is close to me, one that I may occasionally skim through to take in the detail. It's revealing how much I learn about possibilities, which in turn strengthens my resolve to keep moving toward more intriguing directions. I recently reviewed some of my books and could not understand the automatic-ism in the drawings. It's almost as if despite all my thinking, something else had interjected itself, which made the work into a collaboration. Perhaps collaboration with the limbic region, that mysterious space to which some people attribute divine connotations.

I have often suggested to people how a book may be approached: the nature of narrative structures, the significance of maintaining a meta-narrative through all the smaller narratives that makes up our own nar-ratology, an internal geography. How do we gain, aside from the nature of that gain, by seeing and observing the outside? Draw to understand yourself.

Venantius J Pinto

EDEL RODRIGUEZ

Edel grew up in Havana, then Miami, and now lives in a small town in New Jersey. He earned a BFA at Pratt Institute and an MFA from Hunter College and is now an art director at *TIME* magazine and a freelance illustrator. You can see more of his work at www.edelrodriguez.com.

My sketchbooks are strictly for myself. I mostly use them to record life events and travels; sometimes I sketch ideas in them. I don't have rules for my sketchbooks. They're a place to experiment, a free place to do whatever I want—make mistakes, draw and tell stories through the drawing.

I use my book to record the places I visit on my travels. I don't go somewhere just to draw it; I like finding accidental things. I always wanted to go to Egypt, and drawing there was an added bonus. I feel like I'm closer to a place if I've slowed down and taken the time to draw it. Many of my sketchbooks are filled with collage elements of things I come across when I travel—postage stamps, museum maps, beer coasters, napkins. These can be visual notes that remind me of a place or just a sentimental keepsake of where I've been. In my Egypt sketchbook, I did a drawing of the Sphinx over some sand directly from the ground next to the Sphinx, that I had glued down on the sketchbook. Pages in other sketchbooks have leaves and straw from the mountains in Italy and Greece.

Sometimes I draw people I meet on my travels, and it's a good way to get to know some of the people of a particular country. They're usually very interested in what one is doing. I've been in places drawing something seemingly insignificant and a crowd gathers around to ask why I'm drawing that particular thing. I then try and explain the beauty of something they might have overlooked, and it makes for a great conversation. This has happened several times on my trips back to Cuba.

Occasionally, if I'm in a certain town, I try to see it through the eyes of an artist that lived there. I was in Nice, France, at the beach, and, through my drawing, was able to see how the landscape affected the work of Matisse. As I drew the colors, palm trees and architecture of the buildings, I got a better understanding of Matisse and other artists of his time. Last year, I was in Giverny, France, visiting Monet's house and was really taken with the town. I began doing a few Impressionist type drawings and wondering what it was like for Monet to be walking around that landscape. I'm very interested in art history and my sketchbooks allow me to delve deeper into that.

When I was in college, sketchbooks were places to try anything. A place to copy and learn from drawings by Michelangelo, van Gogh, da Vinci, etc. A sketchbook was a place to learn. I still feel my sketchbooks are about learning. My sketchbooks are not about the final art; they are about the process.

I like the book format of a sketchbook because one can flip through it and try to create a story from the images.

I really enjoy looking through the books because they remind me of a place and time in my life. It's very fulfilling to have a record to look back on the times when I was a student, when I met my wife, when I graduated college, etc.

I'm not that particular about the books I draw in. I don't like sketchbooks with spiral binding because I like to create full spreads. Usually, the hard, cardboard, black cover sketchbooks work well for me. I use pen and ink, colored pencils, pastels, pencil, collage. I've used many different brands of sketchbooks and art supplies. A small and portable sketchbook is best for travels. Sometimes I carry a small travel watercolor set, and a small selection of colored pencils, along with whatever pen I happen to be using at the time. Currently, I'm using an inexpensive fountain pen made by Lamy. I tend to lose pens and art supplies when I travel, so I don't carry anything that would be hard to replace.

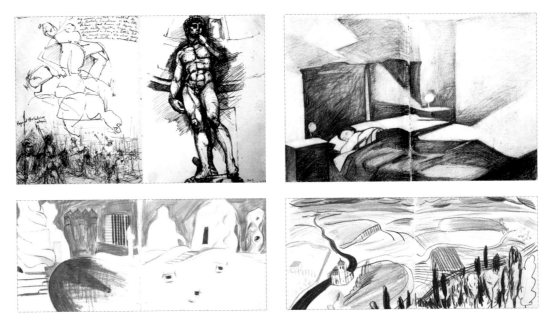

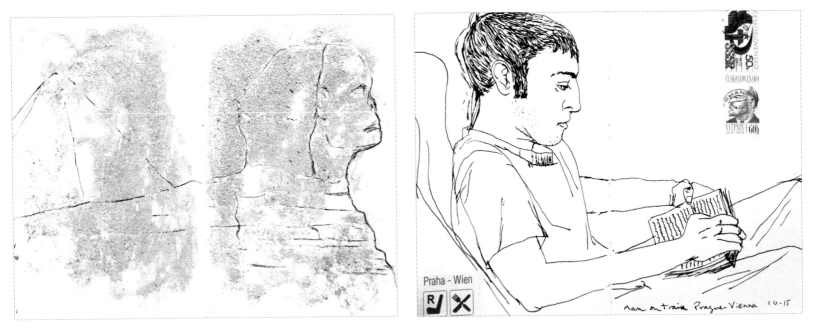

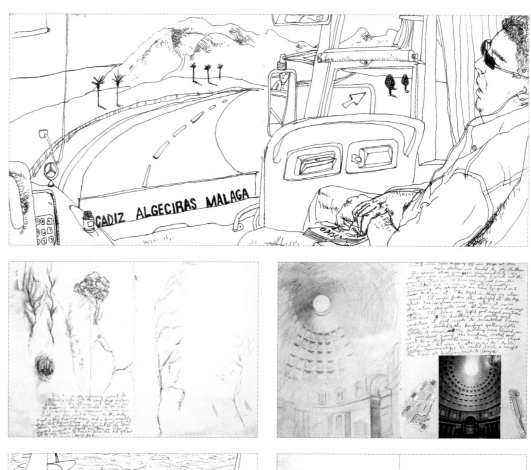

CADIZ ALGECIRAS MALAGA

THERE IS ALWAYS HOPE!

TREVOR ROMAIN

Trevor grew up in Johannesburg, South Africa. He was told he wasn't talented enough to take art at school or college. He only started drawing in his thirties. He now lives in Austin, Texas, where he writes and illustrates children's books and has a children's entertainment company. His many books can be found in bookstores and at www.trevorromain.com.

My sketchbook has become my portable meditation ashram. I lose myself totally when I'm working in it. Sketching has helped me grieve and decompress during some trying times in my life and given me a record of my healing. It is also my portable therapist. I can honestly say that sketching in my journal is *the* most pleasurable thing in my life (other than hot tea and making out).

I spend a fair amount of time with sick children and children in orphanages and refugee camps. I found out early on that if I did not address the residual emotional fallout that comes with this kind of work, my tenure in this field would be short-lived. I use my sketchbook as a performance stage for my pent-up emotions to act on. Its a coping mechanism to help me deal with the pain and sadness that sometimes comes with working with sick and suffering children.

Instead of balling up my emotions and stuffing them in a closet in the back of my mind I use my pens and paint as a conduit or a release valve.

It's amazing how, the minute I open the creative valve and put pen to paper, a sense of well-being rises through the potential gloom like a sunrise after a misty morning.

My sketchbooks are my companions and unconditional friends, especially in a world where not many people understand us creative infidels. My journals never criticize or judge my work. They are always open for business. An open sketchbook is like two outstretched arms welcoming me. They accept me in whatever mood I'm in, and they're always there, open and ready no matter where I am or what undies I'm wearing. Other than a loyal dog, you couldn't find a more forgiving friend.

Before I started working in a sketchbook, I would draw and paint on sheets of paper of various sizes, and they were hard to file and even harder to find when I wanted to look back at them. The book form allows me to follow my growth, my influences and my development as an artist as the years go by. It becomes more of a cohesive history of my work than scraps of creativity fluttering around my past.

Over the years, my pages have become less and less contrived. I used to worry a lot about making perfect pictures. I don't worry anymore, and it has made my work so much better. Sometimes, I draw pictures knowing that I will be using them in my blog or for greeting cards, and that tends to make me tighten them up a little. My new year's resolution this year, other than being taller and more attractive, is to not worry about the final resting place of the picture and just draw.

Sketching has helped me grieve and decompress during some trying times in my life and given me a record of my healing.

My sketchbook seems to be an incubator—not only for professional purposes but also for most of my creative endeavors, including speaking engagements and performances. Sometimes, I will move off on a tangent in my journal that has absolutely nothing to do with anything I am working on professionally. But sometimes (even years later), I will look back and be stimulated by a drawing I did and use it for one of my professional jobs.

I often draw during tea-time, which for me is at least four or five times a day. While others take a smoke break, I make myself a lovely cup of Five Roses or PG Tips tea with a little milk and honey and I draw. I also draw a lot during meetings.

I have stopped drawing for a week or two here and there, but not often, because when I do stop, I feel antsy and uncomfortable. This damn sketching business is medication for me, and I get emotionally constipated when I stop. I do spend a lot of time writing, but drawing keeps me in touch with the real world.

My book goes everywhere with me. Even to the toilet. (My wife does kick my journal out of our bed when she's amorous though.)

When I travel, I try hard to capture the depth of my experiences on paper so I don't forget anything, including smells and sounds that go with the sketch. I draw people more than I draw scenes. Sometimes, I will come up with a character, as a spokesperson, to comment on the places I visit. I tend to write more notes and diarize more than just sketch when I travel so that I don't leave anything out. Drawing a place helps me to see it way better than when I take pictures. I see more details in both the people and the places because I am forced to slow down and not only look, but observe as well.

I have different journals for different media. Watercolor, pen and ink in one; markers and colored pencils in another. Travel, destination and ease of use often determine which journal I use. Watercolor, pen and ink is my favorite though.

I am particular about the books I both paint and sketch in. I spend a lot of time feeling a book before I buy it. Sometimes, people look at me like I'm a pervert as I stroke and caress the paper. It's like a scene from a bloody movie. It's funny, but I have a gut feel about which books work for me. Some are friendly, and some just don't feel like they could carry my heart and soul in them.

I am fond of the watercolor Moleskine for painting in. I use Pitt Artists Pens to draw with and a basic Winsor & Newton 12 pan set and a no. 2 paintbrush. (I will occasionally use a fine sable brush with India ink to draw, but it's tough to use out of the studio.) I use Pitt

Artist Pens and Tombow markers in my marker journal because they don't bleed through to the next page.

I have developed a love for the vellum that engineers use to do blueprints on. It has one side glossy and one side matte. I love the way I can use warm gray Prismacolor Markers on the glossy side almost like paint. I cut the vellum to size and glue it into my journal.

My books sit on my bookshelf with my other important art books. They are precious, valuable books that carry a part of my life in them. I treasure them along with my Ronald Searle, Quentin Blake, Jules Feiffer, David Gentleman and Ernest H. Shepherd books.

When I look back through them, I feel something between pride and awe. I cannot believe I actually did some of the pictures. I sometimes go back and copy a style I did years ago that I had moved away from. Throughout my life there, are times when I have wished that I could turn my foot around to give myself a kick up the arse, but when I look through my journals, I prefer to pat myself on the back because I am so happy that I have documented this wonderful life I live and enjoy every day. Without my journals, hundreds of amazing moments in my life would just be lost memories in some dark filing cabinet in the back of my mind, which will never be seen again.

Trevor Romain

DURING MY RUN TONIGHT I THOUGHT ABOUT RENEE MY SWEET BUTTERFLY. I WAS VISITING RENEE IN THE HOSPITAL WHEN IT HAPPENED. I WAS TELLING HER A STORY BUT IT WAS HARD FOR ME TO CONCENTRATE BECAUSE DEATH WAS HANGING AROUND THE DOORWAY LIKE AN IMPATIENT CHILD. RENEE WAS FIVE YEARS OLD AND ALMOST AT THE END OF HER LITTLE LIFE. CANCER HAD RIPPED HER BODY APART. DEATH STOOD AT THE DOOR, RESTLESS SHIFTING FROM ONE FOOT TO THE OTHER. I KNEW HE WAS IMPATIENTLY WAITING TO GET DOWN TO BUSINESS. "CAN I HAVE A FEW MINUTES? I ASKED HIM. HE TURNED. "ALONE!" HE STEPPED OUT OF THE ROOM. THE SECOND HE DID RENEE REGAINED CONSCIOUSNESS. "RENEE?" I SAID. "HMM" SHE REPLIED. "CAN YOU DO ME A FAVOR?" "HMM." SHE REPLIED. "I WANT YOU TO IMAGINE YOU'RE A HUGE BUTTERFLY." I SAID. "YOU DON'T HAVE TO WAIT ANYMORE." I SAID. "YOU DON'T HAVE TO SUFFER ANY LONGER." SHE SIGHED. "FLY SWEET GIRL. FLY," I WHISPERED. SHE TOOK A DEEP BREATH AND EXHALED. A MOVEMENT AT THE DOOR CAUGHT MY EYE. I LOOKED UP. DEATH WAS BACK TO FETCH RENEE. BUT HE WAS TOO LATE. SHE WAS GONE. HE RUSHED OVER TO THE WINDOW JUST IN TIME TO SEE A BEAUTIFUL BUTTERFLY TAKE OFF FROM THE OPEN WINDOW INTO THE BLUE SKY.

A TRUE Confession: I LOVE BOXES AS A KID I SPENT MANY HOURS PLAYING IN BOXES!

FOR ME, A BOX BECAME A CAR, A PLANE AND EVEN A TIME MACHINE. I WON THE CAPE TO CAIRO MOTOR RALLY IN MY BOX. I HID FROM THUNDERSTORMS IN MY BOX. I KISSED JANET FROM ACROSS THE STREET IN MY BOX. I GOT SLAPPED BY JANET FROM ACROSS THE STREET IN MY BOX. I HID IN MY BOX WHEN MY DAD LOST HIS JOB AND MY MOTHER WAS CRYING. I _____ IN MY BOX WHEN MY DAD CLIMBED INTO THE BOX AND TOLD ME EVERYTHING WAS GOING TO BE OKAY. AND IT WAS!

GRANNY'S UNDIES COCONUTS

A NEW LOOK BOOK IDEA!

HOW TO USE GRANNY'S BIG OL' UNDIES AS A SLINGSHOT (AND OTHER RECYCLING IDEAS.)

TREE BRANCH.

INSPIRED BY QUENTIN BLAKE. 1

LAST NIGHT AT THE HOSPITAL I SAW THREE LITTLE KIDS (ON CHEMO) SITTING ON A BENCH LAUGHING THEIR HEADS OFF. IT WAS AN ABSOLUTELY **WONDERFUL** SIGHT.

IT MADE ME **REALIZE** HOW GOOD MY LIFE REALLY IS.

SOMEONE ASKED ME THE SECRET TO MAKING A LIVING AS A WRITER AND AN ARTIST. I SAID "DARE TO BE FREE!"

DURING MY TRIP TO THE **CONGO**

I WAS PRIVILEGED TO VISIT THE DON BOSCO ORPHANAGE IN GOMA. THERE WERE FIFTEEN HUNDRED KIDS AT THE ORPHANAGE. THE TOWN IS ONE OF THE POOREST PLACES I HAVE EVER LAID EYES ON. IT WAS ABSOLUTELY DESOLATE, YET FROM THE DUST GROWS AN ABUNDANCE OF WARMTH AND HOSPITALITY. I WILL **NEVER FORGET** THOSE AMAZING CHILDREN. I SPENT THE DAY AT THE CENTER WORKING WITH VARIOUS GROUPS OF KIDS.

DURING THE AFTERNOON A YOUNG BOY WHO WAS NO MORE THAN FIVE YEARS OLD TUGGED AT MY ARM. I LOOKED DOWN TO SEE A PAIR OF BIG BROWN EYES LOOKING UP AT ME. THE INTERPRETER SAID THE BOY HAD A QUESTION FOR ME. I PUT MY ARM AROUND THE BOY AND PULLED HIM CLOSER. HE TOUCHED MY FACE WITH HIS HAND. "MISTER CAN YOU HELP ME FIND MY MOMMY," HE SAID. I LOOKED AT THE BOY AND MY HEART BROKE. I WASN'T SURE WHAT TO SAY. I MEAN, HOW DOES ONE ANSWER A QUESTION LIKE THAT? HIS MOTHER HAD DIED. "WHERE DO YOU THINK YOUR MOMMY IS," I ASKED. "OH, SHE'S IN HEAVEN," HE SAID QUITE COMFORTABLY. "I'LL TELL YOU WHAT," I SAID, "WHEN I SAY MY PRAYERS TONIGHT I WILL ASK GOD TO PASS ON YOUR LOVE TO YOUR MOM." "OKAY," HE SAID. "THANKS MISTER."

SKETCHBOOK COVERS

Trevor Romain's Journal ~four~

Trevor's Journal #7

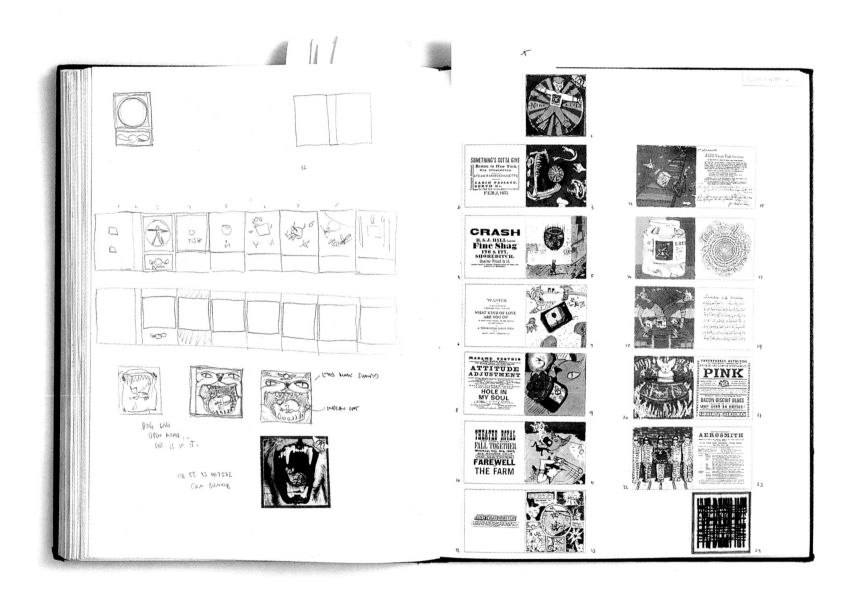

STEFAN SAGMEISTER

Stefan grew up in Bregenz, Austria, studied at the University for Applied Arts Vienna and then at Pratt Institute in New York. He runs a design studio in New York City. His work can be seen at www.sagmeister.com and in two books: *Things I Have Learned In My Life So Far* and *Made You Look*.

I started keeping my first sketchbooks when I was sixteen or seventeen while traveling. But these books were very different, not catalogs of ideas but travelogues containing orange wrappers, plastic bags and ticket stubs glued in for (not very original) collages among the sketches. After art school, I started to draw in the large books. I put in anything that came to mind—doodling, stoned drawings, ideas, shopping and to do lists—which resulted in so many filled books that it became a drag to look through them.

I was forced to learn how to draw in order to get into the University for Applied Arts in Vienna (whose design professor Paul Schwarz would not take anybody without life-drawing skills). So I trained hard every day for a year, got in, and immediately stopped drawing. Even though I have little interest in drawing in itself, I am glad I trained. It does come in handy for work. During the last twenty years, I've mostly drawn to visualize an idea, not because of the pure joy of drawing. Other than faxes to my girlfriend, I don't draw much outside of this book.

These days, I try to keep the books neat. I usually dedicate a double page spread to one project and try to contain all ideas about that project on that spread. Only when it is completely filled up do I start another spread. I write the name of the project on the upper right hand corner.

I often come up with concepts for design projects while traveling, in newly occupied hotel rooms or even in planes. I either draw into my daily planner or on scraps of paper I collect, little, tiny sketches on napkins and such that I then transfer to the big sketchbook upon returning to my studio. I sacrifice spontaneity (which I am not interested in for this context) but gain a possibility to improve the idea.

I buy the Cachet Classic Black Sketchbook, the largest size it comes in, at Sam Flax in New York City. Sometimes I cut fifteen to twenty pages out of it, so when I glue stuff in, it does not bulk up that much. I use all sorts of media, but mostly pencils, colored pencils, markers, Xerox copies.

I keep my sketchbooks all together. I fill about one large book per year, and I have about twenty filled books now. The Museum of Applied Arts in Vienna (MAK) owns a facsimile copy of my first fifteen books. They are a nice overview of any idea I ever came up with. While I don't have ready ideas in there waiting to be transformed into real projects, I often find the seed for an idea that can sprout into something else.

Blank pages never intimidate me. It's a sketchbook. It can't intimidate me. I can beat the shit out of it.

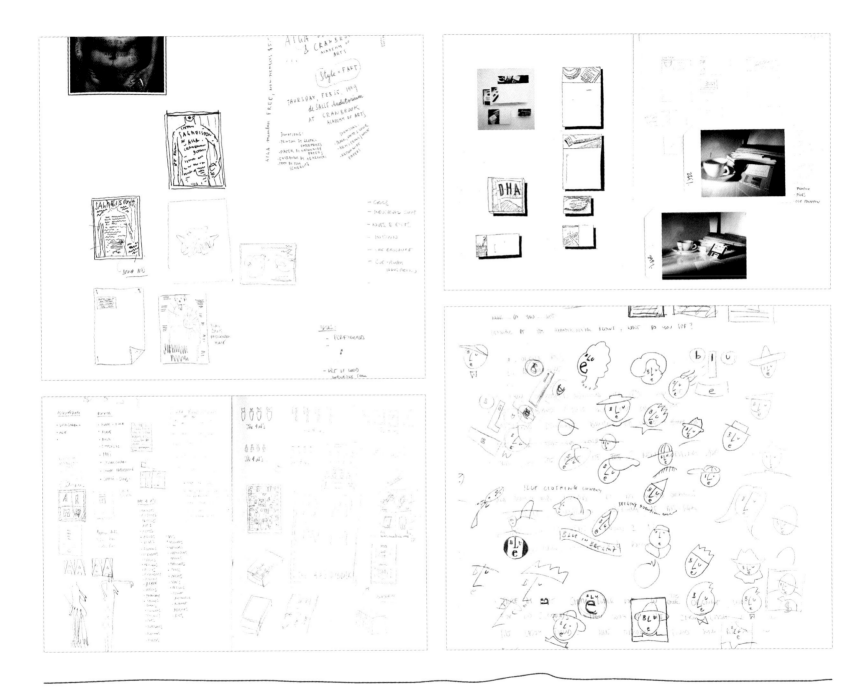

CHRISTIAN SLADE

Christian grew up in New Jersey and San Diego. He earned a BFA in drawing and animation from the University of Central Florida, and a MA in illustration from Syracuse University. Since college, he has lived on the outskirts of Orlando, Florida, working as a freelance illustrator. His diverse projects range from a series of all-ages graphic novels called *Korgi* to drawing on the Disney film *Brother Bear*. Visit www.sladestudio. com for his Welsh Corgi fantasy art and www.christianslade.com to see his online portfolio.

I have been addicted to sketchbooks my whole life. In the early years, the books held drawings of favorite characters from TV, cartoons and toys. In high school, the work became more reflective and moody, and filled with plenty of monsters. During my first year in college, I realized that I was having a difficult time getting the ideas in my head onto paper. I decided to hold off on drawing from my imagination and focus heavily on life drawing. My goal was to learn how to draw and only then apply it to my imagination and abilities as a storyteller.

My work was very academic, and I spent a decade resisting the urge to wander off on an artistic tangent. I was a total sketchbook junkie, filling up a sketchbook every three to four weeks. I slowly saw results and was encouraged to keep going.

In the years since I finished my degrees and started to get illustration work, I have retuned to where I was when I was eighteen and committed to learning how to draw. I am thrilled to finally draw stories worth telling without feeling limited by my abilities.

I never stop drawing. If I am having a tough time with my artwork, I actually draw more to get through it. Of course now, because of my schedule, I take a lot longer to fill up a sketchbook, but I still make time for this wonderful activity.

I have been documenting the life of my new baby twins in my sketchbook. I think significant events are great drawing opportunities as well as a chance to give it that extra level of magic! Drawing my children is my way of celebrating their existence. It has been amazing being a father, and I want to capture

these fleeting moments before they are grown up and gone.

I love my Welsh Corgis, Penny and Leo, too, so it is very important to include them in the pages. It is now getting very interesting as Nate and Kate are starting to hold their heads up and be aware of the dogs. It's been fun capturing moments like Leo bringing toys to a three month old who can't even sit up yet or Penny constantly hovering near Katie and being very motherly.

I always keep one sketchbook that I consider the "formal" one; it features sessions of intense study, usually on travels or around the house, a visual journal with a little text added. I bind these books myself with thick watercolor paper so I can really apply the paint if I want to. I also keep many cheap spiral-bound pads around

NATE

KATIE

Though this drawing was done while in the hospital, I am adding this text a few weeks later. (Indeed, much of this moment is still fresh in my mind, & I can now write about things that have happened since this scene. Ann looks so motherly here, providing nutritious premium ["colostrum"] to Nate and Kate. This only lasted a week, attempting to feed them both directly from the breast; what ever was my guess was the tedious task of dual feeding them at the same time. The fanatic lactation consultant she kept on pushing was creepy. Soon after getting home, Ann decided to pump exclusively — which made it for everyone, not just Ann, to feed the twins. Even before we left the hospital, the feedings augmented with formula. First using the promised bottled formula, then mixing with the powder mix. I recall the hospital stay feeling like it lasted weeks, though this really was a visit in Tuesday night/Friday morning (maybe?). The first night, I slept on a nice pull out sofa bed & Ann & I will get 1-3 more... though the nurses would wheel in the twins who were screaming with the hungers. At one point, the staff implied they put the twins in the room with us while we tried to sleep together. It was too bad the way we keep there, in the dark, hearing the intermittent wails of the newborn twins... It was too much for Ann & I who had been through a rough day & night. We needed sleep, so the nursery took the twins for a few hours while the parents refreshed. Once rested, Ann & I found we were able to take better care of the babies. During the hospital stay Maggie & David visited everyday while Aunt Nanny, Paul, & May stopped in too. Len/Susan & the Florida families sent flowers & presents. While I've written this text, I have changed 2 diapers & held each of them with one arm while I wake with the other. Kate has fallen first, she is sleeping now, & Nate now sleeps peacefully against my chest as I finish writing these last few words.

Drawing my children is my way of celebrating their existence.

the studio that are a notch above scrap and fill them with ideas and random phone doodles.

I'm actually not a big fan of the word "doodle." For me, it explains lazy motion with a drawing instrument. I'm not a big fan of the word "sketch," for that too seems to hint at vacancy somewhere in the creator. I enjoy the word "draw," which sounds much more like what really goes on. Though I'm not against the term "sketchbook," a more accurate definition for one of these books would be "drawing book."

Mostly, my sketchbook work is spur-of-the-moment, though I do try to set up events and places where I can really work in it.

When I go to the zoo, I like to get maps of the place and figure out which animals I want to see the most and devise a strategy for the best way to move through the park. I look at my sketchbook adventures as a ritual. I sometimes joke that sketchbook action is like "hunting." My weapons are my book, pencils and brushes, and I am always on the move looking for solid drawings.

I love sharing my book with others, and I love looking through other artists' sketchbooks even more. In college, I spent weekends drawing caricatures at Sea World in Orlando. This experience helped make me very comfortable drawing in public and taught me a few tricks. For instance, if you get overwhelmed with questions from onlookers, put on headphones—even if there isn't music on—just so you don't have to deal with answering people.

I used to draw in different types of sketchbooks I'd bought in art stores but never found exactly what I

wanted. So, in 1999, I began binding my own books. By binding the book myself, I get to select everything and create exactly what suits me best. I have a sort of ritual when it comes to building the book. I like to have music or movies on as I create, sew and glue the book together in my studio.

I am also a big collector of things like comic books and Star Wars toys. I display everything in my studio like a hunter. I also display my sketchbooks on a shelf when I am done with them, just like my toys. The finished books fill a shelf in my studio. I have well over fifty of them.

I use whatever materials happen to be closest to me— generally a small watercolor set, Winsor & Newton Spectre Gold II sable brushes, Micron pens, fountain pens, both mechanical and wooden pencils and a tube of opaque white.

I like the fact that a sketchbook is like a portable studio and not just a few pieces of paper. Once open, it has a presence and a history with its previous pages. It is also a work surface, something solid and flat. As the pages progress and fill with drawings, it seems the drawings alone are good but that together, they are something much more.

I think there is something special there, just like when a number of people gather; there is that sense of power and purpose, of life. There is a connection there between the life of an artist and the life of a drawing and all the ups and downs that each go through. For me, all drawing, not just sketchbook drawing, is so real. I am definitely at my best there, closer to those eternal truths and answers we all search for. Sure, it's still far away, out of reach, but I am somehow closer to the meaning of it all … and it's so much fun to do!

VERNAY'S RATEL - HONEY BADGER

SAN DIEGO ZOO

July 2007

I ARRIVED INTO SAN DIEGO A FEW DAYS EARLY, ACTUALLY 2 DAYS, TO DRAW AT THE WORLD'S LARGEST ZOO WITH ANIMAL EXPERT & FRIEND BRAD TABAR. THIS FIRST DAY WAS A HALF DAY STARTING AT AROUND 3PM. THE CROWDS WERE AWFUL AND I WAS A BIT RUSTY GETTING STARTED. SO I DREW A HUGE CROWD TO WARM UP WITH. & THIS SEEMED TO WORK AS WE BOTH HAD GREAT DRAWINGS LATER THAT DAY. EVENTUALLY, THE CROWDS THINNED AND WE GOT SOME EXCELLENT VIEWS OF POLAR BEARS, REINDEER AND MY FAVORITE OF THE DAY, THE VERNAY'S RATEL - OR "HONEY BADGER", WHICH HAD A WONDERFUL SIMILARITY TO PENNY & LEO WHOM I MISS DEARLY!

DAY 2 - OF THE SAN DIEGO ZOO BEGAN WITH THESE DUCKS BELOW, SILHOUETTED IN THE MORNING LIGHT. SKETCHED THEM WHILE BRAD WAS IN THE BATHROOM.

WE TOOK THE SKYRIDE TO THE BACK OF THE PARK WHICH WAS HARDLY POPULATED WITH VISITORS. OUR FIRST STUDY WAS THE MAGNIFICENT

SECHUAN TAKIN.

SIMILAR TO THE MUSK OX, THIS ANIMAL WAS ONE OF THE COOLEST HOOVED ANIMALS I HAVE DRAWN. THE CONDITIONS WERE HOT, WITH LITTLE SHADE AND I FOUND THEIR SUBTLE FORMS, ESPECIALLY IN THE FACE, DIFFICULT TO CAPTURE. ALONG WITH AROUND 4 & 5 ADULTS, THERE WAS AN ADORABLE CALF THAT GALLOPED AND TEASED THE OTHERS.

"BULAN"
FEMALE SUN BEAR CUB.
10 months OLD

ELWOOD SMITH

Elwood was born in Alpena, Michigan, attended the Chicago Academy of Fine Arts, and now lives in Rhinebeck, New York. He is an illustrator and more of his work can be seen at www.elwoodsmith.com.

Carrying around a sketchbook is of no interest to me. I fully appreciate artists like Alan E. Cober who carried a sketchbook around like I carry my wallet, filling it with marvelous imagery, but I am not particularly interested in drawing from life. I prefer a digital camcorder if I want to capture stuff that catches my eye. Let the better drawers do the drawing, I say.

I'm more of an idea man. I love manifesting dreams, which, in my case, has been very cartoon character influenced. As a little kid, I soaked up the great Sunday comics from the 1940s and 1950s. I drew as a kid for free, but I now draw for a living.

I doodle whenever I'm on the phone for more than thirty seconds. I draw doodles over watercolor splotches that I make while trying to get the right color for a section on an assignment. The shapes suggest a figure or something, and I use a pencil or pen to make the lines over the fluid, colorful, splotchy shapes. Nifty imagery sometimes appears. Most of it is crappy and gets tossed out. I do feel guilty when I toss the bad ones out. Kind of like when you select a cat from a batch of cats, abandoning those that are less appealing. I draw with whatever mark-making tool is handy, and I cut the doodles out and paste them in a bound sketchbook myself.

I tape mostly snippets of watercolor paper, but sometimes I've doodled on an old envelope or a blow-in card from a magazine or a Post-it note. Whatever I've doodled on is selected, trimmed down to the part I like and taped into the book.

After I select the best doodles from the batch, I end up with art that is freer than I normally do for assignments, I use these doodles for experimental work using Photoshop to create a collage effect, and I also use them for visual stimulus to shake out the cobwebs. When I am in need of creative stimulus, I thumb through the doodle books.

I've been doing these cut and paste books for probably fifteen years. Maybe longer, I can't remember. The oldest ones are pretty dreadful. I cringe at my older stuff. My drawings have improved, but my approach has remained the same.

I draw these things only when I'm on the phone or, sometimes when I'm waiting for freshly applied watercolor wash to dry. Better than chewing nervously on my 2.5 H pencils or falling asleep at my drawing table.

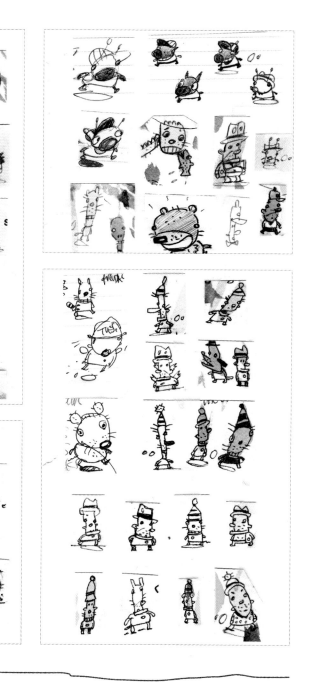

THE EARTH WAS _____ AND VOID AND DARKNESS WAS OVER THE FACE OF THE _____

PAUL SOUPISET

Paul was born in San Antonio, where he still lives. He studied advertising design and studio art in college and is now creative director of his design firm, Toolbox Studios. You can see more of his artwork at www.paulsoupiset.com.

Many of the sketches shown here are part of a Moleskine watercolor journal series I began in February 2007: I embarked on a daily discipline of creating simple watercolored sketches during Lent (a forty-day period of self-examination observed between Ash Wednesday and Easter in more orthodox Christian traditions), primarily as a means for me to slow down and be still every day during the forty-day period.

It's an imposed discipline wherein I must sit still long enough to breathe, consider the blank page before me and pour myself onto the page with intentionality. Yes, to express myself, and then to share with God, with other viewers as well. Adding the color made each session last a little longer, teaching me much-needed patience. The watercolor must dry before I scan it, for

example. One might think that Lenten art ought to be rendered in grays, perhaps using rustic vine charcoal or comprising still life tableaux. Instead I chose whimsy, humor, vivid color.

My journal also lets me pray and participate in the act of creation. There's this term in the Hebrew scriptures, the *Imago Dei*—this idea of being formed in the image of a Creator God who, in turn, delights in our creativity. I like and trust that notion.

Lately, I've forsaken my larger scale paintings to make my Moleskine sketchbooks my primary medium. I retreated to sketchbooks when I got frustrated and impatient with painting. The end product of a painting usually comes so much later than the initial inspiration that the original meaning became lost for me. I was thinking more about my audience and less about the inspiration and subject matter. The journals retain both a sense and a reality of intimacy and immediacy,

even when being shared. Sometimes, I'm surprised by what I find when I look back through old journals. That's the best part—rediscovering part of myself. People are forgetful creatures, and this medium is all about loose snapshot remembrances.

Some of my sketchbooks are places of spiritual retreat, some are visual journals, others are travelogues—they serve as a visual book of days. Some of my other sketchbooks are the places where I collect thumbnails for my client work. Lots of times, they're just how I blow off steam; at lunchtime, I'll duck into a little taqueria downtown and engage in wordplay, cartooning or sketching my environment.

When I'm on a road trip, every rusty gas station, every side-road telephone pole, every water tower is a potential sketch, every pit stop an opportunity to draw. A small digital camera helps if you don't mind occasionally drawing from a photo. Drawing from

memory is so much more rewarding, though. I love driving alone, along stretches of open roads. I'll look for a small town, pull off the highway, find a nondescript diner and sit and eat and sketch. For the last four or five years, for some reason, I've been photographing old highway overpasses with the intention of turning all those shots into drawings sometime soon.

There's usually a Moleskine in my backpack, but I'm not disciplined enough to take it everywhere I go unless I'm in the middle of an assignment. I work in phases, being heavily inspired for a month at a time, then letting the books sit, sometimes for weeks on end. I've recently noticed that my energy and inspiration to create frequently arrive with a change in the weather:

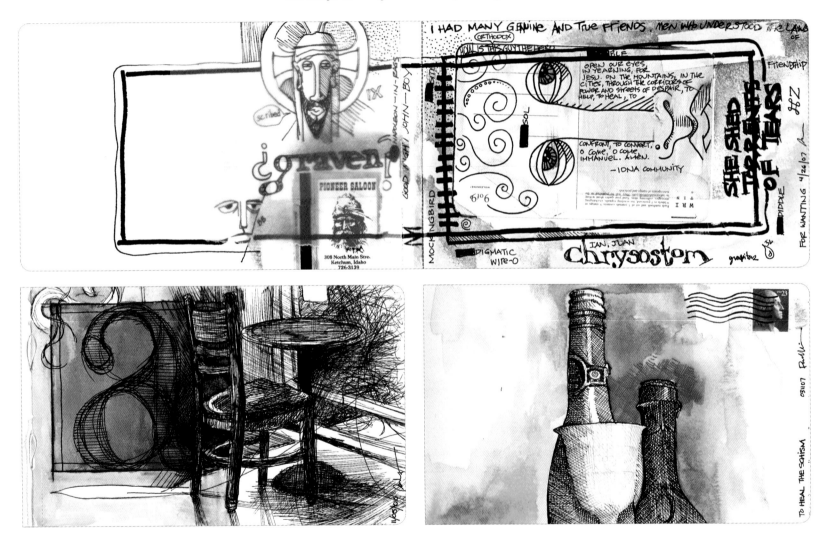

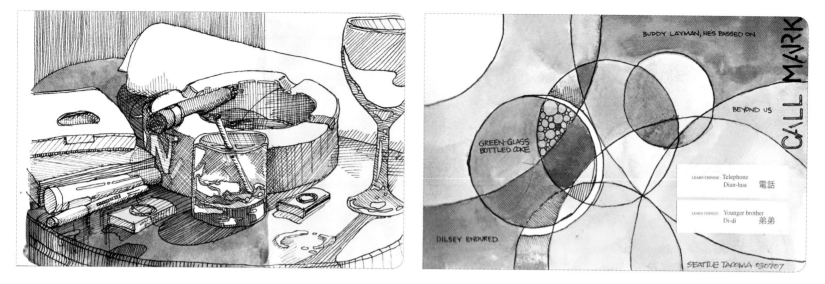

the onset of spring, or the first windy day in autumn or an unexpected thunderstorm, something like that.

This loose chronicling style feels very natural for me. Over the last two decades, I've kept ongoing journals full of cross-hatched travelogues and layered collage elements that inspire/fuel my other art (paintings, songwriting, etc.). I was very inspired at one point by the journals of Dan Eldon, but when I was handed my first Moleskine journal as a gift around 1999 or so, I was hooked. My journals have become less discursive and more visual as I get older. I like that. They actually say more now, in a way.

Some of my books are pen-and-watercolor only—the Moleskine brand watercolor journals. Now, I've got large "office Moleskines" for client thumbnails, a small "getting things done Moleskine" that organizes my life and my sketch journals as well.

I use and recommend Moleskine brand watercolor journals to those who plan to add watercolor or gouache to sketches. The paper is archival and the leafs are perforated so you can send sketches out as postcards. When my wife and I travel, we like to sketch the B&B or guest house we stayed at, and then leave the sketch as a thank-you. I always leave the first page in a journal blank, and then the second page usually has some sort of introductory micro-cartoon or fragment of poetry, sort of an invocation.

Staedtler pigment liners (4-pack: .01, .03, .05, .07 mm), black; Moleskine watercolor notebook, large; Winsor & Newton Artists' Watercolor Compact Set (11 cm to 13.5 cm)—all of this is small enough to fit in a large jacket pocket or the front pocket in my five-dollar Gap backpack. I try to take these supplies with me on every vacation, every road trip, and lately, I keep them with me everywhere I travel.

I'm a doodler. Marginalia is a huge part of my art; I can't help it. The doodles act like a Greek chorus, commenting on the main scene.

I'm much more disciplined at work than I am in my private artwork because there, we adhere to a formal process—each team member, each project, follows a discovery process prior to turning on the creative engines. At work, the goal is to efficiently arrive at the best solution. When I'm sketching, however, process is kept to a minimum; otherwise it would be drudgery. Margins and grids and baselines become deconstructed. Our designers' sketchbooks are also teaching tools around the office, especially when talking to student groups and interns about the importance of thumbnailing and handwork and not rushing off to work out ideas on the computer. We still present tight pencil thumbnails for our initial client proofs instead of computer roughs whenever feasible.

I think my real training was being a curious kid sitting on a barstool and watching my mother sculpt clay, paint watercolors, prepare vats of dye for her batiks, draw and occasionally cut stained glass, and then hanging out at my dad's office, studying blueprints and his architectural hand-lettering. Much of what I've done since can be traced to the wide-eyed wonder of childhood and emulating the creativity I saw.

ROZ STENDAHL

Roz was born in Manila, Philippines, and spent her childhood around the United States and in Australia. She attended the University of Missouri and graduate school at the University of Minnesota. She's lived in Minneapolis since. She is a graphic designer, illustrator and book artist and teaches bookbinding and journaling classes at the Minnesota Center for Book Arts and other venues. Roz has worked on cover and text illustrations for hundreds of college textbooks. Her personal art can be found at www.rozworks.com and www.projectartfornature.org.

I love blank pages. They scream possibilities to me. They clamor for attention. They call to me from across the room while I'm trying to do other work. When I get to the final signature in a journal, I go to the shelf of books I've made and take a couple down, one at a time, turn them around in my hands, open them and look at the type of paper I've used and decide if this is the type of paper I want to work on for the next four or five weeks. It's a very happy moment. Sometimes, I put all the books back and decide to think about it a little longer and decide the next day. But I think that's just an excuse to look at all the books again! When I open them, I see all the fun I'm going to have filling them.

I have always been fascinated with books, and so I love everything about books. I love the way they feel in your hands; I love the narrative aspect, the chronology of the pages, the accessibility, the retrieveability of information; everything. It isn't surprising I went to work in publishing, first as an editor, and then later as a designer and illustrator.

That's why it is important to me that I make my own journals to do my visual journaling work. It's sort of like a painter stretching and gessoing his own canvas. I want to make my books because I want them the page size, number of signatures and paper type that I want to use, because of the type of work I want to push myself to do at the time.

I also like the fact that everything is there, bound in, as it was done, nothing loose to get out of place or lost. I never tear pages out of my journals. Beautiful and ugly pages reside side by side within my journals, and that's important to me because it explains my process and progress. Everything there is there for a purpose or represents something I've learned or noticed or tried.

I think there is also an idea of intimacy connected to books for me. They are objects that you pick up and handle. And I like the idea that I can pick up pieces of my life in that way.

My journal has always been for me. Other people might look at my journals and enjoy them, but bottom line: I keep it for me and only me and put in it what appeals to (or appalls) me, what interests me, without thought to what someone else might think, because at the end of the day there is just me and my journal.

I explain this to journaling students, and those that get it I know will end up keeping journals for the long haul. Those that don't get it keep a journal for a

January 26, 2003 10:45 a.m. #3
Dot in TV room. She just came in from yard time
with Dick, but won't eat any thing.
Susan will be here before noon.
Indigo + violet pencil

short while, get slammed by critical feedback and shut down. Humans have a tremendous need for approval, assurance and recognition even in small incremental things like gradual improvement in their drawing skills. We also have a tremendous desire to share our discoveries with others and find connection. When a new journalkeeper does that without developing a bit of a protective skin first, even an innocuous comment can send him into a tailspin. So I explain various ways to develop a protective skin, forgive others for their own blocked creativity and chug merrily along.

My visual journals are a record of my life and my creative process. I see them as a lab-manual for working out how my brain works, what captures my interest, what engages me, what I am experimenting with artistically (different media). Through my journals, I discover what my next creative project should be.

They are also a playground. One rule I have in my visual journal is to keep pushing and experimenting. It isn't about making perfect pages. In fact, I feel if I don't

I love blank pages. They scream possibilities to me. They clamor for attention.

make a really horrible mess every five page spreads or so, I'm not trying hard enough to push and experiment.

Keeping the visual journal has been a lifelong assignment. Look around. Notice things. Listen. Take notes. Gather evidence. Friends would probably say that's my mantra. On any given day I might decide things like, "I'm going to work on birds this afternoon," and go over to the Bell Museum of Natural History where I can count on stationary specimens to sketch from and focus on. On another day, I might decide that I want to work on my dip-pen skills and do a series of drawings in my journal involving those tools.

I filled forty-three volumes with daily life drawings of my dog, Dottie. The result is a wonderful record of time spent with her, thoughts on our day and thoughts on the drawing or painting medium I used. I recommend

this type of project to anyone who has a companion animal. It's a great way to spend quiet time, really get to know the shape of another being and push your drawing skills. Most drawings were completed in five to ten minutes (she usually walked away before that). And it had to be daily.

My journal is the place where I warm up to do my professional work. It's the place where I note ideas, connections, decisions, results of experiments, instructions to myself on how to repeat a result, etc. Breakthroughs in my thought process about how to approach a creative task get captured here. All of this gets used somehow in my professional work, either in how I see things compositionally to arrange a drawing or a design, how I deal with color and why I select the pigments I select, or simply how I improve my hand-eye-brain coordination. Journaling is the process I use to get my work

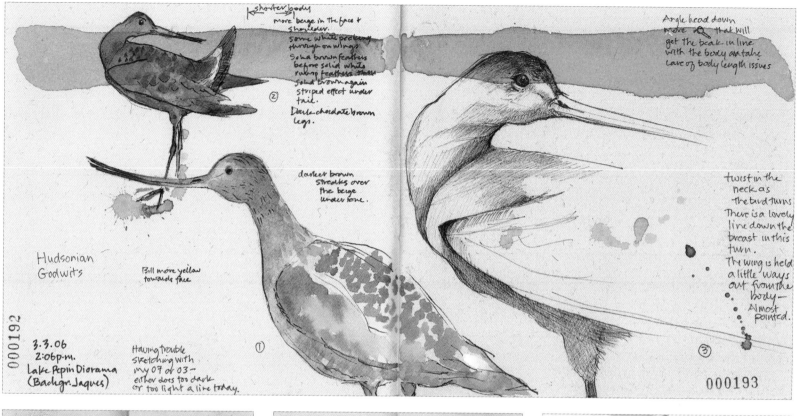

shorter body

more beige in the face + shoulder.

Some white peeking through on wings

Solid brown feathers before solid white rump feathers then Solid brown again striped effect under tail.

Dark chocolate brown legs.

②

Hudsonian Godwits

Bill more yellow towards face

darker brown streaks over the beige under tone.

①

000192

3.3.06
2:06p.m.
Lake Pepin Diorama
(Backgr. Jaques)

Having trouble sketching with my 07 or 03 — either does too dark or too light a line today.

Angle head down move ⟲ that will get the beak in line with the body and take care of body length issues

twist in the neck as the bird turns

There is a lovely line down the breast in this turn.

The wing is held a little ways out from the body —
Almost pointed.

③

000193

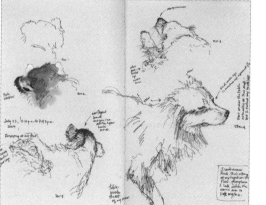

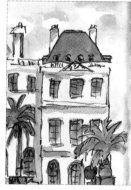

Luxembourg Gardens
(sp?)

The palais - very quickly sketched. With one very short and one tall potted palm. There are also potted citrus trees.

6.07.06 1.18p.m.

done; it's all one thing, my way of responding to the world.

If I haven't journaled for a few days, just seeing the journal on my desk, or having it in my pack when I'm out and about is enough to get me to pick it up and reconnect. If I've got a moment to spare, I give it to the journal.

Lately, friends have been saying that they think my journals are my art form. Does this mean that they don't like my paintings? Does it mean that the sheer

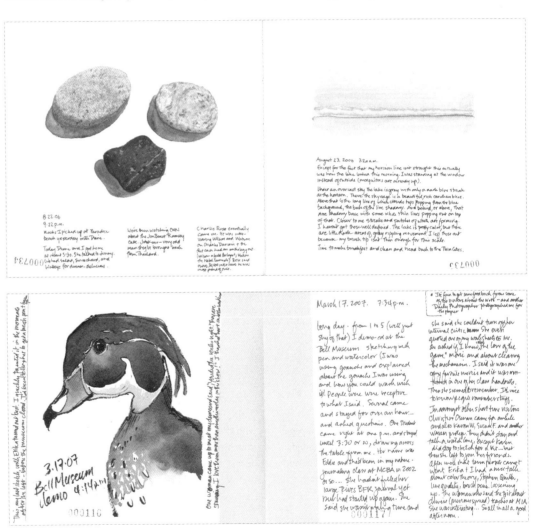

volume of material generated has to be categorized as such to understand it? I don't know. My journals are both sufficient unto themselves and a springboard to my other art.

My journals allow me to stay present in my life and engaged with my surroundings. I find they are a great repository of moments of awe, wonder and gratitude. Additionally, they serve as a file cabinet of information: research, sketches, newspaper clippings that have caught my eye, etc. Therefore, I index my journals.

Before computers, the indexing was done by hand, and while I was pretty anal-retentive about it, the index was full of human errors and difficult to really access with 100 percent efficiency. Then I started indexing on the computer. I can search keywords like "bookbinding" and find all the entries that relate to that topic. I print out the index for each volume and paste it into the back cover. And I have a master printout in a three ring binder.

When I start a new journal, I will cut out several pages throughout the book, leaving a tab. This holds space at the spine but allows room for collaged pieces. If I get to a page that has one of these tabs and I don't want to paste something across it, I might skip a spread and come back to it. This is very rare, however. One of my rules is to take a page as I find it and just work on it, whatever the "problems" might be. To this end, I prepaint pages so that when I get to a new page, it's already painted and I have to deal with what is already on that page.

An absolute rule with me is that I never remove a page; all pages, no matter how awful, how poorly executed, remain. It's all part of the learning process for me, and if they aren't there, I am not documenting my entire journey. That's very important to me. I learn the most from failed experiments.

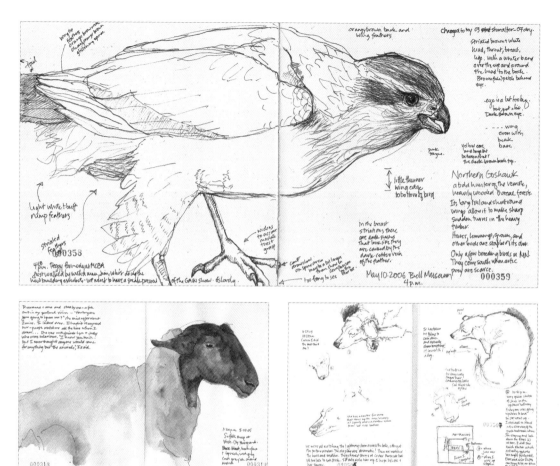

Happy accidents happen all the time if you keep trying different things. As you work around a page, drawing multiple images, they tend to take on relationships with the other images. This is especially true when sketching live animals. I tend to have several sketches on a spread going at the same time as the animal moves about. Each time it returns to a position similar to a sketch I've started, I'll work on that sketch. After a while, one sketch just becomes "more finished" and polished and the others are great in their "half-done" reality because they also show things observed and learned. They relate to the more finished piece, creating a context of the moment. I love this.

CHRIS WARE

Chris was born in Omaha, Nebraska, and has a BFA from the University of Texas at Austin and attended the Skowhegan School of Painting and Sculpture. He is a cartoonist (or a writer and artist) and lives in Oak Park, Illinois. In addition to his many comics and illustrations, he has published two volumes of his sketchbook, both titled *The ACME Novelty Datebook*.

I made tepid attempts at keeping a sketchbook in high school but nothing ever took, as I was too distracted by the popular culture that surrounded me at the time to stay with anything for more than a few pages. My freshman year in college, I started keeping one simply because I realized that if I didn't start soon, I probably never would. (Plus, I was so miserable and lonely at that time I wanted something in which I could record how fascinating I thought I was.) Needless to say, I was fairly disoriented at this point, trying to grow up quickly into the ideas of fine art that I was encountering in school and feeling extremely inadequate in the face of them. This was in the mid-1980s, when so-called postmodern painting was in full bloom, with lots of juxtaposition and overthinking, really confusing me about my own aims and the general viability of doing something directly emotional on the printed page. However, it was about two years later that I first encountered the Zwei

Tausend Eins facsimiles of Robert Crumb's sketchbooks. It was seeing these books that saved my life, I think. I'd already been familiar with Robert Crumb's comics but had not been aware of the regimen he put himself through to improve his drawing ability, to say nothing of simply trying to see the world as intensely as possible, which was what I'd really wanted to do when I originally got to art school but had lost sight of. I'm not sure that without seeing his sketchbooks I'd have had the will or clarity of thought to get myself back on track. I immediately concentrated more on trying to draw directly from life, which I was already doing in a more dutiful way in my life drawing classes—the best classes I ever took in school, by the way, apart from literature classes. As a result, I suddenly found my sketchbook to be a refuge and no longer something to remind me of how irredeemable and unintelligent I was. In other words, Robert Crumb put me back in

touch with myself, which is something I hadn't even really realized I'd lost from my childhood until his sketchbooks showed me I had. I really think he's one of the most important artists alive for this reason, because his work provides this same honest rudder to a reader even if he or she isn't an artist.

I've kept this derivative Crumb-esque format of sketchbook ever since, mostly using it as a means of trying to see the world better, drawing uncensored and indulgent comic strips, planning sculptures and paintings, recording meandering diary entries and the usual "self-dares." As time went on, though, I discovered in my mid-thirties that I was forgetting large chunks of my life. Whole months of my time on Earth were simply gone, lost somehow for the time spent making up stories at the drawing table. So, in mid-2002, I started an additional comic-strip diary to

Whole months of my time on Earth were simply gone, lost somehow for the time spent making up stories at the drawing table.

keep track of it all (an idea which I believe the cartoonist James Kochalka should be credited for, as well.) I've kept this diary ever since, writing/drawing in it in the morning or the evening about the general events of the previous day: odd details, dreams, stupid or angry things I said to people that I regret, etc. There are generally anywhere from one to twelve days covered per page in it, depending on how interesting my life was at that moment. Since my daughter's birth, I've been keeping it almost entirely for her benefit as a record of her early life, and if I'm able, I'll keep it up until my demise. Then all the books will go to her if she wants them.

They won't be printed, however, as they're much too personal and dull for anyone other than my family to bother with. (No one, not even my wife Marnie, reads them.) Included here are two of the least incriminating recent pages, which are consequently also some of the least interesting, for which I apologize.

Since starting this diary, my other sketchbook has taken something of a secondary role, especially since I don't really leave the house anymore. Many of the drawings in my earlier books were done on trains or in classes while I waited for time to pass so I could go

back and work on my comics. On top of that, I've more or less incorporated much of the thinking I used to do, apart from the comics, into the construction of the comics themselves. The free-for-all that the sketchbook provided is not quite as necessary anymore. However, I still draw from life occasionally, because I don't think anything else forces one out of what I think of as "adult-template mode" (i.e. that particular frame of mind when one isn't really seeing the world, but just sort of half-blindly finding their way through it), which is, ironically, analogous to what cartooning is, more or less.

I take both of the books with me when I go on extended trips or when I know I'll be somewhere overnight, though not when I go to the grocery store or to friends'

houses anymore as I used to when I was younger. Maybe when my daughter is older and I'm out of child-watching mode, I'll start carrying them everywhere again, since old men are permitted to appear openly idiosyncratic—moreso than thirty-nine-year-old men are permitted! I also carry a pocket sketchbook and have since the 1980s. It's basically a miniature version of the big one, and writing down or drawing something in it is almost certain death for that idea or drawing, since I never reread it unless I'm looking for a measurement or a phone number.

I still use the rather terrible dark blue Strathmore books I started with in 1986 and which my mother very kindly bought a stash of as a gift for me one year.

They have almost worthless paper and are poorly bound, but simply out of habit, consistency and sentiment, I've stuck with them. The earliest Strathmores actually had very good paper in them, but art supplies, like much else in America, haven't generally improved as time has passed.

Mostly, I use a dip pen or flexible nib fountain pen filled with waterproof ink when I'm drawing from life and a Rapidograph and brush pen when I'm drawing in my diary. Also, occasionally, watercolors, colored inks, etc.—nothing special.

Incidentally, drawing is very rarely, if ever, pleasurable to me. It would be sort of disgusting if it was or at least extremely embarrassing and indulgent to print the results.

I spend a lot of time worrying about whether the pages are interesting or not. And whether certain colors work. Whether a new drawing has ruined an otherwise not-too-terrible page. All of which are paralyzing and stupid thoughts, but I'm an extremely uptight person. (I actually try to use the sketchbook to not be so uptight, but it obviously doesn't work so well.) I do occasionally try to come up with different approaches to storytelling, but I usually feel ridiculous doing such things, as it reminds me too much of art school, and then I start talking to myself while I'm drawing.

It was probably, in the long run, a mistake to publish my sketchbooks. One of the worst things that can happen to an artist is becoming aware of oneself as a "personality," which I've nonetheless tried to make fun of with the books themselves. It's also another reason I started keeping the private comic strip diary.

When I look back through the books I've filled, I feel appalled. And especially that the drawings which I thought were the slightly better ones are actually much worse than I recall.

LITTLE FRENCH CAR,
w/little French Trash Can.

DAVID MAZZUCCHELLI.

ART'S PORTABLE ASHTRAY.

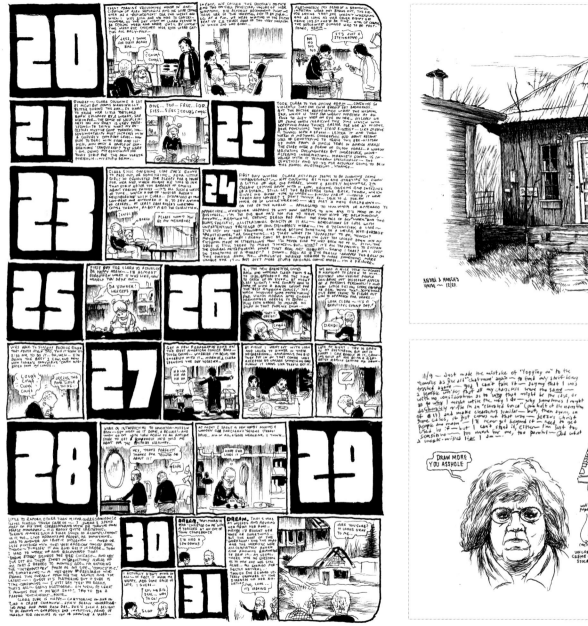

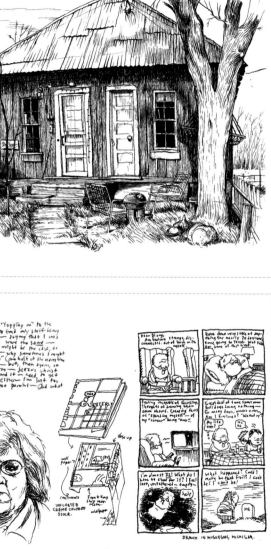

MELANIE FORD WILSON

Melanie was born in Kellogg, Idaho, and spent her childhood moving around the United States and Canada. She has a BA in English from the University of Manitoba in Winnipeg, earned a second degree in journalism from Mount Royal College in Calgary, Alberta, and worked briefly as a journalist before returning to Grant MacEwan College to get a degree in visual communication. She now works as a freelance designer and illustrator in Burlington, Ontario. Several of the children's books she has illustrated and much more of her work can be seen at www.melaniefordwilson.com.

I love drawing. Love it. It's as much a part of me as my hair or my toenails, as vital as oxygen. It's just something I do, like breathing. When I draw, I almost always feel completely at ease, like I'm floating. Everything seems suspended, lighter, better. Even when I'm frustrated with what I'm drawing or it's not turning out the way I want it to, it feels good.

I often tell myself little stories about whatever it is I'm drawing, and later, looking back on the drawing, I will remember all the tiny details I embroidered around that particular sketch whether I wrote it down or not. There's a definite storytelling element to my sketchbooks. Sometimes, I'll make fictional characters from books I've read more "real" for myself by drawing that character as they appear in my mind's

eye. Or I'll draw an experience or a person I saw on the street, not necessarily as they look in real life, but how I interpret the feeling they communicated to me. Or I might exaggerate the feature that really caught my attention and made me look at them. For example: a really long neck or a large behind, a daring sense of fashion, a flirtatious glance, a smug air of satisfaction or someone in a particularly foul frame of mind.

I've always got a sketchbook or three lying around somewhere nearby. I take a sketchbook with me when I remember to, but often I find them too cumbersome to tote around with me (I draw big and favor books that are at least 8.5" × 11", but generally as big as I can find them.) So I tend to draw at home, either in bed or in the backyard, or occasionally at my drawing table, and very

occasionally, in the bathtub, although that's not the most practical place.

The fact that it's a book is really not of any importance to me at all. It's more a matter of convenience, a way to try to contain the clutter. Drawing in a book is really no different to me than on a loose piece of paper or on a canvas except that the sketchbook drawings tend to be more of a whim, a spontaneous thing. If I'm working on a painting or a commissioned work, I tend to be slightly more systematic in plotting out what I'm going to draw and how I'm going to draw it.

My sketchbooks are a playground, or even a holding tank for ideas and characters that occur to me that I may (or may not) follow further in the future. Their

Within the image, handwritten notes read:

I've asked her her name but she won't tell me. I'm pretty sure she's Spanish... maybe Basque. And revolutionary in some way. But that's all I know so far...

This is the drawing of the girl that lived literally on my desktop under my mousepad

primary purpose is just to give me space to play, to explore line, work and ideas that occur to me without having the pressure of producing "real art" or something that I have to share with others. Although I do, sometimes, if a drawing works out particularly well or captures something I feel like sharing.

I doodle on everything. Constantly. Grocery lists, sales receipts, my (literal) desktop, my legs and arms, book covers, my husband … and yes, in my sketchbook! Whenever I clean out my studio (or the house in general), I toss the doodle bits I like into a box. Then every couple of months or so, I go through the box and tape or glue the bits I like, or the bits that are in some way similar to the other bits, onto a sketchbook page for "safe keeping."

I often tell myself little stories about whatever it is I'm drawing, and later, looking back on the drawing, I will remember all the tiny details I embroidered around that particular sketch whether I wrote it down or not.

I use my books to work out problems. For instance, I have trouble visualizing how the head of a person connects to the neck, and I tend to draw head and shoulder pictures over and over to try to position that accurately in my head so I don't have to use photo reference to understand that all the time. Also, I often work out imaginary characters I have gamboling around in my head—what they look like from differ-

ent angles, expressions that might cross their faces, that kind of thing.

Sometimes I push myself to try different media or color, as I tend to work in black and white a lot simply because it's easiest to grab a pen or pencil than a paintbrush, which requires water and paint and a place to balance all of that. I often scan images from my sketchbooks into my computer and play with them digitally.

I also push myself to "learn" how to draw something I avoid when I'm lazy, like cars and buildings and mechanical things. I tend to like to draw organic objects—people, plants, flowers, trees, animals and fruit—and avoid other objects out of sheer laziness. I'll draw things (the same animal, the same posture) over and over again as a way of understanding it, cementing it in my memory so that I can draw it again from recall alone, if and when I need to.

When I was a kid, I somehow latched on to this idea that real artists don't use reference (especially photo reference). I don't know if I just didn't understand that drawing from life was a huge part of developing your artistic skills of observation or if I somehow thought that all great art had to be produced from your imagi-

nation. But by the time I was twelve, I had developed this irrational bias against any form of reference. I know differently now, of course, but that old bias still clings to me and has become a kind of "rule" that I'm regularly attempting to shrug off. I always feel like I am "cheating" if I use photo reference, all the while chiding myself for being so ridiculous. In some ways though, that old bias has paid off. I can produce fairly accurate renderings of most things purely from my imagination, something I know other artists struggle with. And it saves me time and energy searching out appropriate reference materials.

I don't mind other creative people looking at my sketchbooks because I think they understand that not

everything in it is going to be beautifully or skillfully rendered, that it is about playing or experimenting or just working out the knots. But I get a little agitated

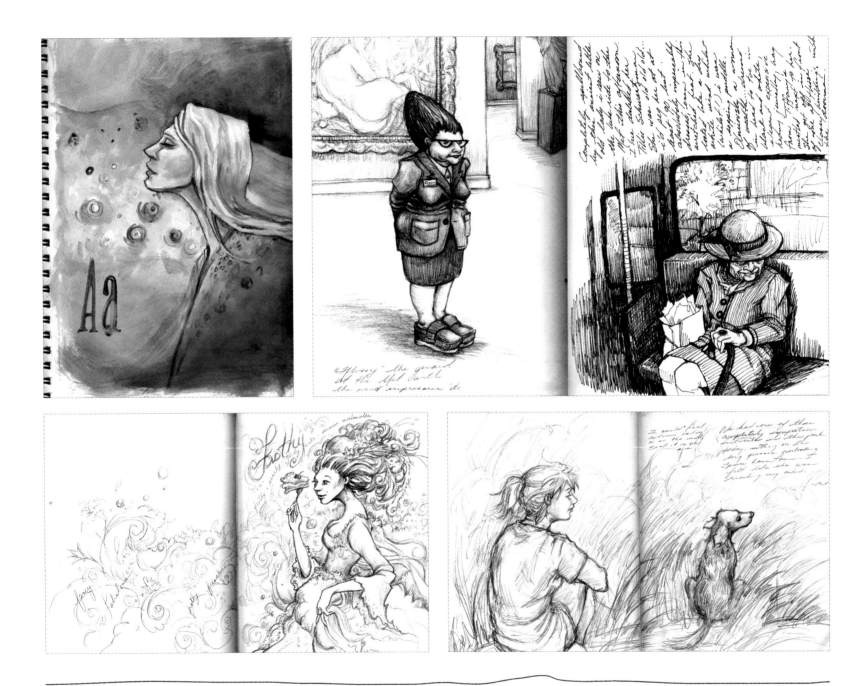

when someone who is not familiar with the art process picks up my sketchbook and just starts leafing through it because I worry that they aren't seeing my work in the best light or understanding my skills. Admitting that is a bit embarrassing because I would like to believe that I draw solely for myself and I don't care what other people think, but the truth is I do care. I care a lot. I want people to think I'm good at this whole art thing! I want them to recognize it as something unique, something special.

Sketchbooks are often more revealing, more interesting than more finished works of art. I believe that no matter what you are drawing, or how you are drawing, some part of your personality is captured in your

work, and I think that peeking into someone's sketchbook offers you some unique perspective into how that person's mind works. And that's a privilege.

I'm not really particular about the type of sketchbook I work in as long as its pages are large enough that my hand isn't sliding off the edge of the book and that I feel I can move freely (if that makes any sense). And I prefer heavier paper so that it doesn't buckle with the heat of my hand or under the pressure of my pen/pencil.

I tend to use a lot of pencil, usually mechanical pencils or soft graphite sticks. I prefer soft media, 2B to 6B, though HB will do. I don't like drawing with a hard lead. I use ballpoint pens a lot, and Pigma Micron ink pens.

I've been experimenting a fair bit with ink washes, lately, using a brush. Occasionally, I will paint with acrylics in my sketchbooks, but generally I like to paint on a more rigid surface, like illustration board.

My advice to would-be-sketchbookers: Just do it! And keep doing it until it feels natural. Have fun with your sketchbooks and don't be timid about messing up a page. And don't worry about other people seeing it, just do it for yourself, in whatever way feels best, with whatever materials are available to you. Try not to compare yourself and your skill level to other people; don't judge. Which all sounds so easy, but is much more difficult in practice, as most things are. And try not to take sketchbooking too seriously.

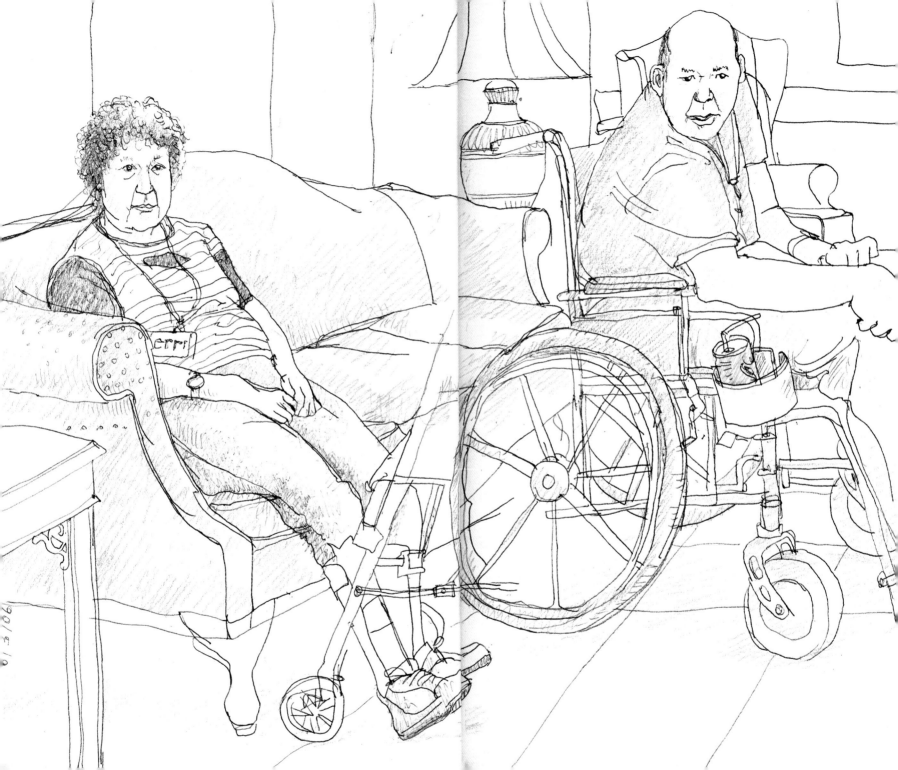

01 3/06

CINDY WOODS

Cindy was born in Richmond, Virginia, graduated from Virginia Commonwealth University with a BFA in illustration and lives and works as a part-time receptionist at The Virginia Home, a nursing home for disabled people. For more of her work, visit www.learndaily.blogspot.com.

My journey to drawing has been a very slow one. I don't remember drawing much as a kid, and my efforts in high school were rather timid, no more than doodles. Though I was constantly looking through children's and art books, that love of pictures didn't translate into making many of my own until I moved away from home. It was the inspiration from Paul Hogarth's book *Drawing People* and moving into a nursing home full of people willing to be drawn that finally got me started. There was a chess club that met with the residents here on a weekly basis and because they were so focused on their game, it provided a safe way to observe people without them taking much notice of me. I gained confidence in drawing this way and started to ask folks to pose for me. These introductions through drawing are how I came to know many of the people here. Since I've lived here for more than thirty years, most of these folks are deceased now, making these early drawings all the more precious to me.

That's how I began to draw, and though there've been periods of inactivity, it has, in one form or another, been a consistent part of my life ever since. The one odd thing is that, in all that time, I'd never kept a sketchbook. That's a recent development, and now that I've started, I regret it's not something I began early on. Even though keeping a sketchbook was encouraged in art school, for some reason I just never took to it. I don't know. Drawing in a sketchbook is sometimes a scary thing. The Internet made a big difference in finally getting me started. Seeing so many beautiful pages on web sites made me regret that I wasn't able to flip through pages of my own. I liked the sense of progression through time that felt so much stronger in a book than with the loose, single sheets I'd always used. And I regretted even more that, as I began to explore illustration, I had stopped drawing from life, drawing my friends, and that there was a huge gap of years and people that had gone unrecorded.

So, with a building full of folks still willing to act as models, I began filling the pages of my very first sketchbook with their portraits. I started a second small sketchbook for travel, keeping it always at the ready in my shoulder bag and learning to scribble quickly whenever there was an opportunity. I joined a figure-drawing group and keep a sketchbook of just those drawings. Blogging all these sketches has made a difference in keeping me committed to the task. I've never drawn so consistently before over such a long period of time, and the rewards of that practice have been fantastic. I notice more, always on the lookout for something interesting to draw or that I want to remember. I can look back in my books, especially my travel sketchbooks, and recall bits and pieces of a day I'd otherwise have forgotten. I'm more confident with my drawing and can capture a scene more quickly. Even when there's barely any time, I've started to dash off the most scribbly notes and use them to work on a sketchbook of scenes from memory.

I've come a long way, but I still have periods of fear, of messing up the pages, that will keep me from working in my books. I also, because of my disability, have a hard time holding some sketchbooks. I don't want to lose this momentum I've gained, so in addition to a sketchbook, I always make sure I've got a cheap pad of paper from the drugstore with me so at least I have something I can switch to when I'm feeling less confident and intimidated about using my book.

I'm also still finding and am constantly inspired to try new things by the examples I find on the web. I'm curious what keeping a set time and place for sketching would feel like or drawing a whole book just out of my imagination. I want to try collage, work more on composition and lettering. If I could remember them, an illustrated dream journal might be neat. I've been slow in starting and developing this sketchbook habit, but now I can't imagine stopping.

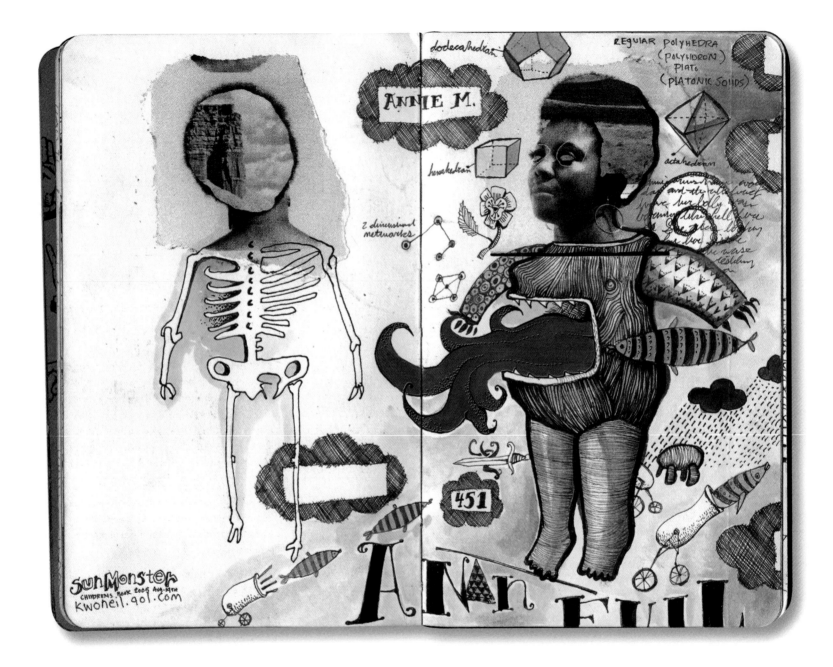

ANNIE M.

dodecahedron

REGULAR POLYHEDRA
(POLYHEDRON)
PLATO
(PLATONIC SOLIDS)

hexahedron

octahedron

2 dimensional
networks

451

SunMonster
CHILDRENS BOOK 2005 Aug. 19th
kwoneil.aol.com

ANNE FULL

BRYCE WYMER

Bryce grew up in West Palm Beach, Florida, and currently lives in Brooklyn, New York. He studied illustration and design at Ringling College of Art and Design in Sarasota, Florida, and now does illustration and design in the broadcast/motion design industry. To see more of his work, visit www.brycewymer.com.

Of all of my many works, my visual journals have the strongest purpose and are the truest form of art. They're one of the few places where my thoughts are expressed solely for my own expectations, a vehicle for self-exploration, not polluted by commercialism and monetary gain. When I look through a finished journal, I can remember exactly the state of mind I was in during that period.

The fact that my journals are books is essential to the way I use them. Things just change when they live between the covers of a book. For instance, sometimes my artwork can seem stale or unfinished for weeks. I need to be able to flip the page and not look at an idea for a little while. It keeps things fresh. Turning over the page clears the idea from my mind. It's like how certain artists will flip their canvases toward walls or hide their designs in some computer filing system.

I try not to impose too many rules on my books. The only thing that has remained a constant is that I start each book four pages in. I don't know exactly why—I suppose there is something slightly intimidating about the first three empty pages. Then, eventually, I come back and fill in those front pages.

Occasionally, I work through my professional concepts in my books. But these are almost always edited over. Eventually, I will paint or draw over them. At that point, they have already accomplished their purpose. They move forward and become something completely new and surprising.

I don't really have a sketchbook ritual; it is truly a spur of the moment, free-form exercise. There are times when I give myself challenges; for instance, a portrait a day for a month. But these are few and far between.

I have always drawn. It was the first way I learned to truly communicate. I started keeping journals in middle school around age twelve or thirteen. Looking back at those old books, I found I was much more of a perfectionist than I am now. Lots of the pages were ripped out or scribbled over. Over the years, I have learned that imperfections are the strongest, most energetic aspects of my works.

In the last few years, I have been extremely interested in documenting my surroundings. I draw rooms, parks, buildings, anything that is in my immediate environment. I find great solace in this form of representational documentation.

Generally I fill a hundred-page Moleskine in a little under three months. My books go absolutely everywhere with me, so occasionally they do get misplaced, but oddly enough, every single book since 1997 has made it back to my warm embrace.

Over the years, I have tried almost every brand of blank sketchbook. And I can honestly say almost all of them are falling apart, except for the Moleskines. They are just higher-quality books. I tend to switch between their watercolor sketchbook and the standard sketchbooks.

I use just about every sort of art supply in my books—gouache, pencil, 001 Pigma Microns, a Winsor & Newton travel watercolor set, lots of collage, Super 77, and India ink.

Once I fill my books, I keep them in acid-free, airtight bags. I am very careful with them; they are probably the only material objects that I truly would feel lost without.

I like it when other people look through my books. I like the fact that they never say, "What was this designed for" or "Who was this done for." It's like they know they are looking through something that is entirely mine. I also feel that books are a format that people tend to be comfortable with. They're familiar. The only thing

foreign to them is that my books are one of a kind. And if they don't like a certain image, all they have to do is turn the page and see something different. I think this creates a level of intimate comfort with individuals.

My advice to journal keepers: Don't feel ashamed of the mistakes. Live with them a while and they will liberate you.

B r y c ⊆ W y M ≡ r

Turning over the page clears the idea from my mind.

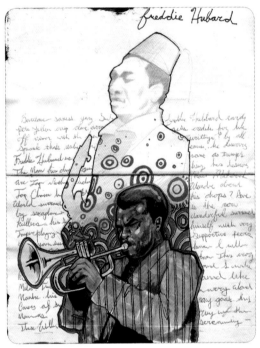

INDEX